AN AMERICAN STYLE

AN AMERICAN STYLE

Global Sources for
New York Textile
and Fashion Design
1915–1928

———

Ann
Marguerite
Tartsinis

Published by Bard Graduate Center:
Decorative Arts, Design History, Material Culture, New York
Distributed by Yale University Press, New Haven and London

This catalogue is published in conjunction with the exhibition *An American Style: Global Sources for New York Textile and Fashion Design, 1915–1928,* held at Bard Graduate Center: Decorative Arts, Design History, Material Culture from September 27, 2013 through February 2, 2014.

Curator of the exhibition
Ann Marguerite Tartsinis

Focus Gallery team:
Head of the Focus Gallery
Ivan Gaskell
Chief curator
Marianne Lamonaca
Exhibition designer
Ian Sullivan
Media producer
Han Vu
Director of the Digital Media Lab
Kimon Keramidas
Dean for Academic Administration and Student Affairs
Elena Pinto Simon

Catalogue production:
Designer
Laura Grey
Coordinator of catalogue photography
Alexis Mucha
Copy editor
Mary Christian

Director, Bard Graduate Center Gallery/ Gallery Publications
Nina Stritzler-Levine

Published by Bard Graduate Center: Decorative Arts, Design History, Material Culture, New York, NY

Exclusive trade distribution by Yale University Press, New Haven and London
ISBN (Yale University Press): 9780300199437

Library of Congress Cataloging-in-Publication Data

Tartsinis, Ann Marguerite, 1978–
An American style : global sources for New York textile and fashion design, 1915–1928 / Ann Marguerite Tartsinis.
 pages cm
ISBN 978-0-300-19943-7 (pbk.)
1. Textile design—United States—History—20th century—Exhibitions.
2. Fashion design—United States—History—20th century—Exhibitions.
3. American Museum of Natural History—Public relations—Exhibitions.
4. Ethnological museums and collections—Public relations—New York (State)—New York—Exhibitions.
I. Bard Graduate Center for Studies in the Decorative Arts, Design, and Culture. II. Title.
NK8912.T37 2013
746.0973'0747471—dc23

 2013024842

Printed by GHP, West Haven, Connecticut

Cover: Ilonka Karasz in "Peruvian poncho," ca. 1916. Photographer unknown. Image 2A18815, American Museum of Natural History Library.

Endpapers: Elements of beaded designs from examples in the American Museum of Natural History. From Clark Wissler, "Indian Beadwork: A Help for Students of Design," (1919), 25, 27, 29. Private collection. Cat. 9.

Frontispiece: Walter Mitschke for H. R. Mallinson & Co. Drawing for "Zuni Tribe," ca. 1927. Pencil and gouache on paper. Museum of fine arts Boston, Gift of Robert and Joan Brancale, 2008.1950.35. Cat. 36.

Contents

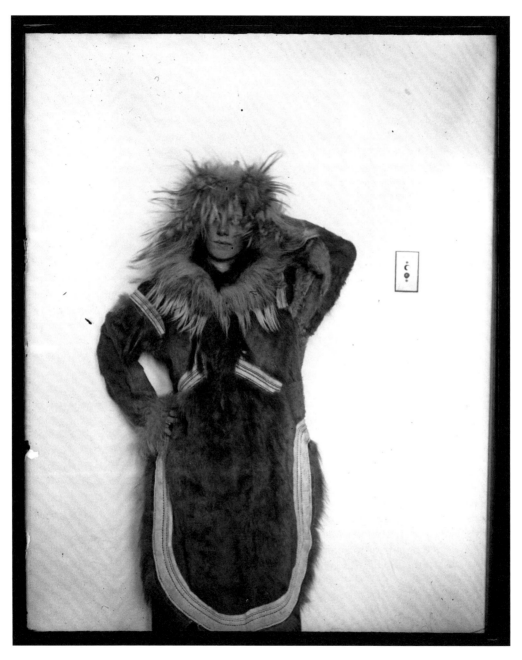

Model in "Eskimo" hide, fur, and sinew coat, ca. 1916. Photographer unknown.
Image 2A18808, American Museum of Natural History Library.

Director's Foreword

The twentieth anniversary of the founding of the Bard Graduate Center is the appropriate occasion to highlight achievements by former students. Ann Marguerite Tartsinis, curator of *An American Style*, was awarded the Clive Wainwright Prize for the best master's thesis of 2011 for "Intimately and Unquestionably Our Own": The American Museum of Natural History and Its Influence on American Textile and Fashion Industries, 1915–1927." She was subsequently appointed assistant curator at the BGC, and was recently promoted to associate curator in recognition of her outstanding work on a series of both Main Gallery and Focus Gallery exhibitions. As we celebrate twenty years of innovative work in all divisions of the BGC, it seems only fitting that we should turn to the work of one who is "intimately and unquestionably our own."

In *An American Style*, Ms. Tartsinis tells the story of how a group of curators at the American Museum of Natural History (AMNH) encouraged a number of New York textile and fashion designers to seek inspiration among the fabrics, garments, and other artifacts in the museum's ethnographic collections. An emerging American national self-confidence and cultural particularism prompted New York designers to turn to Indigenous American materials and, later, more global artifacts as sources at a time when the French fashion and the German dyestuffs industries were both critically disrupted by the First World War. Rather than continuing to be in thrall to Europe, New Yorkers made a virtue of what was immediately at hand to produce designs that were distinctively American. The AMNH played a central role in this development. The high point of the story Ms. Tartsinis tells is the *Exhibition of Industrial Art in Textiles and Costumes* held at the AMNH in 1919. Designers exhibited their new fabrics and garments alongside some of the items in

the museum's collections that had inspired them in alcoves temporarily installed in the museum's Eastern Woodlands and Plains Indians Halls.

Ms. Tartsinis has drawn on the AMNH Division of Anthropology collections, and on the AMNH Research Library Special Collections (Institutional Archives, Manuscripts, and Personal Papers, and the Photograph Collection). This project marks a further development of the special relationship between the BGC and the AMNH that has seen the appointment of three successive BGC–AMNH postdoctoral fellows, significant collaborative teaching, research opportunities at the AMNH for BGC students, and the realization of two previous Focus Gallery exhibitions with a third in preparation for spring 2014. I should therefore like to acknowledge our debt to Ellen V. Futter, president of the AMNH, for the loans from the museum's collections and archives that have made the exhibition possible. The chair of the AMNH Division of Anthropology, Laurel Kendall, lent invaluable support. Kristen Mable, Division of Anthropology registrar for archives and loans, and Barbara Mathé, AMNH archivist and head of Library Special Collections, generously facilitated access to archival correspondence and the unparalleled collection of museum negatives, without which this project would not have been possible.

In addition to the AMNH, numerous institutional lenders were essential to the realization of *An American Style*. Significant examples of early twentieth-century textile and fashion design have been lent by the Allentown Art Museum; the Brooklyn Museum; The Metropolitan Museum of Art; The Museum of Art, Rhode Island School of Design; Museum of Fine Arts, Boston; and the National Museum of American History, Smithsonian Institution. I would especially like to thank Barry Harwood, curator of decorative arts at the Brooklyn Museum, and Harold Koda, curator-in-charge of The Costume Institute

at The Metropolitan Museum of Art, for their generous assistance with this process. A special expression of gratitude must be given to Solveig Cox, daughter of Mariska Karasz, and Ilonka Sigmund, granddaughter of Ilonka Karasz, for sharing their private collections for exhibition research and loans.

I am especially proud that Ms. Tartsinis's example as an outstanding graduate of the BGC master's program is ever before our current students, particularly Alison Kowalski and Sophia Lufkin, who assisted in the preparation of the biographies of those who figure in Ms. Tartsinis's story, as well as Ms. Kowalski and Zahava Friedman-Stadler, who provided invaluable assistance with research and writing for the digital media components and exhibition texts.

Nina Stritzler-Levine, director of the BGC Gallery and Gallery Publications proposed that Ms. Tartsinis's thesis be the subject of a Focus Gallery exhibition. The dean of the Bard Graduate Center, Peter Miller, continues to sustain the collaboration between the Gallery and the Academic Programs department of the BGC. This collaboration alone makes the Focus Gallery Project possible. His support is complemented by the contributions of Elena Pinto Simon, dean of Academic Administration and Student Affairs; Nina Stritzler-Levine; and Ivan Gaskell, professor and head of the Focus Gallery Project, who oversaw the endeavor. Many BGC staff members collaborated to realize Ms. Tartsinis's concept: Rebecca Allan, head of Education; Eric Edler, Gallery registrar; Laura Grey, former art director; Kimon Keramidas, assistant professor and director for the Digital Media Lab; Marianne Lamonaca, associate Gallery director and chief curator; Alexis Mucha, coordinator of catalogue photography; Ian Sullivan, exhibition designer; and Han Vu, media producer. MediaCombo, led by Robin White Owen, developed the digital interactive that explores the 1919 *Exhibition of Industrial Art* through archival photographs and period texts. The production of this catalogue was aided by the diligent work of our copyeditor, Mary Christian, and proofreader, Charmain Devereaux. I should like to thank them all, as well as all other members of the faculty and staff of the Bard Graduate Center whose support has made *An American Style* possible.

—**Susan Weber**
Director and Founder
Iris Horowitz Professor in the History
of the Decorative Arts
Bard Graduate Center

Foreword

One fitting reason that this project should celebrate the twentieth anniversary of the founding of the Bard Graduate Center is that it epitomizes the expansion of fields of scholarship within the BGC since its inception.

Western textile and fashion design history has always been an important constituent of the BGC's world. Anthropology is one of its more recent additions. *An American Style* ambitiously addresses both. Another scholar might have been tempted to tell the story of the emergence of a self-consciously American design strategy in fabrics and clothing deliberately distinct from European models as World War I raged as a triumphal American achievement. But Ann Marguerite Tartsinis knows that textile and fashion design history is not self-contained. Neither is the propriety of cultural appropriation by designers of European extraction from Indigenous American, African, East Asian, and Oceanic sources to be taken for granted.

Even during the years Ms. Tartsinis examines—1915 through 1928—the idea of devoting the anthropological resources of a leading scholarly institution in the field—the American Museum of Natural History—to support commercial activity that exploited the products and knowledge of what we would call subaltern peoples did not go unchallenged. However, we should be careful not to be anachronistic when assessing either support for the AMNH program that found expression in the museum's 1919 *Exhibition of Industrial Art in Textiles and Costumes* or its critics. Pliny Earle Goddard's reservations about the promotion of the commercial use of the collections by his departmental colleagues, M. D. C. Crawford, Charles W. Mead, Herbert J. Spinden, and Clark Wissler derived from his conception of what was proper to the study of anthropology rather than from ethical doubts regarding cultural appropriation. As Ms. Tartsinis shows, Crawford and his associates' call for the creation of a textile and sartorial arts department to foster industrial arts education at the AMNH—soon amplified to include ceramics, interior decoration, furniture, and jewelry—came to nothing. Goddard's emphasis on linguistics proved enduring, and to this day remains an important factor in North American ethnographic scholarship at the AMNH.

In *An American Style*, Ms. Tartsinis shows how textile and fashion design history intersects with the complex history of museum anthropology. The BGC is, above all, concerned with intersections among seemingly disparate fields in the decorative arts, design history, and material culture. There is surely no better way of demonstrating the fecundity of this approach on the occasion of the twentieth anniversary of the BGC than by presenting a fascinating case study that embraces both textile and fashion design history and anthropology by a former student who is now one of its curators.

—Ivan Gaskell

Professor of Cultural History and Museum Studies
Curator and Head of the Focus Gallery Project
Bard Graduate Center

Author's Acknowledgments

An American Style is the product of the dedication of and collaboration among many talented members of the Bard Graduate Center (BGC) community. I am deeply indebted to the BGC's founder and director, Susan Weber, for her enthusiasm and commitment to this project from the outset. This exhibition would not have come to realization without the foresight of Nina Stritzler-Levine, director of the BGC Gallery, who initially proposed that my 2011 BGC master's thesis be the subject of a Focus Gallery Project. For this and her unwavering support I am extremely grateful. The continued success of the Focus Gallery Project is a testament to the leadership of dean Peter Miller, whose dedication, along with that of Susan Weber and Nina Stritzler-Levine, has fostered this unique vision for academic and curatorial exploration. Ivan Gaskell, head of the Focus Gallery, has been an invaluable mentor and colleague and his expert guidance has shaped this endeavor in many ways.

Since this project was first conceived as my master's thesis, I have benefited enormously from the formative comments, mentorship, and encouragement of several BGC faculty members, particularly my advisors, Michele Majer and Aaron Glass. I am also grateful to the additional faculty members and colleagues whose insights have shaped my own thinking over the last five years: Ken Ames, David Jaffee, Amy Ogata, Elizabeth Simpson, and Catherine Whalen, among many others. I would also like to thank Susan Weber, Peter Miller, and Jeffrey Collins for recognizing my thesis with the Clive Wainwright Award for outstanding master's thesis in the field of decorative arts, design history, and material culture, and so kindly encouraging further work on this project.

This exhibition and accompanying volume is also the outgrowth of the collaborative efforts of the Focus Gallery team, whose generosity, enthusiasm, and tireless ambition brought this project to realization: Ian Sullivan designed the striking installation; Han Vu produced the *American Museum Journal* interactive and the arresting slide show and projection of negatives from the American Museum of Natural History Special Collections; dean Elena Pinto Simon provided generous feedback and assistance; and Kimon Keramidas effortlessly managed the production of the *American Art in American Dress* interactive, an indispensible component of the exhibition in which Robin Wright Owen, Evan Rose, and Ellen Zhao of MediaCombo have artfully brought my ideas to life. Finally, I must express my sincere gratitude to chief curator Marianne Lamonaca, who graciously shared her curatorial expertise throughout the completion of this project.

I am indebted to many additional colleagues at the BGC for the boundless energy, time, and support they devoted to this project, especially: Rebecca Allan, Kate DeWitt, Eric Edler, Izabella Elwart, Alexis Mucha, Stephen Nguyen, Aurora Robles, Vanessa Rossi, and Lynn Thommen. I would like to recognize Earl Martin and Elizabeth St. George for their kind assistance, diligent proofreading, and insightful conversations. I am thankful to BGC graduate students Alison Kowalski, Sophia Lufkin, and Zahava Friedman-Stadler for their important research and notable contributions to the catalogue and exhibition texts. I would also like to acknowledge the many members of the extended BGC community who have contributed to the production of this volume: Mary Christian, copy editor; Charmain Devereaux, proofreader; Bruce White, photographer; and Enid Zafran, indexer. Sally Salvesen at Yale University Press, kindly shared her editorial wisdom. I extend a very special thanks to Laura Grey, former BGC art director and a dear friend, whose skillful catalogue design

truly evokes the story of *An American Style*.

I would like to join the director in thanking the lenders and contributors to this exhibition and accompanying volume, especially at the American Museum of Natural History: Laurel Kendell, chair of the Division of Anthropology; Kristen Mable, Division of Anthropology registrar for archives and loans; Judith Levinson, Division of Anthropology director of conservation; Samantha Alderson, Division of Anthropology objects conservator; Barbara Mathé, archivist and head of Library Special Collections; and Gregory Raml, Special Collections and research librarian. Without these individuals' generous assistance this project would not have been possible.

Numerous archivists, collectors, curators, librarians, and scholars kindly guided me through the dense thickets of correspondence, periodicals, storage rooms, and museum collections essential to the realization of this project, and to these colleagues I am indebted: Barry Harwood and Leslie Gerhauser, the Brooklyn Museum; Deirdre Lawrence and Angie Park, the Brooklyn Museum Library and Archives; Lynn Weidner, The Museum at FIT; Harold Koda and Sarah Scaturro, The Costume Institute at The Metropolitan Museum of Art; Julie Tran Lê, the Irene Lewisohn Costume Reference Library, The Metropolitan Museum of Art; James Moske, Office of the Senior Vice President, Secretary and General Counsel Archives, The Metropolitan Museum of Art; Meghan Melvin and Lauren D. Whitley, Museum of Fine Arts, Boston; Kate Irvin, Museum of Art, Rhode Island School of Design; Doris Bowman and Margaret Grandine, National Museum of American History, Smithsonian Institution; Ashley Callahan; Donna Ghelerter; Ira Jacknis; Giles Kotcher; Madelyn Shaw; and Susan Ward. Particular thanks go to Joan Brancale, Solveig Cox, and Ilonka Sigmund, who shared personal collections and family histories.

Many friends and family have extended their support over the course of this project's realization and to them I am extremely grateful.

I extend a special note of thanks and appreciation to Ben Harrington, without whose deft editorial hand, encouragement, patience, and infinite humor I would not have sustained this project. And last but not least, I would like to express deep gratitude to my mother, Jean, and dedicate this volume to my late father, Dimitrios K. Tartsinis.

"A NEW AMERICAN DECORATIVE ART": THE AMERICAN MUSEUM OF NATURAL HISTORY AND THE PURSUIT OF A NATIONAL DESIGN IDENTITY, 1915–1928

In March 1915, esteemed educator Arthur Wesley Dow called for the creation of a national design language built upon the forms and ornament of indigenous artifacts of the Americas:

It is time we throw off these shackles and endeavor to express ourselves in our own way. Our design should be distinctively American. We ought to create a new period style for our own needs. As a step toward this, let us study the art that was here before us, not to copy it, but to see if it expressed something of this country's nature and life. Here is an art that grew up on our soil,—from the outline design on a clay pot to the sculptured temples, from a woven mat to a perfectly wrought tapestry.

What may we learn from it?[1]

Dow was driven by a genuine admiration of indigenous design aesthetics, but his vision also responded to the practical exigencies of World War I, which had embroiled the European design centers on which the American industry had historically relied. With no fresh designs from abroad to adapt and emulate, American designers were compelled to forge an original and authentic design idiom distinct from European traditions. With their nation standing at the precipice of engaging in the war, some Americans endeavored to cultivate, through design innovation, a national identity that could stand apart from the dominant imperialist and nationalist politics particular to Western Europe.[2] They did so by looking not only at the ethnic heritage of Native Americans but—as Dow suggested—by embracing artistic expressions from other indigenous cultures in Central and South America. Though few, if any, proponents of the movement could assert membership in the cultures it embraced, the design heritage of the Americas was heralded for its freshness and non-European dimension, and claimed by the American design community as distinctly "our own."[3]

A design movement drawn upon indigenous materials is, of course, reliant upon the institutions and museums in which artifacts can be collected, assembled, and studied. And New York museums, roused by the call for a national design language, would participate in the movement by opening their doors to designers, albeit with differing degrees of enthusiasm and divergent visions of what American design might look like and mean. The American Museum of Natural History (AMNH) was an early, and particularly spirited, proponent of the project. With its vast collections, the museum sought to educate designers in the principles of indigenous design and, more ambitiously, to unite them with industry leaders capable of manufacturing products modeled upon ethnographic materials.

Among the central figures in this project at the AMNH were curator of Peruvian art Charles W. Mead (1845–1928), assistant curator of anthropology Herbert J. Spinden (1879–1967), curator of anthropology Clark Wissler (1870–1947), and M. D. C. (Morris De Camp) Crawford (1883–1949), amateur expert in Peruvian textiles, AMNH research fellow, and journalist for the daily fashion trade paper *Women's Wear* (figs. I–IV).[4] Crawford was a key liaison to designers and manufacturers but many documents in the AMNH Division of Anthropology Archives suggest that Mead, Spinden, and Wissler were equally instrumental, if not more so, in the efforts at the museum to promote American design steeped in principles of what was then called "primitive art." In their effort to use study collections, the curators at the AMNH were aligned with secretary Henry Watson Kent (1866–1948) and associate of industrial relations Richard F. Bach (1887–1968) at The Metropolitan Museum of Art, as well as John Cotton Dana (1856–1929) of the Newark Museum.[5]

Drawing upon the nineteenth-century model of London's South Kensington Museum (now the Victoria and Albert Museum)—where design reformer Henry Cole provided examples of British handicraft and folk art in the museum's galleries to stimulate manufacture—collectively,

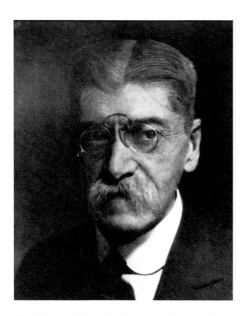

Fig. I. Charles W. Mead. Photograph by Thane L. Bierwert of an undated portrait, 1943. Image 326587, American Museum of Natural History Library.

these men promoted object research at their museums through the installation of study rooms that showcased their respective collections. The Metropolitan Museum opened its first textile study room in 1910; and in 1914, in conjunction with an educational initiative reflecting the more conservative tastes of the period, Kent opened six more study rooms dedicated to European furniture, American decorative arts, Western ceramics, English furniture, Near Eastern arts, and Far Eastern arts.[6] While the Metropolitan Museum placed special emphasis on classical and European objects, particularly French decorative arts, the AMNH and the Brooklyn Museum Institute, the latter under the direction of Stewart Culin (1858–1929), opened study rooms dedicated solely to ethnographic specimens with the explicit aim of generating a more purportedly unique and genuine American design language.[7] These distinct approaches represented a cultural divide between conser-

vative tastemakers and the more progressive design innovators that hindered the creation of a singular modern American style.

Unlike their counterparts at the AMNH, the curators at the Metropolitan Museum were critical of the formalist avant-garde aesthetics associated with modern art. As historian Jeffrey Trask has observed, many of the museum's administrators and curators saw the modern art movement and its extension into the production of a contemporary American design as radical and antithetical to the mission of that institution.[8] Yet, for the AMNH, cultural currents such as the American Arts and Crafts movement and modernist primitivism, as well as canonical ruptures such as the 1913 Armory Show in New York—a seminal exhibition trumpeting the formal, non-representational manner that marked the emergence of modern art in America—synergized to signal a formative encounter with the artistic and intellectual avant-garde.[9]

While recognizing the creative and instructive potential of the anthropology collections to art and industry, the AMNH also embraced the non-representational mode native to modern art. The museum's adoption of a more avant-garde design vocabulary can be seen in its enthusiastic endorsement of Dow's vision—a national idiom modeled after conventionalized motifs found in non-Western objects. The AMNH was at first provincial in its focus, seeking to unearth an "American" textile design aesthetic based on the museum's ethnographic collection of artifacts from the Americas. To advance this effort, the Department of Anthropology opened its collection to designers, published didactic manuals beginning in 1915, and hosted a series of lectures, temporary exhibitions, and contests commencing the following year. Through this outreach, the museum staff advocated for the utility of the collection and presented a compelling discourse on the merits of prehistoric design with an explicit focus on ancient American weavings, baskets, and pottery. Such efforts found a naturally receptive audience among progressive designers, particularly those

working in the thriving artistic and cultural center of Greenwich Village; many of whom were women, drawn to the museum through Crawford's outreach in *Women's Wear*.

In late 1916, paralleling the country's imminent entry into World War I and emergence onto the world's stage, the project to inspire designers began to embrace a more global array of artifacts, hailing from such diverse locales as Siberia, the Philippines, and Africa. At this same time, there was also a marked expansion of the Department of Anthropology's educational priorities—from textile design to women's fashion design and clothing manufacturers on a larger scale. The shift was in part aimed at curbing

the imitation of French and European fashions by American makers, but more so, it sought to incite unique, well-wrought interpretations for a new American mode.[10]

The geographic expansion of the AMNH's focus resulted in a dizzying confluence of divergent indigenous-inspired design motifs, as was evident in the variety of ornament and garment construction presented at the *Exhibition of Industrial Art in Textiles and Costumes*, mounted for two weeks in November 1919. The exhibition featured a comprehensive display of indigenous artifacts and contemporary design—represented by both handcrafted and industrial objects—and overtly aimed to

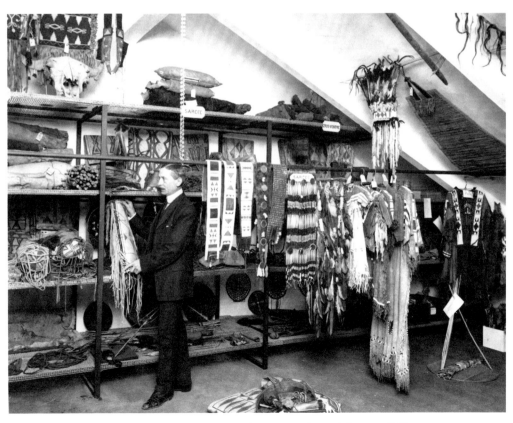

Fig. II. Clark Wissler in the Plains Indians storage room, American Museum of Natural History, ca. 1908. Photograph by Julius Kirschner. Image 32172, American Museum of Natural History Library.

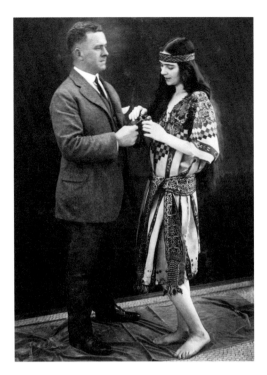

Fig. III. M. D. C. Crawford with Ilonka Karasz, ca. 1916–19. Brooklyn Museum Archives. Records of the Department of Costumes and Textiles: Crawford study collection. Peruvian textiles, 1 of 3.

practices employed by early twentieth-century craft and fine-art societies such as the Boston Society of Arts and Crafts and the National Arts Club in New York as well as more commercial progenitors such as the John Wanamaker department store.[11]

Despite its critical success, the exhibition would signal the end of the AMNH's active collaboration with designers and manufacturers. Following the exhibition, the AMNH tentatively pursued a department of industrial design. However, it abandoned the project as it returned to a more museological—and specifically for the Department of Anthropology, a more scientific and less commercially driven—pedagogical platform, thereby slowly shrinking away from its engagement with textile and fashion industries. As the museum refocused its institutional priorities, the Brooklyn and Metropolitan Museums would pick up the AMNH's efforts and foster more constructive relationships with these industries. And even though the AMNH's ties with industry unwound in the decade following the 1919 exhibition, the museum's collections would nonetheless be used to create a selection of popular contemporary textile designs—products that would attest to the lasting impact of the progressive effort to engage designers at the AMNH.

The project at the AMNH was only one facet of the broader Designed in America movement instigated by Crawford and William Laurel Harris, editor of *Good Furniture*, in 1916. As Lauren Whitley has shown in "Morris De Camp Crawford and American Textile Design, 1916–1921," this effort united industrial magnate Albert Blum of United Piece Dye Works and publisher E. W. Fairchild of *Women's Wear* with representatives from both the Metropolitan Museum and the AMNH to improve American industrial design. The campaign was driven by a torrent of editorials in *Women's Wear*, bolstered by joint lecture series in both museums and, most importantly, *Women's Wear*-sponsored textile design contests held from 1916 to 1922.[12] In her essay "In Search of a National Style," textile historian

promote the utility and value of the museum to designers and industry. By including commercial products within a museological display, the AMNH sought popular approval while demonstrating the economic viability of its "American" project. But more than a celebration of contemporary products, the exhibit provocatively displayed a new progressive design language—albeit somewhat tempered by the inclusion of classical and European objects. And, further, it was the only exhibition of its kind at the AMNH and one of the first museum installations in America to display ethnographic artifacts next to the commercial objects that they had inspired. Largely conceived by Spinden, this juxtaposition of material drew upon display

FEATURES
SPORTS

BROOKLYN EAGLE

CLASSIFIED
COMICS

BROOKLYN, N. Y., WEDNESDAY, APRIL 5, 1939

Entered in the Brooklyn Postoffice
as 2d Class Mail Matter

Curators of Culture

Dr. Herbert J. Spinden

Curator of Primitive Peoples

He's Leading Authority on Mayan Civilization . . . And Thinks We Should Return Gratitude to Indians for What They've Contributed to Our Culture

by JANE CORBY

Third Article in a Series

Dr. Herbert J. Spinden thinks that even if we don't give anything else back to the Indians we might at least return a little gratitude for their contributions to our civilization. We got a lot more from them than the land we live in, he says—some of our most important domestic plants, for instance, and the basis for some mighty fine arts.

You can believe Dr. Spinden when he says anything about the American Indians—North or South—he KNOWS. He's a leading authority on Mayan civilization, which was a high-powered, ancient civilization of Yucatan. He's on familiar terms with the daily lives of the ancient Aztecs and the Pueblos and the Long Island Indians, whose past performances weren't any too brilliant, compared with those of smarter Indians elsewhere and who "gave few indications of the future culture of Brooklyn," Dr. Spinden says. Curator of primitive peoples at the Brooklyn Museum, he not only knows as much as any one in the world about Indians, he also knows a great deal about other primitive folk in the far corners of the world—the Arctic tribes and Australian bushmen, Siberian tribes and Polynesians, African Negroes and the Malays of Sumatra.

Dr. Spinden's thick hair has grown white during his years of delving through jungles, hunting missing links in modern knowledge of lost civilizations and societies. His eyes are very blue and reflect a ready laughter. He is a great man, who must stand out in sharp contrast with the dark little unsmiling peoples of the forests he visits.

Vegetable Plate Indian Gift

What does he mean by that crack about the Indians giving us important farm products and some good ideas in art? He means that the Indians domesticated some of the most valuable of our plants today—corn, beans, squash, potatoes, pineapples, peanuts, tomatoes and peppers. They also had cotton and tobacco plants tamed by the time the white man took over the country, and they introduced the white man to rubber.

Dr. Spinden thinks that the importance of ancient America should be emphasized in education and taught that modern children should be taught that modern American culture contains many ancient American ingredients. Any Pan-American link might very well begin with a few words on the contribution of the Indians to our present day civilization, for besides handing us corn, the cob and the rest of our vegetable plate, the Indians "who stayed an extremely important part of our history and who are an element of our population, have also contributed a heritage of beauty, a gift of fine arts, illusions and immaterial creations. Americans of the future will surely realize an epic grandeur in the song sequences and old stories of the first Americans." The graphic and plastic art of the American Indian is "rich in decorative quality and especially rich in symbolism."

Served Harvard Museum

Dr. Spinden, who is the author of many books and learned papers on the Indians and other primitive people in his charge, came to the Brooklyn Museum in 1929 from the Buffalo Museum of Arts and Sciences, where he was Curator of Anthropology. Born in South Dakota, when buffalo still roamed the plains, his family later moved farther east and he saves Indians as a daily matter of course. After his graduation from Harvard, he served as a museums; for three years he was engaged in field work in archaeology and ethnology in North Dakota and Idaho for the Peabody

Museum at Harvard; he was for 12 years with the American Museum of Natural History and in the 1920's was curator of Mexican archaeology at the Peabody Museum.

For six months of last year Dr. Spinden was in Peru, making collections for the Brooklyn Museum, and this year he has been combining his duties as curator with giving courses in the School of Art at New York University. He is responsible for the Brooklyn Museum School, an experiment in education consisting of a series of illustrated charts for the teaching of social geography in schools.

The collections in his department include one of the largest and most important groups of pre-Columbian gold objects in existence, and marvelous models representing the wonders of Maya architecture, and textiles, sculpture, bead and feather work, woodcarvings, etc., all representing the achievements of aborigines in America, Japan, Polynesia, Melanesia and Africa.

When he isn't exploring ruined cities in Central America or preparing exhibits on Aztecs or engaged in similar strictly studious occupations, Dr. Spinden goes about encouraging the use of primitive art for modern industrial purposes. He began during the war to suggest American Indian art as inspiration for design, to American manufacturers, and this year he displays at the Museum of Peruvian textiles and Central American and other art in stone, gold and ceramics have been designed to re-emphasize the importance of inspiration materials and modern uses. It is his hope that a truly national art may be developed in the United States by resorting to basic principles illustrated in the marvelous craftsmanship of the American Indian civilizations.

The bookcases in Dr. Spinden's office on the sixth floor of the museum are filled with other things besides books. A large aquamarine, carved into a very good likeness of a grasshopper by the ancient Aztecs, for instance, finds shelf room. His desk holds more than papers—a three-legged terra cotta bowl, from

FRIGATE BIRD MOTIVE

FLYING FOX (FRUIT BAT) MOTIVE

HUMAN ANCESTOR MOTIVE

NEW GUINEA SYMBOLISM

The original importance of animal helpers in the religion of primitive peoples is reflected in conventional designs which decorate and at the same time carry prayers.

Dr. Herbert J. Spinden, curator of primitive peoples at the Brooklyn Museum, is holding a textile from Sumatra. It is a woven picture, in gold and black, of the "Spirit Ship," which plays a large part in the tribal lore of the Malays of Sumatra.

Yucatan, with an elaborate design showing an eagle wearing a sort of brooch.

Dr. Spinden defends the Indian habit of drawing things that aren't so, like eagles wearing brooches. "A great civilization is based on social illusions, on things that in one sense aren't so, and in another are so."

According to this reasoning, eagles may be pictured as wearing brooches because an eagle is the kind of elegant bird that could wear a brooch with propriety.

Indians Here 5,000 Years

... came in this ... they hopped over from Asia, away up there at the North, around four or five thousand years ago.

"Some people put the migration as far back as 20,000 years, but the American Indian came over with the culture of the Neolithic Age, and that age didn't begin until around 3,500 B. C. It was the New Stone Age."

"That's the age when people began to use stones for implements and weapons and got the idea of

Design on buffalo shield of the Pueblo Indians. The buffalo horns here are the sun (above), the milky way with bear's feet (below) mean a prayer for strength and knowledge.

the North and South Americas and the Central American and other warm climate groups forged ahead of the others in accomplishment, because "civilization starts in the tropics."

Dr. Spinden has an idea that it would be well "to join the history of ancient America to that of modern America as a wholesome means of offsetting the insidious tendency to use history for racial and national propaganda." He has an idea that the whole story of America should be taught "fairly, generously and with entire regard for the ultimate truth." He just illuminating

Stela at Piedras Negras, a Mayan work. A ruler enthroned among the stars is shown on the upper part of the monument and below is a man dressed for interment with a line of naked footprints leading up the front of the throne from the corpse to the deified reincarnation. This drawing is in the Brooklyn Museum School Service.

grinding them to make them the proper shape. After they got here the Indians spread out over

Thunderbird and lightning serpent of the Northwest coast. The thunderbird (at right) is carrying off a whale which he has killed with two lightning serpents. Figure at the left is a design on harpoon representing two-headed lightning serpents.

Fig. IV. Herbert J. Spinden. From Jane Corby, "Curators of Culture," *Brooklyn Eagle*, April 5, 1939. Brooklyn Museum, Library Collections, BMA Institutional Files. Herbert J. Spinden File.

Whitney Blausen attributes the development of a profitable relationship between New York museums and the American silk industry to these design contests.[13] A more robust narrative of the commercial engagement with museums can be found in William Leach's seminal text *Land of Desire*, which briefly notes the 1919 *Exhibition of Industrial Art* but places special emphasis on Crawford's and Culin's relationships with department stores and industry.[14]

Despite this scholarship there remains fertile ground for inquiry into the AMNH's efforts to court designers.[15] In particular, while prior investigations have hinged on Crawford as the crucial figure in uniting designers and industry, a mission to which he certainly was critical, the documentary record reveals that Mead, Spinden, and Wissler were a dynamic trio of curators whose didactic efforts complemented and, indeed, were equally if not more foundational to the work of the museum. Moreover, the AMNH's sustained attempt to inspire fashion designers and manufacturers, while noted in the scholarship, has not been thoroughly examined, nor has the 1919 exhibition itself, which in many ways stands as the outward culmination of the museum's endeavors.

An American Style examines the progressive initiatives of the AMNH Department of Anthropology to inspire an American design language while illustrating new dimensions to the biographies of anthropologists Mead, Spinden, and Wissler, whose activities at the museum have long been viewed as traditionally defined in the historical discourse. Both Wissler and Spinden are well-known figures in the narrative of early twentieth-century anthropology. Yet, even in anthropological literature, Wissler is often overshadowed by his predecessor at the AMNH, the "father of American anthropology" Franz Boas (1858–1942), and Spinden has received little attention as a result of his more art historical approach.[16] The contributions of Mead, moreover, have fallen almost entirely from the historical record. More broadly, the Department of Anthropology's role in stimulat-ing American design during and after World War I is entirely absent from institutional histories of the AMNH. The marginalization of the curators' involvement with the textile and fashion industries is exhibited in Stanley Freed's recent two-volume history of the Department of Anthropology at the AMNH, which features fairly extensive biographies of Spinden, Wissler, and to a lesser extent Mead, but omits the efforts of these curators to educate designers, influence manufacturers, and stage the 1919 *Exhibition of Industrial Art*.[17]

The story of the museum's involvement with design industries is one wrought with complex and at times opaque motivations and numerous contradictions. Naturally, the AMNH's project sparked questions about appropriate anthropological and museological practices and, in this respect, it weathered criticism during even its most vital and potent moments, including, most notably, from AMNH curator of ethnology, Pliny E. Goddard (1869–1928), who frequently questioned the use of the collections. While shedding light upon less-recognized contributions of the AMNH Department of Anthropology to design education in New York, this publication and exhibition seeks to unravel the interwoven and somewhat muddied narratives of appropriation, nationalism, and design and cultural history present in the museum's work. In doing so, an interdisciplinary methodology has been used. While exclusively anthropological or art historical perspectives would surely be illuminative, merging these separate fields permits greater exploration of the intersections that characterized and animated the AMNH's project itself.

By looking at archival correspondence, ephemera, and contemporaneous publications, this project aims to recover the contributions of the curators whose roles in the larger narrative of design history have been eclipsed by that of Crawford. I trace the use of indigenous objects from the Americas—by these curators and the AMNH as a whole—to express a national design idiom, one prompted by the practical necessities of World War I and driven by the nationalistic

impulses that the crisis fostered. Tracking the shift in late 1916, from artifacts of the Americas to objects drawn from a more expansive and diverse selection of indigenous cultures, I articulate how the curators' expanding focus resulted in a re-conceptualization of ethnographic specimens as sources of artistic value and innovation. In situating the project at the AMNH within the search for an American identity, two dates of particular resonance act as the bookends to this inquiry: 1915, the year in which Dow called for a distinctly American design language and the "fashion staff" at the AMNH formed; and 1928, the year of Mead's death, which effectively ended the museum's collaboration with the design industry, and saw the release of H. R. Mallinson & Co.'s much-celebrated American Indian series—in many ways the movement's swan song.

The essay that follows is divided into four parts. The first discusses the design community's response to the war and, using Dow's 1915 proclamation as a platform, examines the role of the museum in design education and the cultural avant-garde's appropriation of pre-industrial methods and mores. I continue by outlining the pedagogical methods employed by Crawford, Spinden, Mead, and Wissler at the AMNH. Part II focuses on specific textile and fashion designers and their selection of artifacts from a variety of non-Western cultures, which resulted in a denaturing of cultural identity and a decontextualized design aesthetic. Examples of the more progressive department stores and designers have been highlighted to elucidate the diverse connections involved in the AMNH's project. Part III describes the *Exhibition of Industrial Art in Textiles and Costumes*, and by looking at a key selection of seven exhibitors I assess both the immediate success of the exhibition and its legacy. Additionally, new attributions have been ascribed to textiles and garments created for the exhibition and many of the ethnographic objects in the display have been identified. And, finally, the fourth part outlines events at the AMNH after the exhibition, particularly

failed attempts by the AMNH staff to expand design education at the museum, and highlights designs from the 1920s that were based on museum objects.

Utilizing an extraordinary trove of previously unpublished negatives in the AMNH Library Special Collections, two photographic essays have been included in this catalogue to assert the agency given to the designers who participated in the project at the AMNH. The first features documentary images of models in ethnographic garments taken at the museum around late 1916. The second group of images documents the fashion designs created for the *Exhibition of Industrial Art*. These two selections are essential to illustrating the story of American designers working in the museum, and documenting the enthusiasm with which these women, and to a lesser extent men, engaged with the collections. Beyond that, the corpus of negatives evidences a more complicated and nuanced narrative regarding the shifting identity of the modern woman, perceptions of the female form, and the role of fashion photography in the 1910s and 1920s. By comparing these two sets of images, from around 1916 and 1919 respectively, a stark contrast embodied in the project itself is also apparent. The first series of photographs documents the liberated, vibrant, yet intimate encounters out of which the AMNH's project grew. While the later set presents a more polished message, one that is seeking public approval and consumer validation for the AMNH's work. Using this catalogue as a starting point, this project will continue to expand, shift, take new directions, and ultimately contribute a more robust investigation of the complex narratives embedded in these remarkable images.

Finally, this text includes work by designers who went on to become celebrated in their respective fields, such as industrial designer Ilonka Karasz, textile designer Ruth Reeves, and fashion designer Jessie Franklin Turner. But also highlighted are lesser-known designers warranting further investigation, such as textile

designer Martha Ryther, designer and illustrator Harriet Meserole, and fashion designer Max Meyer, to name a few. To give proper attribution and recognition to designers who left an indelible imprint on the project at the AMNH, the catalogue concludes with a small selection of short biographies. Additional biographies of key manufacturers and department stores, as well as of the curators, have been added to illustrate the project's diverse network of participants. To be sure, many of these participants are deserving of further research, which might highlight fresh perspectives on the project itself, but given the limited scope of *An American Style*, only a partial view of the project's complexity and diversity is possible.

Translating the compelling and complicated narrative of the AMNH's engagement with design industries to the one-room Focus Gallery at the Bard Graduate Center presented a number of curatorial challenges. While a wealth of ephemera and archival material remains, extant contemporary designs—frequently unique, one-off models or limited serial productions—are rare. The scarcity of surviving examples from this period reflects not only the institutional preference for collecting couture and upmarket garments and textile samples, but also underscores the anonymity of individual designers in textile manufacturing and department stores at this time and the fleeting nature of this movement. Materials survive for successful firms like H. R. Mallinson & Co. and prominent designers such as Ilonka Karasz—both of which are featured in the exhibition. Yet, as research thus far has not uncovered surviving examples, textiles and garments from lesser-known designers like Martha Ryther and firms like Johnson, Cowdin & Co. or fashion designers like J. Wise remain underrepresented in the exhibition.

It was determined rather early in the planning stages that the inclusion of a contemporary garment in this exhibition was pivotal to articulating not only the AMNH project's focus on stimulating a new fashion design idiom but also to highlight the influence of the Greenwich

Village avant-garde at this time. The challenge of locating such an item proved more difficult than expected, as many surviving garments of this type are attributed to European designers and feature a more "Orientalist" mode. However, we are grateful to include a fantastic example on loan from The Costume Institute at The Metropolitan Museum of Art. While unattributed, it represents the unique marriage of batik handicraft, diverse non-Western ornament, and the caftan silhouette pervasive in avant-garde circles at this time and featured at the AMNH *Exhibition of Industrial Art* in 1919.

Ephemera and journal articles by Mead, Spinden, and Wissler are included in the exhibition to convey the ambitious activities of these curators. Additionally, a selection of ethnographic objects and garments are on loan from the AMNH to highlight key source objects and give voice to the numerous cultural identities that would be appropriated during the course of the AMNH's project to stimulate a wholly American style.

———

A note on terminology is necessary. In the primary source material, namely departmental correspondence and articles written by Dow, Crawford, and the AMNH curators (for both popular and scholarly audiences), terms such as "primitive," "native," "aboriginal," and "indigenous" were used interchangeably, inconsistently, and rather ubiquitously to reference the cultural artifacts of any and all ancient, pre-industrial, and non-Western cultures. Such usage strikes a discordant tone with the modern reader, reflecting as it does an ethnocentric and overly generalized conception of non-Western cultures that compounds ethnic, tribal, geographic, and temporal differences of great significance. This text, because it seeks to examine the work of the AMNH and its affiliates, necessarily reflects the slippage or elision of these terms characteristic of contemporaneous correspondence and publications. In doing so,

the use of terms such as *primitive* or *primitive-inspired* is unavoidable but clearly deficient. Furthermore, the cultural attributions found in the documentary and archival record are often incorrect, reflecting the state of the scholarship prevailing at that time. When possible I have tried to correct the cultural associations for misattributed objects.

Methodological problems associated with the usage of the term *primitive* of course transcend this project. What has been perceived as primitive has shifted continuously to situate Western civilization in opposition to the "other," positioning the modern against the pre-industrial and has been understood to be physically or temporally distant "savage." And by the same token, the conception of the other has also drifted to meet the needs of Western culture. For example, in certain eras primitive has been used to describe the Gothic and folk traditions of Europe; elsewhere it has stood to denote the ancient cultures of Egypt, Persia, or India.[18]

The definition of primitivism—formally the influence of African and Oceanic arts on the European avant-garde—has become more nuanced and sensitized since Robert Goldwater's canonical text *Primitivism and Modern Art* (1938) and William Rubin's massive yet contested exhibition *"Primitivism" in 20th Century Art* (1984). But discussion of the role of indigenous objects from the Americas in this discourse, particularly as a model for American Modernism, has remained relatively scant. Notable exceptions include Barbara Braun's examination of pre-Hispanic objects in *Post-Columbian World: Ancient American Sources of Modern Art* (1993); William Jackson Rushing's similar efforts in respect to the art and artifacts of the North American Indian in *Native American Art and the New York Avant-Garde* (1995); and Elizabeth Hutchinson's account of the intercultural exchange between Native American and Euro-American artists, teachers, and critics from the end of the nineteenth century to World War I in *The Indian Craze: Primitivism, Modernism, and Transculturation in American Art, 1890–1915* (2009).

In the early twentieth century the American emphasis on Native American objects inflected modernist primitivism with a strong national flavor.[19] This particular strain is more germane to the endeavors at the AMNH to create a national design language built upon so-called primitive objects. As Rushing has explored, the pursuit of an authentic American modernism blended "proto-modernist recognition of aesthetic value of Native cultural objects *and* political nationalism."[20] Modernist primitivism in this context includes not only the visual arts but also literature, popular culture, and ethnography—particularly as loci of inter- and cross-cultural exchanges.[21] As a cultural movement, primitivism was spurred by dissatisfaction with modern society. Furthermore, it valued the perceived sincerity and community of pre-industrial societies while attributing an essential primacy or authenticity to primitive ideologies.[22] In the project at the AMNH the celebration of pre-industrial culture or the inception of an "anti-modernism"—as termed by T. J. Jackson Lears—was channeled to cultivate a uniquely modern American design identity through its perceived authenticity and originality and premised on primitive-inspired objects and, as the movement aspired, thereby elevate American taste.[23]

1 Arthur Wesley Dow, "Designs from Primitive American Motifs," *Teachers College Record* 16, no. 2 (March 1915): 31.

2 Historian Amy Kaplan argues that the United States "defined itself ideologically against the territorially based colonialism of the old European empires . . . the spatially unbounded quality of the 'New [American] Empire' promised to reconstitute national uniqueness." Amy Kaplan, *The Anarchy of Empire in the Making of U.S. Culture* (Cambridge: Harvard University Press, 2002), 96.

3 M. D. C. Crawford, "Creative Textile Art and the American Museum," *American Museum Journal* 17, no. 3 (March 1917): 253.

4 The daily newspaper *Women's Wear* became *Women's Wear Daily* in 1927.

5 Jeffrey Trask, "American Things: The Cultural Value of Decorative Arts in the Modern Museum, 1905–1931" (PhD diss., Columbia University, 2006); and *Things American: Art Museums and Civic Culture in the Progressive Era* (Philadelphia: University of Pennsylvania Press, 2012). Trask has explored the role of The Metropolitan Museum of Art in promoting cultural reform through American industrial design. See also Ezra Shales, "John Cotton Dana and the Business of Enlightening Newark: Applied Art at the Newark Public Library and Museum, 1902–29" (PhD diss., Bard Graduate Center, 2006); and *Made in Newark: Cultivating Industrial Arts and Civic Identity in the Progressive Era* (New Brunswick, NJ, and London: Rivergate Books, 2010).

6 Christine Wallace Laidlaw, "The Metropolitan Museum of Art and Modern Design: 1917–1929," *Journal of Decorative Arts and Propaganda Arts* 8 (Spring 1988): 90 note 4.

7 For more information on the Metropolitan Museum emphasizing French sources for designers, see Daniëlle Kisluk-Grosheide, "The Hoentschel Collection Comes to New York," in *Salvaging the Past: Georges Hoentschel and French Decorative Arts from The Metropolitan Museum of Art*, ed. Daniëlle Kisluk-Grosheide, Deborah L. Krohn, and Ulrich Leben. (New Haven and London: Yale University Press with the Bard Graduate Center, 2013), 1–17. For the Brooklyn Museum, see Stewart Culin to M. D. C. Crawford, 2 Oct. 1918, Culin Archival Collection, Department of Ethnology [3.1.021]: correspondence, 1/1919–10/1918. Brooklyn Museum Archives.

8 Trask, "American Things," 11.

9 For more on the 1913 Armory Show, see Martin Burgess Green, *New York 1913: The Armory Show and the Paterson Strike Pageant* (New York: Collier Books, 1989). See also Marilyn Kushner and Kimberly Orcutt, *The Armory Show at 100: Modernism and Revolution* (New York: Giles with the New-York Historical Society, 2013).

10 For a discussion of copyright infringement plaguing French couturiers such as Paul Poiret, see Nancy J. Troy, *Couture Culture: A Study in Modern Art and Fashion* (Cambridge and London: MIT Press, 2003), chapters 3 and 4.

11 Credit is often given to Crawford for designing the 1919 exhibition, however, Spinden was the major architect of this project. In addition to numerous archival sources, his authorship was also noted in George C. Valliant, *Indian Arts in North America* (New York: Cooper Square Publishers, 1973), 2 note 1. For early twentieth-century exhibitions of this ilk, see Elizabeth Hutchinson, *The Indian Craze: Primitivism, Modernism, and Transculturation in American Art, 1890–1915* (Durham, NC: Duke University Press, 2009), 118–29. For Wanamaker's, which had been employing this display technique as early as 1914, see Neil Harris, *Cultural Excursions: Marketing Appetites and Cultural Tastes in Modern America* (Chicago: University of Chicago Press, 1990); and William Leach, *Land of Desire: Merchants, Power, and the Rise of a New American Culture* (New York: Pantheon Books, 1994). This was the only exhibition of this nature at the AMNH; after 1919 other museums would employ this exhibition display (contemporary products with ethnographic sources) over the course of the next century. The Metropolitan Museum began its series of Designer and the Museum exhibitions in 1917, but these showcased contemporary decorative arts, textiles, and furniture based on classical and European sources.

12 Lauren D. Whitley, "Morris De Camp Crawford and the 'Designed in America' Campaign, 1916–1922" (1998). Textile Society of America Symposium Proceedings. Paper 215. http://digitalcommons.unl.edu/tsaconf/215 (accessed 29 Dec. 2012); and Lauren D. Whitley, "Morris De Camp Crawford and American Textile Design, 1916–1921" (master's thesis, Fashion Institute of Technology, 1994).

13 Whitney Blausen, "In Search of a National Style," in *Disentangling Textiles*, ed. Mary Schoeser (London: Middlesex University Press, 2002), 145–52. See also Whitney Blausen and Mary Schoeser, "Wellpaying Self Support: Women Textile Designers," in *Women Designers in the U.S.A., 1900–2000*, ed. Pat Kirkham (New Haven and London: Yale University Press with the Bard Graduate Center, 2000), 145–65.

14 See Leach, *Land of Desire*, 164–73.

15 Mary Donahue highlights Crawford's articles in the *American Museum Journal* as well as the *Exhibition of Industrial Art* in "Design and Industrial Arts in America 1894–1940: An Inquiry into Fashion Design and Art Industry" (PhD diss., The City University of New York, 2001). The role of Stewart Culin in the exhibition has been noted in Diana Fane, Ira Jacknis, and Lise M. Breen, *Objects of Myth and Memory: American Indian Art at the Brooklyn Museum* (Brooklyn: Brooklyn Museum in association with the University of Washington Press, 1991); and Freya Van Saun, "The Road to Beauty: Stewart Culin and the American Clothing and Textile Industries" (master's thesis, Bard Graduate Center, 1999).

16 Until recently, this period at the AMNH Department

of Anthropology has received little attention, with much of the literature focusing on the period before the departure of Franz Boas in 1905 and then skipping to the late 1920s. See Stanley A. Freed, *Anthropology Unmasked: Museums, Science, and Politics in New York City* (Wilmington, OH: Orange Frazer Press, 2012), vol. 2.

17 See ibid.

18 Virginia Gardner Troy, *Anni Albers and Ancient American Textiles: From Bauhaus to Black Mountain* (Burlington, VT: Ashgate, 2002), 5.

19 Leah Dilworth, *Imagining Indians in the Southwest: Persistent Visions of a Primitive Past* (Washington, DC: Smithsonian Institute Press, 1996), 4.

20 W. Jackson Rushing, *Native American Art and the New York Avant-Garde* (Austin: University of Texas Press, 1995), 6.

21 Ibid., 3. Rushing draws upon Marianna Torgovnick's use of a modernist primitivist discourse in her book *Gone Primitive: Savage Intellects, Modern Lives* (Chicago and London: University of Chicago Press, 1990).

22 Dilworth, *Imagining Indians in the Southwest*, 182; Arthur O. Lovejoy and George Boas, *Primitivism and Related Ideas in Antiquity* (1935; Baltimore and London: The Johns Hopkins Press, 1997), 7. See also Hutchinson, *The Indian Craze*, 240 note 71.

23 See T. J. Jackson Lears, *No Place of Grace: Antimodernism and the Transformation of American Culture 1880–1920* (Chicago and London: The University of Chicago Press, 1994).

I
—

WORLD WAR I, DESIGN EDUCATION, AND THE MUSEUM

"Back to the Museum!" . . . Not with a "dry-as-dust" idea in the back of the mind, but armed with enthusiasm and imagination; not to copy but to adapt the beautiful primitive designs and color schemes to modern use.[1]

Beginning in 1915, the American Museum of Natural History (AMNH) Department of Anthropology took deliberate steps to expose American designers to the museum's vast and growing ethnographic collections as part of its efforts to innovate a national design aesthetic. The museum encouraged designers and textile industry professionals to visit its collection and generously provided "the facilities for the proper use of the material to be found in its halls."[2] But the AMNH did more than open the museum's doors. Between 1915 and 1919 the museum staff spearheaded an intensive design education program. They held classes, created manuals, mounted temporary exhibitions, and presented frequent lectures, all drawing upon the extraordinary ethnographic resources of the institution. The departmental staff members— M. D. C. Crawford and curators Charles W. Mead, Herbert J. Spinden, and Clark Wissler—extended their assistance to those working in the textile and fashion industries. This group, whom in 1917 Elizabeth Miner King dubbed the "fashion staff," primarily emphasized object research with the hope that greater and more intimate exposure to indigenous artifacts would spark creativity and authenticity of design distinct from that of Europe.[3]

The political and industrial implications of World War I factored heavily into the AMNH's campaign to use its collections to inspire a modern and distinctly American identity. Specifically, the project to develop an American aesthetic rooted in a non-Western design vocabulary would be energized by the exigencies of war. The outbreak of war in Europe in July 1914 stunted many of France's important industries, including textiles.[4] As part of the war effort, supplies were reappropriated; textile mills were both retooled for wartime use and destroyed; and well-known designers such as couturier Paul Poiret were called to duty.[5] The war caused the closure of several fashion houses in Paris and by 1915, American manufacturers felt the absence of "life-giving ideas," thus disbanding what Kristin Hoganson (invoking Benedict Anderson) has called the "imagined community" of dress, whereby shared affinities conjoined American and French fashion and textile industries into an assumed single "national" network.[6] Not only did the absence of French creative direction maroon American textile and fashion manufacturers, the sudden loss of synthetic dyestuffs from Germany also greatly hampered the industry.[7]

The interruption in regular and frequent communication with Paris and the difficulty of transatlantic trade and travel nevertheless presented an opportunity for domestic textile and clothing designers and manufacturers. Indeed, the breakdown of these networks was criticized from within, as the pages of *Vogue* and *Women's Wear* were peppered with droll critiques claiming that current Euro-American models—featuring more utilitarian styles with shorter skirts, hip-length jackets and tunics, in drab, anemic palettes of white, olive, and gray—lacked originality.[8] In these circumstances, *Women's Wear* introduced its Making Designers column in May 1915. Aiming to stimulate designers and reinvigorate industry, the articles often featured interviews with local designers, manufacturers, and department store representatives. In a notable example, fashion designer J. Wise anticipated the movement at the AMNH by stressing the importance of quiet study rooms for designers and forward-looking methods of design education.[9] Confronting the design issues World War I engendered, the column's narrative often centered on industrial art education and the need for a purportedly authentic American style, at times placing a perceptive emphasis on the fractured nature of the industry and the resulting tensions between designers and manufacturers.[10] As Caroline

Milbank has outlined, during this period New York fashion spread across multiple divisions: ready-to-wear manufacturers, department stores, tailors, dressmakers, and custom-import houses.[11] Furthermore, the Making Designers column openly grappled with the fiscal and industrial problems besieging the textile and fashion community as a result of the war.

The interest in stimulating domestic support for American fashion was shared by reformers outside the fashion and design fields. Even the progressive "muckraking" journalist Ida M. Tarbell (1887–1944) appealed to American women in the pages of the trade journal *Silk*, imploring them to shed their covetous ties to European finery and to instead purchase domestic silks, embroideries, and gowns.[12] This patriotic sentiment would be repeated in the pages of contemporary magazines, perhaps most forcefully in editorials in *Good Furniture* by William Laurel Harris (1870–1924). In early 1916 he wrote, "The American ideal is an accomplished fact, definite in character . . . and forms the basis of true American life. As yet this mighty force has failed to permeate our native art, especially as it failed to inspire and vivify the arts that are allied to industry."[13] Specifically referring to the applied arts, Harris was attempting to awaken enthusiasm for patriotic design as well as the creation of textiles, garments, ceramics, and other manufactured products of better quality. Articles of this ilk, laying emphasis on the lack of a truly distinctive American design language, crescendoed into a rousing call to action. But a more fundamental question remained: What constitutes an "American" style?

Since the mid-nineteenth century, the perpetual challenge for American manufacturers was not the efficient mechanical production of textiles or clothing but rather how to break from the creative hegemony of Europe with original American artistry and, even more importantly, how to sway domestic consumers to purchase the new American products. Nationalist motivations for American fashion drew on economic concerns and fostered incremental increases in trade tariffs on European goods beginning in 1897 and continuing into the first decade of the twentieth century.[14] These initiatives also dovetailed with major tenets of the American Arts and Crafts movement, with collectors, designers, and artisans aiming to reform aesthetics and looking to pre-industrial crafts and Native American artifacts to define an authentic yet more democratic American identity.[15]

The mission for a domestic market also found traction in the *Ladies Home Journal*'s American Fashions for American Women campaign from 1909 through the beginning of World War I.[16] Despite these efforts to spur American interest in domestically produced textiles and clothing, at the onset of the war the United States was still viewed by tastemakers such as William Laurel Harris as "a great industrial nation without an industrial art."[17]

America, as a vast amalgamation of different cultures, lacked a singular cultural heritage from which a distinctly American aesthetic might naturally arise. This aspect of American life was particularly acute during the war years and in New York, where the tail end of a massive immigration wave had brought millions of immigrants to design centers on the Eastern Seaboard.[18] Moreover, the nation's historic dependence on European design institutions had inhibited the development of the creative spirit needed to cultivate an explicitly unified national style. There were multiple reactions to the challenges of forging an American style. One vision was the colonial revival, a social and aesthetic movement that romanticized America's colonial and early republican period, promoting architecture and decorative arts based on the Georgian and neoclassical styles of the American colonies on the East Coast.[19] However, these period styles were ultimately anchored in more British and European forms. Another was a more utilitarian response, mainly formed by the needs of the war. But a particularly progressive and nationalistic vision for an American style, one ultimately championed by the AMNH, looked to indigenous designs of the

Americas and beyond. The proponents of this project believed that the study and interpretation of indigenous motifs would vivify the industrial arts and establish an authentic American design identity.

Modernist Primitivism and Design Education in New York

An especially progressive vision for American design was most clearly expressed by the venerable educator and theorist Arthur Wesley Dow (1857–1922) in early 1915. As director of the art department at Columbia University's Teachers College, Dow was perfectly situated to be especially influential in the pursuit of a national idiom. At the end of the nineteenth century, he began collecting Indigenous American artifacts for the purpose of instruction and interpretation, particularly for classes that highlighted the artistic qualities—such as form, line, color, and the Japanese concept of *notan*—of Native American pottery and baskets (fig. 1).[20] Specifically, his research on Native American principles of design brought him in contact with the formal qualities found in Aztec art.[21] He articulated his overarching theories in his 1899 design manual *Composition* and in subsequent essays written for the *Teachers College Record*.[22]

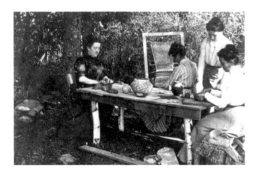

Fig. 1. "Arthur Wesley Dow Summer School at Emerson House," in Ipswich, Massachusetts, ca. 1900. Courtesy of the Ipswich Museum.

Dow's article "Designs from Primitive American Motifs" was particularly influential in garnering support for a new American aesthetic ideology in the service of broader cultural and industrial needs to fill the vacuum for a truly national design vocabulary.[23] Highlighting the arts of the "mound builders, cliff dwellers, pueblo tribes, Alaskans, Aztecs, Mayans, and Peruvians," he emphasized the freshness and patriotic value of indigenous art imploring domestic artists, designers, and manufacturers to "throw off these [European] shackles" and create a new, distinct style for a modern American expression. He called for the active use of recently formed ethnographic collections such as that of the AMNH, illustrating various nascent designs already created by Teachers College students (fig. 2). He heralded indigenous art from the Americas as an "unspoiled type" that could serve national needs similar to how folk-inspired design or Paul Poiret's "Martine" had served Europe.[24] By referencing the Atelier Martine and École Martine—Poiret's experimental art school for young, working-class girls at his Rue d'Antin salon—Dow subscribed to the pejorative notion of non-Western peoples as naive and childlike. He sought to capitalize on this perceived naïveté to stimulate a new American mode. He continued by suggesting that Euro-Americans could form a "period style" based on "primitive American" forms alluding to the lasting impact of this movement for generations to come.[25] For Dow the use of these materials was a wellspring of national qualities that, in turn, could generate a truly American art form.

Dow's use of indigenous materials from the Americas was clearly concentrated on energizing and improving domestic design production, but his focus was not so isolated. His theories also participated in the broader cultural movement of modernist primitivism burgeoning within artist and bohemian circles at this time. These largely middle-class communities, which W. Jackson Rushing collectively referred to as the American "cultural avant-garde," thrived in artistic centers like Taos, New Mexico; Woodstock and Aurora,

Fig. 2. Design for printed cotton "based on hieroglyphs from the Yucatan," ca. 1915.
Image 36782, American Museum of Natural History Library.

New York; and most importantly, Greenwich Village in New York City.[26] Notable members included educators like Dow, artists such as Marsden Hartley (1877–1943), and prominent literati including Mabel Dodge Luhan (1879–1962), Mary Austin (1868–1934), and Robert J. Coady (1876–1921). Magazines such as *The Soil* (1916–17), *Bruno's Weekly* (1915–16), and Alfred Stieglitz's *Camera Work* (1903–17) would all explore a varied range of non-Western material in poetry, photography, and art. Indeed, *The Soil* served as a vehicle for Coady's manifesto on the creation of a genuine American art form drawn from the cultural production—inclusive of technology—inherent to and created by the peoples living in the United States. *The Soil* also devoted considerable space to Mexican and Peruvian art as well as the arts of Africa and Oceania, the latter being more traditionally associated with

the European iteration of primitivism.[27] Modern artists such as Max Weber, and William and Marguerite Zorach, and notable illustrator Fritz Winold Reiss are all credited with frequenting ethnographic collections—namely the AMNH—in New York.[28]

For these artists, designers, and writers, the relationship to non-Western material was aligned with the preceding American Arts and Crafts movement, which had paved the way for a formal, conventionalized, and at times increasingly non-representational design language.[29] Furthermore, their attraction to Native arts was driven not simply by base fetishization of an artifactual language—though fetishization was not absent from the movement—but by a perceived shared aesthetic and cultural affinity with so-called primitive forms.[30] The avant-garde reconstituted the indigenous arts of

the Americas—particularly that of the Native American—in its own image and emphasized what James Clifford has defined as "universal, ahistorical 'human' capacities," thus negating the indigenous identity in the final products.[31] This thorough embrace of "universal" (non-Western) qualities created a fluid mechanism for the assimilation and appropriation of cultural forms, particularly absorbing indigenous aesthetics for fresh and modern expressions wholly detached from their cultural identities. These shared universal characteristics are precisely what Dow emphasized to his students and what undergirded his call for a national art form. By providing a repository of indigenous artifacts to study, the AMNH played a critical role in enabling designers to realize Dow's vision.

The museum had, since the beginning of the century, crafted its displays and educational outreach for a more popular constituency, aiming to educate and cater to lower economic classes and immigrants. This focus spawned a lively debate at the museum during the first decades of the century, between the proponents of more popular educational efforts and those advocating for a more scholarly and scientific approach.[32] One of the leaders of the popularizing contingent was M. D. C. Crawford, whose research appointment would spark the museum's efforts to use its ethnographic materials to educate and inspire American textile designers and, later, fashion designers. When he joined the Department of Anthropology staff in 1915, his exuberance for Peruvian weavings as well as textiles from a more global set of communities appealed to the museum's administrators. President Henry Fairfield Osborn (1857–1935), in fact, acknowledged that the research position had been created expressly for Crawford in appreciation of his important contributions to the AMNH and the broader field of non-Western textiles.[33]

By this time Crawford, as a fashion editor of *Women's Wear*, had already established himself as a crucial figure in the effort to "bridge the design gap between designers and museums"

Fig. 3. Design suggestion from "Northern Colombian clay cylinder" print. From M. D. C. Crawford, "Rolling the Cycle of Time," *Women's Wear* (December 6, 1916). Fairchild Photo Service.

with the Designed in America campaign, which he and William Laurel Harris initiated at the beginning of World War I to stimulate domestic products and consumer support.[34] After Crawford took up his research position at the AMNH, the pages of *Women's Wear*—which had served as a vehicle for Crawford's proselytizing since 1914 and was frequently filled with his design suggestions (fig. 3)—increasingly featured examples of AMNH artifacts, mostly textiles. In fact, his position at the daily trade journal was critical to promoting the mission of the AMNH anthropology curators during this period.

Crawford's popularizing platform was enthusiastically endorsed by other members of the Department of Anthropology, including curator of anthropology Clark Wissler and curator of Peruvian art Charles Mead, but particularly and most importantly assistant curator of anthropology Herbert Spinden, who in his public lectures and writings on design frequently relied on nationalistic rhetoric to appeal to manufacturers and consumers. Spinden's area of specialty was the art and culture of the ancient Mayans and he applied his great enthusiasm for Mesoamerican

and other pre-colonial civilizations as well as his rigorous analytic methods—resulting from the confluence of aesthetic appreciation and exacting attention to the evolution of archaic forms and motifs—wholeheartedly to the current mission.[35] Despite his more scientific approach, Spinden was viewed as "an art historian among anthropologists."[36] Throughout his career he focused on the artistic value of ethnographic objects, approaching cultural production not as a series of artifacts, but as a social art history.[37] Crawford and Spinden employed unmistakably nationalistic and imperialistic overtones in their embrace of indigenous materials from the Western Hemisphere—materials they came to describe as "our own."[38]

In 1917, two years after joining the AMNH, Crawford summarized his vision for a national design language drawn from indigenous artifacts of the Americas:

Fashion seems to require almost constant change, and it may well be that the designers will at different times emphasize different collections in the museum. But the addition to our decorative arts of the inspirational wealth of aboriginal American design will be of permanent value. We shall turn to it again and again, each time with added skill and appreciation. These records are so intimately and unquestionably our own, that they will serve as a basis for our distinctive decorative arts and lend a virile character to all our future creative work.[39]

In this statement he elucidates his belief in the national ownership of indigenous art from the Western Hemisphere, particularly in his claim that artifacts of the Americas "are so intimately and unquestionably our own."

The irony of this sentiment is not lost on the contemporary reader. The indigenous art and artifacts of the Americas, and in particular those of Native Americans, were distinctly not those of the dominant Euro-American culture. In this sense they are no more "our own" (in the sense of "belonging to the nation") than relics from the African Congo or the Amur River valley. Crawford's casual claim to this heritage was, however, fully consonant with the then (and in some sense still) prevailing view, that the Western Hemisphere and its peoples fall under the purview and hegemonic authority of the United States.[40] This conception of the United States' hemispheric supremacy found political expression in the Monroe Doctrine (1823) and reaffirmation in the Roosevelt Corollary (1904), which declared that if any European power were to intervene in the Western Hemisphere the United States would act as an "international police" and check any foreign aggression.[41]

By the end of the nineteenth century the United States had been drawn into the swelling tide of imperialism and had flirted, despite historic isolationist leanings, with the policies of engagement and expansion prevailing in many European nations.[42] However, it would be a mistake to confuse American political and cultural leanings with those of nationalist or imperial Europe, especially in regards to the idea of nationhood as defined through design. Since the nineteenth-century, European countries had revisited the vernacular traditions of their folk cultures to articulate their national identities.[43] While at the beginning of the twentieth century the United States was seeking to define itself in opposition to its European heritage, the search for an inherently American design language was an issue of critical importance as the country sought to establish an authentic identity. In some respects, the American embrace of indigenous artifacts and the revival of folk traditions in Europe were parallel tendencies. Both movements looked to pre-industrial cultures, somewhat romantically, as instructional in some respect. But what distinguished the movement in the United States is that the American design community had no unified and distinctly "American" folk tradition to which it could turn. To be sure there were regional traditions at play but, particularly for the purposes of textile and

fashion design at this time, a singular aesthetic vision was elusive. So, in essence, American craftsmen and designers adopted the design modes from the indigenous cultures of the Americas, to which Euro-Americans had laid claim expressly against nineteenth- and early twentieth-century European colonialists who might otherwise interfere.[44]

Crawford's predilection for artifacts of the Americas reflected the manner in which American national identity forged itself in opposition to its European heritage. Interestingly, this movement was not unique to the United States: a parallel effort was also occurring in Canada.[45] This phenomenon has been perhaps accurately termed a "postcolonial dilemma"; these ancient American objects and the cultures from which they arose, though surely not Euro-American, were even less European.[46] At a time when the nation was striving to develop a distinctly American design language—one distinguishable from dominant modes hailing from Europe—it is not surprising that Crawford and his compatriots would attach supreme importance to cultural expressions from the Americas.

However, others did not necessarily share Crawford's opinion that Indigenous American and Mesoamerican arts were superior to those from elsewhere. To be sure, many designers placed emphasis on Native American and pre-Hispanic artifacts by appropriating and interpreting their design motifs, but by 1917, the majority looked more broadly at the diversity of cultures represented at the museum and drew inspiration from a wider variety of artifacts. This universalistic approach to an assumed "primitive" typology was most manifest in the writings of Spinden, who claimed that "really successful designs are successful for all times and all peoples and that all the modern artist has to do is to make modifications according to materials, etc. while keeping fundamental ideas of form."[47] Later in more grandiose terms he stated: "A truly national art [inspired by conventionalized symbols] will express and extend the joys and satisfactions of the people as a whole; it will awaken a consciousness of universal sympathy and put new purpose and beauty into many lives."[48] These statements evince Spinden's departure from Crawford's more singular and provincial focus, demonstrating that Spinden defined "primitive" in its most generic (or in its broadest) sense—as being inclusive of many non-Western cultures and not confined to cultures of the Americas—therefore allowing room for indigenous material from a wider array of global cultures.[49] While Crawford appreciated such designs arising from a diverse selection of sources, like Dow before him, he maintained that the American design community could lay special claim only to indigenous artifacts from the Americas.[50]

Specimens and Study Rooms

The study collections at the AMNH had been accessible to students and designers, at least in some capacity, as early as 1903.[51] At the end of the nineteenth century, anticipating the popularity of the collection in the next decades, the AMNH renovated its facilities to accommodate the rapid growth of its holdings from massive collecting expeditions that commenced with the Jesup North Pacific Expedition (1897–1902) and continued with North American fieldwork in the Plains and Southwest regions throughout the next two decades.[52] To this end, the Department of Anthropology—which included both the ethnology and archaeology sub-disciplines—had eight exhibition halls, the majority of which composed a newly built wing that had opened in 1900.[53] The new facilities also housed study rooms for researchers, students, and designers (fig. 4).[54]

The installation of research facilities at the AMNH satisfied the institution's mission to present an education platform geared for more popular, widespread appeal and reflected the ideals of what has been called the "museum age" (1880–1920). During this period of intense museum building in the United States, ethno-

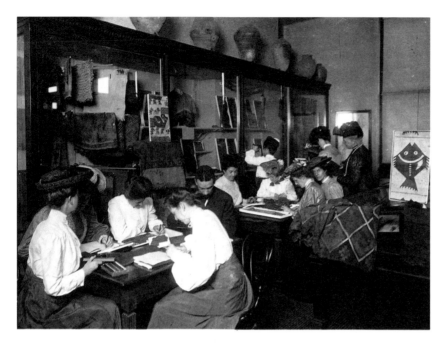

Fig. 4. Study room, Department of Anthropology, ca. 1908. Photograph by Walter L. Beasley. Image 324636, American Museum of Natural History Library.

graphic collections (and in some cases fine art collections) were deployed as cultural mediators between artists, designers, and manufacturers. These collections were a tonic for growing anxieties about the emergence of the modern industrial era, with newly fashioned cultural institutions such as the United States National Museum of Natural History (1869, Smithsonian Institution), the Brooklyn Museum Institute, and the Field Museum (both in 1893) acting as agents of social and educational reform.[55] George Brown Goode (1851–1896), assistant secretary of the Smithsonian Institution, noted in 1897 that "The study of civilization or the history of culture and the development of various arts and industries have brought into being special collections which are exceedingly significant and useful. . . . Nearly every museum which admits ethnological material is doing something in this direction."[56] Goode continued

that the utility of such collections would ultimately extend to the applied arts and industry.[57] Goode's comment also betrayed his interest in the commercial museum, one of the six institutional types that he defined to accommodate the rapidly changing categories of knowledge at the end of the nineteenth century.[58]

Affirming Goode's prediction, in 1908, Leila Mechlin—secretary of the American Federation of the Arts and frequent contributor to the *International Studio*—invited basket makers and designers to study the Native American collection at the Smithsonian Institution for structural and ornamental inspiration.[59] To be sure, the now-fading frenzy for trading, collecting, and displaying Native American art, especially basketry, in domestic "Indian Corners" had fueled interest in these museum sources since the late nineteenth century.[60] Presaging the movement spearheaded seven years later by the

AMNH, she lauded indigenous motifs for their important conventional designs. And voicing objectives later expressed by Dow, Crawford, and Spinden, Mechlin observed, "We must be not only large producers, but good producers . . . we must, in a measure, follow the example of the aborigines, employ the best form and hold fast to simplicity."[61] Echoing this sentiment five years later, in 1913, Mary Lois Kissell (1864–1944), assistant in textiles at the AMNH (1907–12), promoted the application of aboriginal weaving for industrial art education. Her Columbia Teachers College master's thesis, "The Textile Museum, Its Value as an Educational Factor," called for a bridge between museums and the design industry. This would address the lack of a "historical sense" or a sensitivity to native styles in the United States, as well as the need to emulate the methods of design education found in Europe, particularly in Germany.[62]

The work of Goode, Mechlin, Kissell, and the broader museum movement illustrate the influences that merged to set fertile ground for the project at the AMNH. However, it was not until the hiring of Crawford in 1915 that the Department of Anthropology deliberately and wholeheartedly targeted industrial artists, starting with textile designers, as a means of fostering American design innovation. Wissler would proclaim in 1917, "A new school of design is born." Crediting Crawford with igniting this movement, he continued, "He costs us nothing, but the $76,970 we spent in field collecting [that] made his work possible. Our men gathered authentic type design samples from our vast vanishing Indian tribes. Other museums did not, they went after what they called rare things. Result, no where else did you find a workable collection of native art."[63] Echoing Dow's 1915 statement decrying the passing and acculturation of Native American art, Wissler in this passage applauds the nineteenth-century practice of "salvage anthropology"—whereby Native artifacts were collected to preserve what had been dubbed the "vanishing Indian," that is, the perceived disappearance of indigenous

cultures resulting from the effects of warfare, disease, and assimilation—in the formation of the AMNH's superior collection.[64] As the Department of Anthropology head since 1907, reportedly Wissler's mission was to "collect the most beautiful handiwork of the primitive peoples of the world with the idea that it would become an inspiration to industrial art in America."[65]

Adding to the selection of "type design samples" and underscoring the curators' mission to present indigenous materials from the Americas to designers, the scope of the AMNH ethnographic collections was expanded by a loan from The Metropolitan Museum of Art in 1915. The museum deposited 1,936 specimens of ceramics and stone sculptures from its Peruvian and Mexican collections with the AMNH explicitly for study and exhibition purposes.[66] This loan established the collection as the foremost selection of prehistoric artifacts from the Americas in New York and offered visitors—particularly industrial designers—an unparalleled opportunity to examine both the decorative schemes and individual motifs of objects such as Mexican stone sculptures and Peruvian ceramics. In addition to the permanent displays in the museum halls, the study rooms held objects of value to designers and researchers alike. In some cases the most ambitious designers visited the curators' offices, Mead's in particular, to look at specimens not formally displayed.[67]

While the content of the study rooms during this period was never fully catalogued, photographs taken by Crawford in 1916 show examples of Peruvian weavings, ceramic rollers, and pottery, all displayed for inspection by designers. The photographs illustrate that the artifacts were isolated from their cultural contexts and recast as objects exemplifying formal design principles and decorative qualities (fig. 5). If presented as such, the artifacts were detached from a specific indigenous language and effectively "decultured," prized for their aesthetic qualities alone. To further deny any specific artistic or ethnic

Fig. 5. "Peruvian printing rollers in study room," ca. 1916. Image 2A18803, American Museum of Natural History Library.

Fig. 6. "Amazon loom," ca. 1916. Image 2A18817, American Museum of Natural History Library.

attribution, many of these objects appeared to be placed alongside those from other cultures and geographic regions. For example, Colombian ceramic cylinders and Peruvian pottery were placed in close proximity, conflating different cultural identities into one "exotic" pre-industrial culture. Indigenous looms were also on display in the study rooms, but, rather than illustrating design schemes, the looms were included to symbolize and emphasize alternative and in some cases ancient methods of weaving (fig. 6).

By October 1916 the popularity of the study collections had grown significantly. In its annual reports the Department of Anthropology proclaimed, "the demands upon our reserve and study collections have been unusual. Developments in this line have so far outstripped our physical expansion that we have neither the space nor the necessary assistance to meet all the legitimate calls."[68] In response, the following year Wissler reported that a room "on the storage gallery" was outfitted for students and researchers, while additional space on the office floor had been devoted to Crawford and designers at the expense of scientific staff.[69] Affirming the success of the departments' educational prerogatives, these accommodations

illustrate the AMNH's unmistakable prioritization of design research over other pursuits. These motivations also led to further collecting activities tailored to the mission at hand. During a 1917 expedition to Central America, Spinden shipped samples of dyestuffs, textile fragments, and garments to bolster the AMNH study collections with items of particular significance for the United States in regard to "war conditions."[70] Spinden selected specimens that he perceived to be of high decorative value, including certain Guatemalan huipils, bags, and looms.[71] The expedition would even be noted as a break from the United States' slavish relationship to French design, intimating that for designers and merchandisers, trips to Central and South America would soon replace those to Paris.[72]

In 1918, the physical space of the Department of Anthropology was further enlarged to accommodate the increasing numbers of students and designers, upwards of 300 a month, who consulted the study rooms and Mead's collection of Peruvian art, tapestries, and clothing.[73] Two years later, George Sherwood, curator of public education at the AMNH, described the improvements: "Two rooms are reserved for the use of designers to whom unusual facilities for

study are offered. Garments, pieces of cloth, pottery, baskets and other objects illustrating primitive arts are placed on tables; books from the Museum Library that have proved most helpful are kept at hand, and often students are permitted to go to the storerooms to make their own selection of materials."[74] Allowing students into the thirty-three storage rooms, which contained the ethnological collections of more than 100,000 artifacts from Asia, Africa, and the Americas, was indicative of the museum's trusting and nonrestrictive policies (see fig. II).[75]

In addition to making objects available to designers and researchers on an individual basis, the AMNH had by 1916 undertaken more overt and proactive methods of education, including Saturday morning classes for industrial designers.[76] Owing to popular demand, Wednesday-night sessions taught by H. R. Mallinson & Co. employee Martha Ryther were added in 1918.[77] Classes were attended by progressive textile and garment designers like Ruth Reeves and by members of the Keramic Society of New York.[78] Under the guidance of ceramist Marshall Fry (1878–after 1941), who had drawn upon Native American forms since the beginning of the century,[79] the society produced more traditional European forms—tea sets and candlesticks—adorned with motifs drawn from Indigenous American and Mesoamerican artifacts. Examples include vases covered in designs derived from Ojibwa beadwork by society president Dorothea Warren O'Hara, as well as a matchbox and pepper shaker featuring Hopi and Akimel O'odam (Pima) motifs by member Esther A. Coster (figs. 7, 8).[80]

Despite the museum's predominant focus on textile designers at this time, these classes aided in bridging disparate industrial fields under the common pursuit of a unified American design language. Reflecting on this pursuit, Coster, in her article "Decorative Value of American Indian Art," suggested that textile and fashion designers draw inspiration for contemporary rugs and dress trimmings from such diverse sources as Zuni painted skin bags and robes,

Fig. 7. Dorothea Warren O'Hara. Pottery decorations based on Ojibwa beadwork. From "Seen in New York," *Good Furniture* (June 1917).

Fig. 8. Esther A. Coster. Matchbox featuring Hopi motifs and pepper shaker with Akimel O'odham (Pima) motifs, 1916. Image 101313, American Museum of Natural History Library.

Navajo weavings, and beaded bands from the Indigenous peoples of the Eastern Woodlands.[81] Coster, speaking more generally, outlined the ideal selection process of motifs for decorative purposes: "First, the artistic value of the original example; second the suitability of the design to the material and medium to be used; third, the suitability of the designing to the size, shape, and use of the article to be decorated; and fourth, the addition of the personal element in the adaptation for design. If these principles are rigidly followed the Museum exhibits will prove of inestimable value, and will open the way for

the development of a truly American art expression."[82] Coster not only defines an effective adaptation method for designers, it also articulates the pervasive desire among many types of American designers to sever ties with traditional European sources and establish a unique and wholly national design identity.

Disseminating Design

In addition to opening the anthropology collections to interested students and designers, Mead, Wissler, and Crawford published articles and manuals to reach a broader audience. The various curatorial departments at the AMNH printed booklets or "guide leaflets" for the permanent collections to aid the visitor through the exhibition halls and to imprint the museum's (or the curator's) broader ideologies upon the experience. The museum also published the *American Museum Journal*—an illustrated periodical devoted to the broader field of natural history and scientific research—and the department's own *Anthropology Papers of the American Museum*, aimed at disseminating its mission to museum members and scholars.[83] Given the broad circulation of these publications, it is not surprising that the AMNH "fashion staff" would use this arm of museum outreach to court designers and industry.

Mead, curator of Peruvian art, had by 1907 already published illustrated texts on Andean featherwork and textile design and, more generally, espoused the usefulness and inspirational qualities of pre-historic Indian life.[84] In

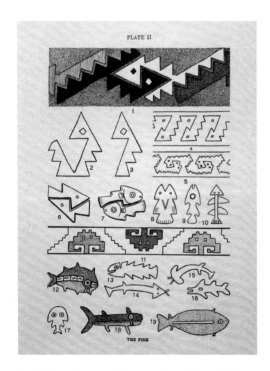

Fig. 9. Conventionalized fish designs. From Charles W. Mead, "Peruvian Art: A Help for Students of Design" (1917), pl. II. Private collection. Cat. 8.

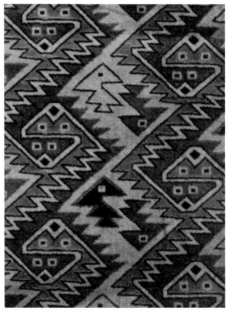

Fig. 10. Central Textile Co. design featuring conventionalized Peruvian bird and fish motifs. From M. D. C. Crawford, "Creative Textile Art and the American Museum," *American Museum Journal* (March 1917). Library, Bard Graduate Center. Cat. 12.

concert with the department's efforts to educate designers he published numerous educational texts concerning artifacts of ancient Peru, including the article "The Conventionalized Figures of Ancient Peruvian Art" in 1915 and the influential
guide "Peruvian Art: A Help for Students of Design," in 1917 (fig. 9).[85] Mead's manual for designers included key conventionalized figures (human, bird, fish, and puma), described formal elements of design, and deconstructed the degeneration of animal forms into symbolic motifs. The manual resonated with audiences outside the museum, but it would be particularly influential among professional designers and design students. Just months after its first printing, the museum would claim, "a handbook of Peruvian Art prepared by Mr. Charles W. Mead, has been in greater demand by the public since its recent issue than any other handbook of the American Museum except the one on butterflies."[86]

Attesting to its popularity, there are strong indications that designers such as Ilonka Karasz and manufacturers like the Central Textile Co., who both drew heavily from the AMNH collections to create contemporary designs, used Mead's handbook to inform their work (fig. 10, see cat. 13).[87]

Wissler also published texts for a design-minded audience. After publishing a slate of articles focused on more traditional ethnographic subjects, such as Native American material culture and, most notably, the development of the "culture-area" concept, beginning in 1915 Wissler frequently published on the garments of the Plains Indians.[88] Wissler's manuals were written for a dual audience, anthropologists and designers. "Costumes of the Plains Indians" (1915) and "Indian Beadwork: A Help for Students of Design" (1919) identified, isolated, and diagrammed the sartorial elements of Plains Indians' decoration and dress (fig. 11, see cat. 10). In these texts Wissler presented innovative silhouettes by illustrating the structural differences in single-hide, two-hide, and three-hide garments as well as distinctions in style found

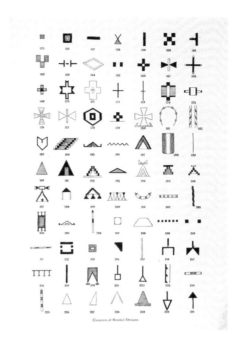

Fig. 11. Elements of Arapaho beaded designs from examples in the American Museum of Natural History. From Clark Wissler, "Indian Beadwork: A Help for Students of Design," (1919), 29. Private collection. Cat. 9.

throughout the central and western United States. Moreover, by analyzing the structure and decorative elements of Blackfoot and Dakota Indian garments (especially beadwork and quillwork), the guides supplied fashion designers with a "new" ornamental language that could inform a progressive aesthetic. "Indian Beadwork" would quickly stimulate articles in *Women's Wear*, including one published in November 1919 with illustrations by Harriet Meserole featuring "white cotton frocks" with embellishments of beading, embroidery, and ribbons.[89]

Wissler's and Mead's texts adhered to the format Ernest Batchelder (1875–1957) used before them, isolating indigenous motifs and detaching them from their symbolic or cultural significance. A leading American Arts

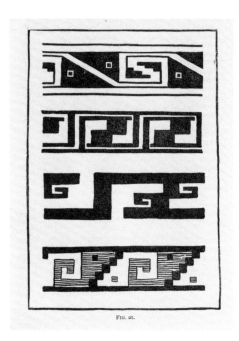

Fig. 12. "Area Designs from Pottery and Blankets of American Indians." From Ernest Batchelder, *Design in Theory and Practice* (1914), fig. 21. Private collection. Cat. 6.

and Crafts designer and regular contributor to Gustav Stickley's magazine *The Craftsman* (1901–16), Batchelder deconstructed individual indigenous motifs in the manuals *The Principles of Design* (1904) and *Design in Theory and Practice* (1906) for American artists and designers (fig. 12, see cats. 5, 6).[90] Both manuals trumpeted rhythm, balance, and harmony, resulting in conventional designs to be applied to modern work such as stenciled or embroidered textiles for the domestic interior.[91] As art historian Elizabeth Hutchinson has observed, Batchelder disregarded the indigenous makers of these designs in favor of crediting his readers as the true artists. In contrast, while Wissler and Mead emulated Batchelder in isolating indigenous motifs, as anthropologists they were careful to give credit to the original makers and their cultural heritage in the accompanying texts.[92]

The frequency of design-related articles in the 1916 volume of the *American Museum Journal* suggests increased efforts by the AMNH staff to promote the utility of the museum's collection to designers. Beginning in May of that year, the museum published Coster's aforementioned article on the value of Native American art to designers and an essay to accompany Wissler's exhibit of Indigenous moccasins from the northern United States and Canada to illustrate the relationship of ornament to structural form. In October the journal published Crawford's "The Loom in the New World," and Mead's "Ancient Peruvian Cloths," both of which expressed the value of these subjects to modern textile production. And, in November, "Design and Color in Ancient Fabrics" by Crawford and "A Suggested Study of Costumes" by Wissler were published.[93] These last two articles were perhaps the most ambitious in their call for a modern American design identity rooted in the AMNH collections. Here Crawford celebrated the artistry of a diverse array of non-Western textiles while promoting the superiority of Peruvian weavings, suggesting that study of their technical structures could inspire experimentation among designers and manufacturers and thus new, advanced methods of production.[94] Wissler, on the other hand, explored the use of animal hide in indigenous garments, illustrating that the shape of the skins for Plains Indians determined their traditional silhouettes, whereas Inuit and other Arctic cultures cut and fit the hides to tailor garments to the human form.[95]

To more directly target the desired constituency, Wissler and Crawford organized a series of lectures devoted to the education of designers and department store buyers.[96] Beginning in October 1916, the inaugural series featured a weekly lecture by a member of the Department of Anthropology staff. Wissler and Crawford initially overlooked Spinden for the lecture series. During the planning stages for the lecture program, Crawford expressed surprise at Spinden's enthusiastic and eloquent presentation on Mesoamerican art for a group

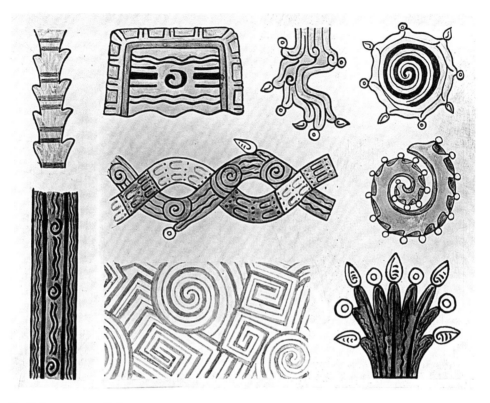

Fig. 13. Aztec water motif, shown at Herbert Spinden's lecture, "Textile Arts of Mexico and Central America," 1916. Image 219784, American Museum of Natural History Library. Cat. 22.

of designers from an unnamed large silk printing firm.[97] Thereafter, Crawford asked Spinden to participate. Spinden's lecture, "Textile Arts of Mexico and Central America," highlighted ancient and modern textiles from this region, as well as individual designs like the Aztec water, snake, or floral motifs that were particularly ripe for contemporary interpretation (fig. 13, see cat. 22). In contrast to Spinden's detailed analysis of individual motifs, Wissler spoke more broadly on non-Western textile design. His presentation "Primitive Textile Arts" was illustrated with both lantern slides and museum objects such as garments with fine quillwork, intricately beaded moccasins, and woven baskets (fig. 14). Naturally, Wissler focused on materials hailing from Native American cultures, and he advocated that "if a designer or artist would select one Indian tribe, get into the spirit of their daily lives, study their social customs, religious beliefs, sport, etc, he could with the aid of a little imagination, be able to bring forth a design or designs that could be utilized in our modern times, thereby striking a new note in decorative art."[98] Wissler was offering not only new sources, but a method of interpretation and application of indigenous art for contemporary use.

Crawford book-ended these lectures, opening the series with "Special Textile Processes and Products," which included a discussion of Chilkat Northwest Coast and Tapa Oceanic bark cloth, as well as a Tehuelche (Patagonia)

39

SHOWN AT THE WISSLER LECTURE

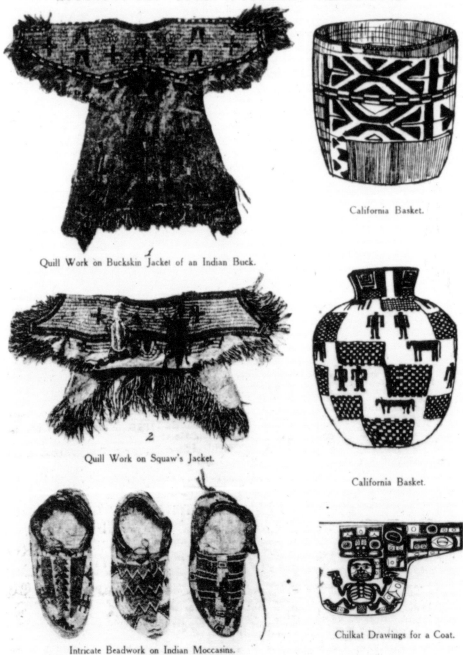

Quill Work on Buckskin Jacket of an Indian Buck.

California Basket.

Quill Work on Squaw's Jacket.

California Basket.

Intricate Beadwork on Indian Moccasins.

Chilkat Drawings for a Coat.

Fig. 14. Anthropology collection objects presented at Clark Wissler's lecture "Primitive Textile Arts." From "Shown at Wissler Lecture," *Women's Wear* (October 19, 1916). Science, Industry & Business Library, The New York Public Library, Astor, Lenox and Tilden Foundations.

Fig. 15. Detail, Tehuelche hand-decorated cowhide from Patagonia, Argentina. Purchased in 1909. Courtesy of the Division of Anthropology, American Museum of Natural History, 40.0/756.

painted cowhide, and closing with "Textile Arts of Peru" (fig. 15).[99] Crawford sought, in particular, to illuminate the similarity between "primitive textile decoration" and "modern machine ornamentation," a concept on which he would focus for years to follow.[100] Interest in the first lecture series began as early as June 1916; intrigued industry members included Arthur Curren (United Piece Dye Works), J. Engel (manufacturer of cloaks and suits), Henry Goldwater (H. Goldwater & Co., Inc., manufacturer of girls' coats), and Georgia Moreland (John Wanamaker).[101]

The lecture series illustrates the Department of Anthropology staff's focus on pre-modern weavings in their broader effort to construct a decorative vocabulary drawn from and modeled after non-Western motifs. Emphasis on pre-industrial weave structures was also intended to encourage experimentation and spur a renewed interest in handicraft, a goal that harkened back to earlier design reform movements but also, more pragmatically, aimed to aid American textile manufacturers as they strove to extricate themselves from dependence on European

technology and products. The return to non-mechanized technologies such as embroidery, batik, and block printing naturally aligned with the revival of handicraft germane to the Arts and Crafts movement in the United States.[102] Moreover, the dye crisis of World War I prevented textile producers from accessing German dyes and utilizing rich coloring for mass-market goods. The so-called primitive methods, especially block printing and other pre-industrial printing techniques, were advocated by Crawford as a means of reintroducing vibrant hues to textiles and garments.

While Crawford was involved in the AMNH's promotion of specimen rooms, publications, and lectures, his activities were not so limited. Most notably he used his position at *Women's Wear* to further spur industry and steer it toward what he perceived to be a more interpretive and correct form of appropriation. In 1915 the Oriental Silk Co. issued a line of silk handkerchiefs that featured decorative elements of "Chiriquí Indians" from Panama (fig. 16).[103] Crawford quickly

Fig. 16. Oriental Silk Co. and American Designing & Reproducing Co., scarf, ca. 1915. Image 19991, American Museum of Natural History Library.

Fig. 17. Illustration of the proper adaption of indigenous motifs. From M. D. C. Crawford, "Producing the Goods in Original American Design," *Women's Wear* (September 27, 1916). Fairchild Photo Service.

dismissed the scarves as simple "souvenirs," and criticized them for overtly replicating the indigenous material instead of interpreting it to achieve a more innovative design. In a gesture that mirrored Crawford's interest in ethnographic sources and more formal scholarship, especially as an impetus to a new American design identity, he advised *Women's Wear* readers to consult Yale professor George Grant MacCurdy's recent article "A Study of Chiriquian Antiquities" for a more sophisticated analysis of this culture and its design language.[104]

While recommending the MacCurdy's text for further reading, Crawford presented illustrations that demonstrated the appropriate interpretation of the Native designs without copying them outright (fig. 17). However, the blatant mimicry of Panamanian or "Chiriquí" motifs, which replicated entire pots, did not detract from these handkerchiefs' commercial appeal and they were in demand at department stores and at the 1915 Panama-Pacific International Exposition in San Francisco.[105]

In the interest of uniting designers and industry, *Women's Wear* design contests, initiated by Crawford in 1916, were a singular success. As Whitney Blausen and Lauren Whitley have chronicled, five consecutive contests for textile designs intended for industrial production and

six concurrent contests for hand-decorated fabrics ran until 1922.[106] Manufacturers like H. R. Mallinson & Co. and Cheney Bros. Silks, whose executives (along with educators such as Dow, fashion designers like Max Meyer, and professionals such as Henry W. Kent) often doubled as jurors for the contests, sponsored the competitions, and produced many of the winning designs for the larger market.[107] These design contests thus generated a profitable and direct link between the burgeoning design movement and the commercial market. As the motivating force behind the contests, Crawford unsurprisingly mandated "that the inspiration [for the designs] be drawn from a primitive source and adapted to modern use."[108] Naturally, many of the designers who frequented the AMNH's collection submitted designs. Notable winners included Marion Dorn, Ruth Reeves, Martha Ryther, Hazel Burnham Slaughter, and Marguerite Zorach.[109]

The *Women's Wear* design contests were an instant popular and critical triumph for American design. The *New York Times* proclaimed, "It is significant that many of the designs show the good effect of museum inspiration. There is almost nothing of the copyright's dullness in the exhibition."[110] Naturally, Dow heralded the success of the contests and even appealed to Crawford to consult on the formation of a new textile design curriculum at Teachers College.[111] The painter Maxwell Armfield (1881–1972), commenting on the first *Women's Wear* competition, championed the appropriation of Native American ornament and praised the competition for its national relevance. He wrote that the United States is "unique in being the natural heir to all of the civilizations of the world, and especially in having at its doors the Indian art which is perhaps more pure and more highly developed as far as it goes than any other school of pattern making."[112] Armfield's statement is especially potent as he acknowledged a more imperial position of the United States on the global stage, as the "heir to all civilizations," and even more so that he suggested a hierarchy in

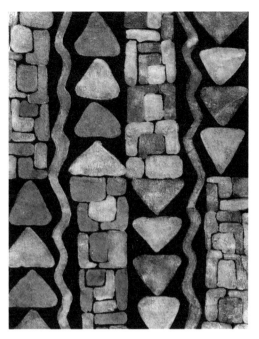

Fig. 18. Design based on objects from the Amur River, produced by Levinson & Bessels Manufacturing (top), design based on "Mexican motif for sand and water" (middle), and design based on Aztec "shield motif" (bottom), produced by Joseph Berlinger, 1917. Photograph by Kay C. Lenskjold. Image 36384, American Museum of Natural History Library.

Fig. 19. Martha Ryther for Belding Brothers. Textile design based on Tohoro O'odham (Papago) and Akimel O'odham (Pima) pottery, 1917. Photograph by Kay C. Lenskjold. Image 36386, American Museum of Natural History Library.

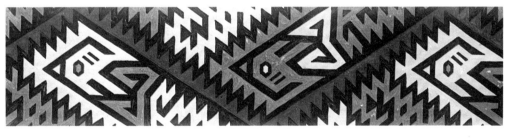

Fig. 20. (Top) Cheney Bros. Silks. Design for silk based on Peruvian motifs, 1917. Photograph by Kay C. Lenskjold. Image 36381, American Museum of Natural History Library.

Fig. 22. (Bottom) John Wanamaker. Embroidered silk with a design based on a "Peruvian cylinder" print, ca. 1917. Photographer unknown. Image 36390, American Museum of Natural History Library.

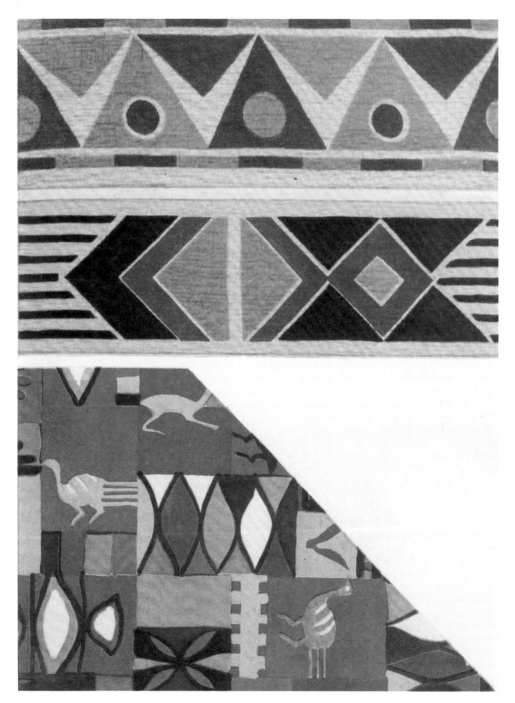

Fig. 21. Designs based on a "Titicaca pot" by Arthur Curren (top) and Native American basketry by Harriet Hart (middle); both for H. R. Mallinson & Co. Design inspired by Guatemalan belts and girdles by Ilonka Karasz (bottom). From M. D. C. Crawford, "Creative Textile Art and the American Museum," *American Museum Journal* (March 1917). Library, Bard Graduate Center. Cat. 12.

ornament and design—in which Native American art is at the top.

In addition, Armfield's view found favor with Crawford, who in similarly grandiose terms just months later declared in the article "Creative Textile Art and the American Museum": "We are a nation composed of many strains of blood, a people which has drawn traditions from innumerable sources, and the political unity which holds us together will be strengthened and vivified by an art which we may truthfully call our own."[113] In this passage Crawford alluded to the many émigré artists and independent designers who were contributing to the formation of an American design identity at this time. Most prominently, the Hungarian designer Ilonka Karasz, who used the AMNH's ethnographic collections to inspire textiles that were sold in Greenwich Village boutiques.[114] Later, in 1917, William Laurel Harris contrasted the bohemian ideals of Greenwich Village artists and designers, like Karasz, to the stodgy manufacturers of New York's Fourth Avenue, who produced derivative European-inspired designs. Harris noted the efforts of Crawford in particular to shepherd avant-garde designers from the United States and Europe—such as Martha Ryther, Jock Fulton, and Gwenyth and Coulton Waugh—through the halls of the AMNH in pursuit of a style that could evoke an "America for Americans."[115]

Crawford's article also illustrated the enthusiastic responses of textile manufacturers who recognized the commercial utility of the museum. Representatives of Johnson, Cowdin & Co., Belding Brothers, Levinson & Bessels Manufacturing, and Joseph Berlinger produced textiles with nuanced or explicit references to museum objects (fig. 18). A Belding Brothers silk design inspired by the pottery of the Tohono O'odham (Papago) and Akimel O'odham (Pima) Indians by frequent contest winner Martha Ryther was also illustrated (fig. 19).[116] In many of these designs, the impact of Mead's manual was apparent: for instance, silks manufactured by Cheney Bros. used the conventionalized Peruvian bird motifs found in weavings from Ica, Peru (fig. 20).

At Crawford's request, E. Irving Hanson of H. R. Mallinson & Co. dispatched his designers to study the ethnographic collections of both the AMNH and the Brooklyn Museum, and even increased his staff to facilitate the creation of the new design idiom.[117] Under Hanson's supervision, former Women's Wear competition winner Alfred J. Heinke went on to head the company's design department.[118] Previously celebrated for its 1914 Mexixe line—which utilized and conflated constitutive design elements from Mesoamerican and Native American cultures as a point of departure for a new design scheme for a series of seven novelty silk prints (see cats. 1–4)—Mallinson garnered attention anew for its innovative designs based on ethnographic artifacts.[119] In particular, the company produced new designs in its successful Khaki-Kool silk line by Arthur Curren and Harriet Hart, which featured bold, geometric patterns based on a Titicaca pot and southwestern basketry designs (fig. 21).[120]

Independent designers and silk manufacturers were not the only industry representatives culling inspiration from the museum. Through publicity in Women's Wear and its daily design illustrations, Crawford also attracted local department store staff, namely representatives from Lord & Taylor, B. Altman, and John Wanamaker to the collections.[121] These department stores were uniquely situated to influence style and taste with their big New York emporiums targeting consumers on a larger scale. John Wanamaker first responded with a new line that featured sport silks inspired by Peruvian clay rollers and carved Mexican stamps in 1917 (fig. 22).[122] Wissler approved. Later that year he wrote, "There is something going on in decorative art, the consequences of which few of us realize . . . we are witnessing the beginning of a truly American art Again and again, I notice that the original and good things . . . are based upon primitive art and more often than not, upon native American art. This is a good thing."[123]

MODELS
IN THE
STUDY
ROOM

—

1916

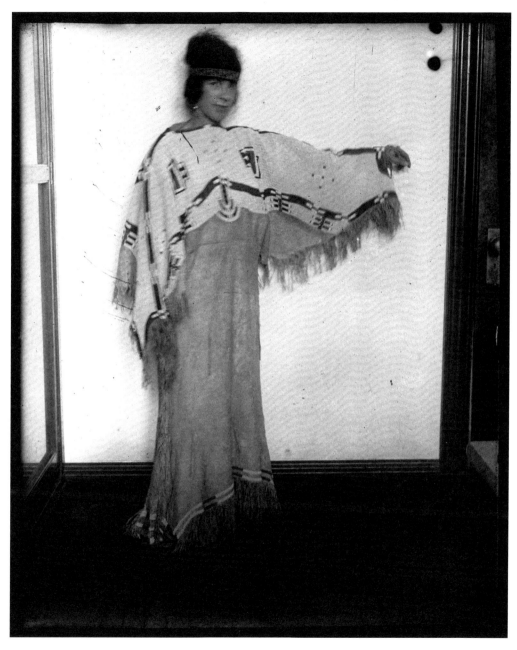

Fig. 23. Model in Sioux dress with beaded yoke, ca. 1916. Photographer unknown.
Image 2A18844, American Museum of Natural History Library.

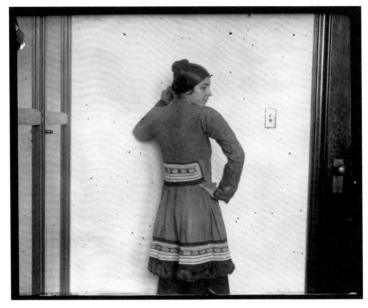

Fig. 24. Ilonka Karasz in Reindeer Tungus (Evenk, Siberian) hide,
fur, and sinew coat, ca. 1916. Photographer unknown.
Image 2A18823, American Museum of Natural History Library.

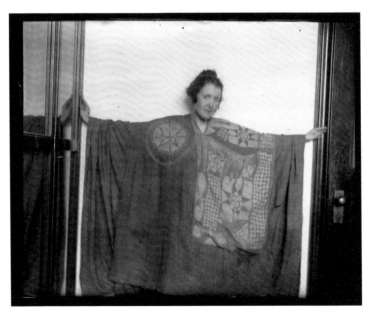

Fig. 25. Model in West African Hausa embroidered cotton
agbada or *boubou* robe, ca. 1916. Photographer unknown.
Image 2A18809, American Museum of Natural History Library.

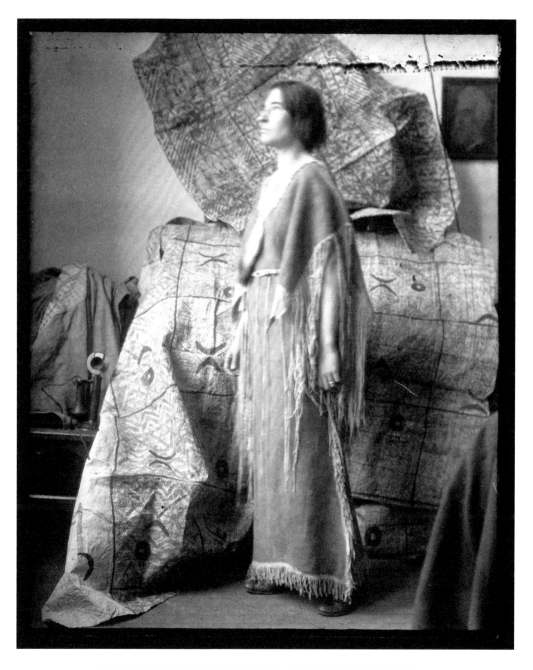

Fig. 26. Ruth Reeves in Native American dress, ca. 1916. Photographer unknown.
Image 2A18824, American Museum of Natural History Library.

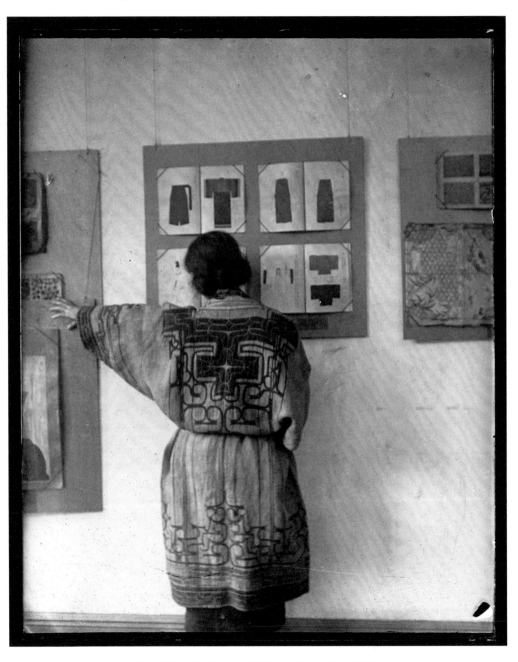

Fig. 27. Model in Ainu bark fiber robe, ca. 1916. Image 2A18806,
Photographer unknown. American Museum of Natural History Library.

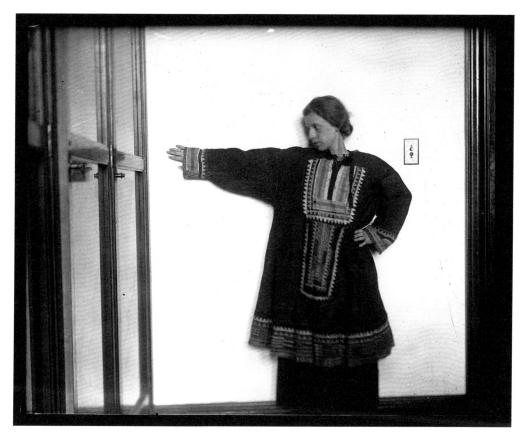

Fig. 28. Harriet Meserole in Koryak (Kamenskoye, Siberian) hide, fur, cloth, sinew, and yarn coat, ca. 1916. Photographer unknown. Image 228393, American Museum of Natural History Library.

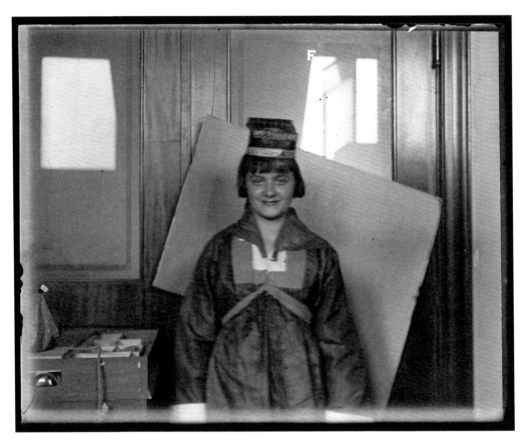

Fig. 29. Mariska Karasz in Korean silk garment, ca. 1916. Photographer unknown.
Image 2A18848, American Museum of Natural History Library.

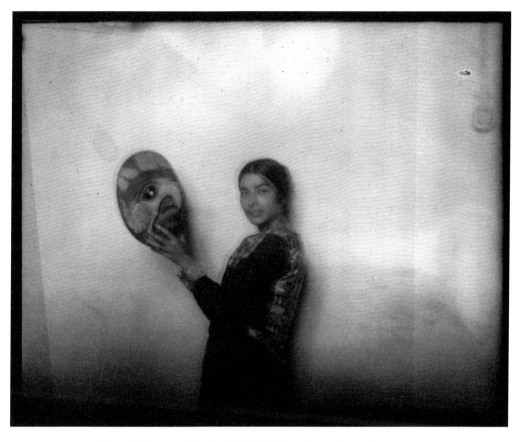

Fig. 30. Ilonka Karasz with a Nuxalk (Bella Coola) mask, wearing a modern garment
with a textile of her own design (see fig. 21), ca. 1916. Photographer unknown.
Image 2A18812, American Museum of Natural History Library.

II

—

FASHION DESIGNERS AND GLOBAL ARTIFACTS

In April 1917 Germany resumed submarine warfare in the Atlantic, prompting the United States to abandon the provincialism that had defined the country's foreign policy since the nineteenth century and to officially enter World War I. The United States' unprecedented intervention in global affairs induced national self-reflection and innovation, particularly within progressive circles.[124] Specifically at the AMNH, the wartime mobilization stimulated the museum's nationalistic agenda. But more than that, just as the nation was repositioning itself on the world stage, the most ambitious designers inspired by the AMNH's collections began to select from a wider and more global array of ethnographic materials, reaching beyond objects from the Americas to embrace indigenous design sources from a panoply of cultures.

During the same period, curators at the museum expanded their focus from textile design alone to the next logical and more ambitious arena: clothing design. By late 1916 the quality of European design direction had dramatically diminished owing to the now fully realized effects of war, prompting one commentator to note, "Parisian models on the American market are weak, weak in inspiration and freshness."[125] The absence of what was perceived to be good design reached a tipping point that forced ambitious American designers and clothing manufacturers to recalibrate. But unlike textile designers and manufacturers, who responded with immediate enthusiasm to the efforts of the AMNH, the clothing industry was at first skeptical of repurposing ethnographic material.

In 1917 journalist Elizabeth Miner King wrote that "obstinately [the designers and manufacturers] will not see the crux of the whole situation in museum study and adaptation according to the methods which have brought such success to the Rue de la Paix."[126] Here King made reference to the fashionable Parisian street that housed such famous late nineteenth- and early twentieth-century couturiers as Charles Frederick Worth, Jacques Doucet, and Jeanne

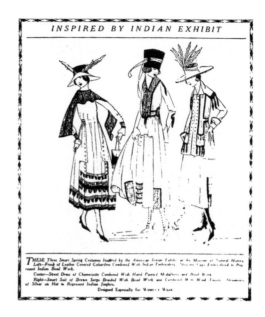

Fig. 31. "Inspired by Indian Exhibit." From *Women's Wear* (December 22, 1916). Fairchild Photo Service.

Paquin. However, her allusion was more likely to Paquin and Paul Poiret (whose couture house had been located on the Rue d'Antin since 1909) and their celebrated use of "Orientalist" sources.[127] King suggested that American fashion designers would find it profitable to mine museums for creative direction, paralleling the modern art movements that were gaining attention in the United States. She also observed that some clothing manufacturers placed little stock in the value of the museum while others lacked faith in the American consumer to support museum-inspired designs. However, she acknowledged that a few open-minded firms were taking advantage of the museum's resources to considerable acclaim.[128]

Seeking a toehold in the broader world of fashion design, the AMNH curators, likely at the urging of Crawford and enthusiastically supported by Spinden, took steps to attract designers and reluctant manufacturers to the museum.[129]

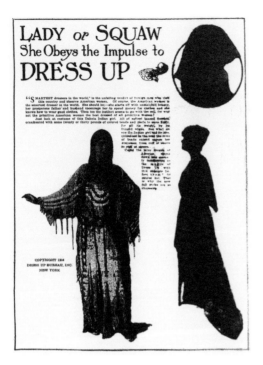

Fig. 32. Dress Up Bureau advertisement. From *Women's Wear* (September 22, 1916). Fairchild Photo Service.

Fig. 33. Dress Up Bureau advertisement. From *Women's Wear* (October 6, 1916). Fairchild Photo Service.

Echoing Armfield's imperialistic notion that the United States is the "heir to all civilizations" (not just the Americas), the AMNH staff supplemented the study room collections with a larger variety of specimens—from indigenous cultures worldwide—including Javanese textiles, West African robes, Koryak fur garments from Siberia, and Nivkhi fish-skin coats from Japan and Russia (see figs. 24, 25, 27–29). Designers responded, creating designs suggestive of objects from the Philippines, Siberia, the Amur River, and the Ainu collection (see cats. 27, 28).

As they had in the past, the pages of *Women's Wear* directly echoed the activities of the museum. The paper's illustrations alternately suggested valuable museum specimens and examples of the proper adaptation of these

artifacts, such as the appropriate interpretation of a Sioux beadwork yoke or sinew fringe (fig. 31).[130] The proliferation of ethnographic-inspired suggestions extended to advertising, particularly, to a campaign by the Dress Up Bureau juxtaposing non-Western garments with contemporary fashions in late 1916 (fig. 32). The advertisements sought to rouse consumer interest for an event in local stores. More so, it aimed to cultivate a mystique around American fashion, positing that taste and style were "in the soil" and suggesting that the modern American woman had inherited these traits from "aboriginal" American women who were the "best dressed of all primitive women."[131] Reflecting the increasingly global scope of cultural artifacts in the AMNH study collections,

the Dress Up Bureau advertisements included comparisons of what appear to be Blackfoot Indian and Koryak garments to current designs (fig. 33).[132] The advertisements focused on elemental similarities, such as fur embellishment or the drape of a sleeve, suggesting that the contemporary garments (which were no doubt modeled upon their "primitive" counterparts) tapped into transcendent design principles that had informed a supposedly earlier age. These advertisements reinforced the pejorative notion that these cultures were physically and temporally distant, evincing what Renato Rosaldo has dubbed "Imperialist Nostalgia," whereby sentimentality is projected upon cultures acculturated or "tainted" by modern civilization.[133]

Designers in the Study Room

Beginning around 1916 the AMNH produced photographs of women modeling a selection of specimens for object research. Currently catalogued at the AMNH in the M. D. C. Crawford Photograph Collection, these may have been executed under the direction of museum director Frederic Lucas (1852–1929). In a letter from William H. Sabine to Lucas in August of that year, Sabine states "that the costumes you wrote to me about were photographed yesterday Ten persons helped in the work, and I can assure you that the big store room has the appearance of being a dressing room for the preparing of a small carnival."[134] The photographs were likely intended as aids for designers who might use these pieces as sources of inspiration for progressive silhouettes. Included are images of Ilonka and Mariska Karasz and *Women's Wear* illustrators Harriet Meserole and Ruth Reeves modeling Tungus (Evenk, Siberian), Korean, Peruvian, and Native American garments from the museum's collection (see figs. 24, 26, 28).[135] These images capture an energy and vibrancy suggestive of the increasingly liberated woman in New York and emit a playfulness typically absent from documentary photography at this time. However, to convey the scientific quality of the project, the photographs' subjects assumed rigid poses—frontal, side, three-quarter, and rear views—common to anthropological documentation. These images merge the methods of anthropometric photography—placing the subjects against gridlines or rulers to collect scientific data, particularly in postures emphasizing the subject's anatomical details[136]—with other types of documentation which aimed to highlight the subject's culturally specific garments and artifacts, resulting in a unique marriage of artful and scientific images.[137] In a few of these images, museum specimens, including Tapa bark cloth and a Nuxalk (Bella Coola) mask from the Northwest Coast, were deployed as props (see figs. 26, 30). Potentially used to authenticate the images, these interposed items only aided in denaturing any specific identity from the scene, fostering a kind of visual acculturation that celebrated a conflated and projected exoticism and subordinated cultural authenticity for purely aesthetic ends.

In addition to recording ethnographic garments, the museum photographed a few "modern adaptations" with batik and embroidered details. Both batik decoration and embroidery drew from the American Arts and Crafts movement, where they were found on women's garments and interior textiles.[138] Such decoration was also favored in the type of so-called artistic dress—defined by long silk robes, sandals, and, most importantly, the disavowal of the corset—that was popular among bohemian women in New York's Greenwich Village (fig. 34). This new mode permeated avant-garde circles at the beginning of the twentieth century and, by 1914, came to define a more progressive feminist style that was constructed in opposition to both the conservative corseted shirtwaists and even the more forward Poiret-inspired tunic dresses and hobble skirts.[139] Initially sold only in small independent shops, artistic dress was quickly taken up by mainstream fashion and made available in larger, midtown stores like Bonwit Teller (fig. 35).[140]

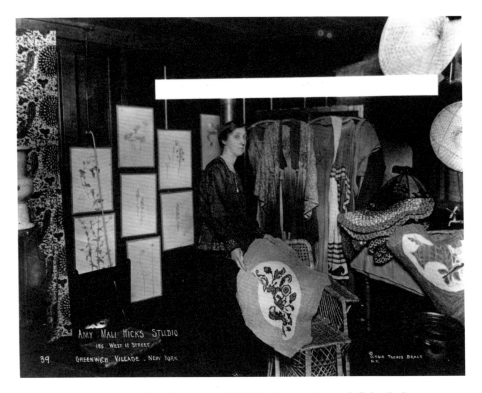

Fig. 34. Amy Mali Hicks Studio, West 11th Street, ca. 1910–1920s. Photograph by Jessie Tarbox Beals. Museum of the City of New York, 95.127.25.

These modes of decoration, as well as the simple, loose-fitting silhouette associated with many ethnographic garments, received official sartorial validation in the pages of *Vogue* beginning in 1919 and appeared at the AMNH *Exhibition of Industrial Art* that year.[141] Indeed, a reviewer of the exhibition noted the inherent functionality of this progressive silhouette.[142] It is not unreasonable to trace this look, at least in part, to the efforts of independent designers and avant-garde trendsetters like Village feminist Henrietta Rodman, illustrator Clara Tice, and the "fashion staff" of the AMNH.[143] Specifically, Wissler's articles analyzing the garments of the North American Plains Indians frequently illustrated this very shape, particularly in two- and three-hide dresses (see cat. 10).

American Art in American Dress

While forging constructive relationships with the avant-garde, the AMNH did not ignore more established players in the fashion industry. The illustrious New York branch of the Philadelphia-based department store John Wanamaker, in particular, made active use of the resources found in local museums. In 1916, Crawford noted that representatives from the store had visited the AMNH collections.[144] One such designer may have been one-time Wanamaker employee and fashion designer Mariska Karasz (sister of Ilonka). In a rare surviving sketchbook, numerous pages are filled with representations of birds, swastikas, and geometric scrollwork

found in non-Western decoration (see page 106).[145] Karasz was clearly fascinated with these conventionalized designs; the motifs are sketched in repeated variations, evidence of the designer working through a decorative scheme. Alongside these drawings are notations for source materials, namely: "Evolution of Bird Design K. M. Chapman Publisher."[146] Karasz may have been first exposed to these diagrams at Spinden's 1917 lecture at the AMNH, "Indian Pottery and Decorative Arts," where he featured slides of Chapman's illustrations.[147] In addition to the Indigenous American bird motif, Karasz drafted decorative schemes from more global sources, including African and Coptic costumes.[148] Though known for women's and children's garments with Hungarian-inspired embroidery and appliqué in the 1920s and 1930s, Crawford identifies Karasz as one of the many artists working in the museum at this time. Indeed, Karasz found this experience particularly rewarding and her research in the AMNH American Indian collections later informed the negligees and bathing costumes she designed under Jessie Franklin Turner for Bonwit Teller's custom salon.[149]

In 1916 under the guidance of Wanamaker's design director, Charles A. Frutchey, in-house designers began producing Central and South American-inspired garments with the aim of fulfilling the company's ubiquitous advertising slogan, "Wanamaker—originator." After months of peppering trade journals and fashion magazines with previews of "Maya Fashions," tailored to attract the "Modern Maya Maid," Wanamaker's presented a spectacle of Central American arts and culture in conjunction with the line's official release in March.[150] Display manager Harry Bird decorated the in-store gallery with Guatemalan textiles, large photographs of Mayan ruins, a display of "Indian huts," and flanking the stage "sat a native Indian girl in Maya dress" (fig. 36).[151] Wanamaker's was well-suited for this type of ethnographic demonstration, as they had been exhibiting and selling non-Western goods from North America, Egypt,

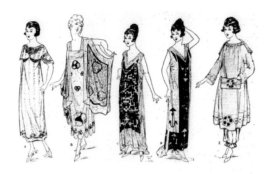

Fig. 35. "Greenwich Village Art in Bonwit Teller Costumes." From *Women's Wear* (April 11, 1917). Fairchild Photo Service.

and the Far East since the New York branch opened in 1896.[152]

The store's designers were comprehensive in their appropriation and application of the purportedly Mayan motifs and materials to contemporary wares: "tailored suits with bright Maya embroidered bands . . . Indian blankets made into cushions and lining many women's coats; parasols with designs copied from a poncho; sports hats bound with Maya scarfs, bags with Maya embroideries, et cetera."[153] With a strong emphasis on the native culture, the lavish display was structured to reinforce the indigenous elements of Wanamaker's line, but the fact that it did not endeavor to accurately portray cultural or historical realities of any particular indigenous way of life betrays the underlying character of exploitive appropriation.

While Wanamaker's was the most outspoken in their use of non-Western materials, representatives from the fashion manufacturing firm A. Beller & Co. and department store Bonwit Teller & Co., as well as notable New York designers such as Edward L. Mayer also made use of the AMNH's collection. To court a larger group of designers and manufacturers, the Department of Anthropology occasionally loaned artifacts to designers to facilitate the creative process. Despite the fragile nature of the specimens, priority loans were given

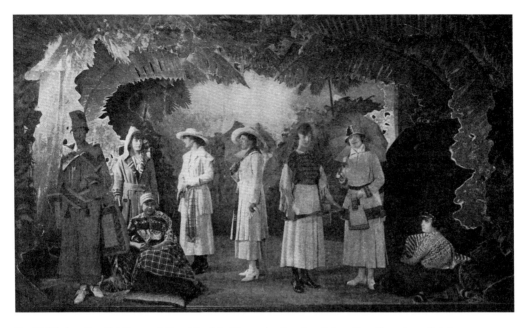

Fig. 36. "Modern Maya Maid," presentation at the John Wanamaker department store. From "Launches a Style," *Merchants Record and Show Window* (March 1917). Courtesy Smithsonian Libraries.

to fashion designers, enabling them to drape the ethnographic garments on a dress form and analyze their silhouettes.[154] For example, in 1918 a selection of Guatemalan huipils, a Burmese cloth skirt, and a Moro jacket from the Philippines were sent to Mayer for his evaluation.[155] Eventually the AMNH would extend the privilege to textile designers as well, including a diverse array of pottery, woven baskets, and gourd vessels, among other object loans (see cat. 20).[156] By current institutional standards this practice is surprising; museum objects are lent only at the most discerning level and under the most stringent conditions. However, one suspects that during this period the department's fairly lenient lending policies extended to other research areas. But a later comment by Wissler suggests otherwise. In 1923, when the Metropolitan Museum's Richard Bach queried Wissler about their policy for loaning specimens to designers

and manufacturers, speaking retrospectively, Wissler indicated that these requests were only approved when judged "by us" to be of the utmost importance to stimulating and "elevating" industrial art.[157]

Reflecting on the "first fruits" of the AMNH's collaboration with the fashion industry, Crawford penned an article for the *American Museum Journal* in January 1918.[158] Crawford acknowledged, in particular, Dow disciple and Teachers College instructor Ruth Wilmot, who emphasized museum research in her costume design classes with remarkable success—Wilmot's students' designs were purchased by the likes of Jessie Franklin Turner for Bonwit Teller & Co. and Mary Walls for John Wanamaker. Walls, an early supporter of "native designs," brought her creative team—possibly including Mariska Karasz—to the museum. Their work culminated in many of the Philippine-inspired designs illustrated in Crawford's article (fig. 37).[159]

Crawford's *American Museum Journal* article also evidences, albeit implicitly, designers' embrace of an increasingly broad spectrum of ethnographic material. Indeed, the expansion of the selection of specimens at the museum was reflected in many of the sartorial illustrations featured. Perhaps indicative of Spinden's preference for a more universal "primitive" typology, the wider appropriation of indigenous forms was clearly apparent in the designs of Max Meyer (for the high-end wholesale manufacturer A. Beller & Co.) who conflated diverse source materials: a coat with a long capelike panel at the back was inspired by Chinese artifacts in the Asian Ethnographic Collections while the print for its silk lining imitated a design from a sample of Tapa (bark) cloth.[160] Wholesale designer Edward L. Mayer also found inspiration in the North American Indian collection, explicitly appropriating tassel-and-bead ornamentation from a Dakota or Lakota Sioux garment for a satin evening gown (fig. 38). Native American motifs also adorned a negligee by Turner, who combined the indigenous ornament with structural elements from girdles of the Guajiro (or Wayuu) people from Northern Colombia. Turner also looked to a Koryak (Siberian) fur coat as inspiration for a tea gown of silk duvetyn with bead and fur decoration (see cat. 24). Bonwit Teller produced these designs envisaged by Turner and photographs of the garments were illustrated alongside Crawford's by-now standardized proclamation on the utility of the museum to American designers in *Vogue* (fig. 39).[161]

While designers and manufacturers were responding to the efforts of the AMNH curators, the new products would weather criticism by more conservative tastemakers. Despite the overlapping, albeit divergent aims between the Metropolitan Museum and the AMNH, Richard Bach would decry the use of "primitive" motifs as a "hoary art manner," proclaiming further that "in the course of a few weeks it will be as difficult to dodge motives inspired from the old [primitive] style . . . and many of our most

Fig. 37. Harriet Meserole, Ruth Reeves, and Sylverna Prior. Illustrations of garments for Edward L. Mayer and John Wanamaker. From M. D. C. Crawford, "Modern Costume and Museum Documents," *American Museum Journal* (April 1918). Library, Bard Graduate Center. Cat. 24.

Fig. 38. Harriet Meserole, Ruth Reeves, and Sylverna Prior. Illustrations of garments by Jessie Franklin Turner for Bonwit Teller & Co. and Edward L. Mayer. From M. D. C. Crawford, "Modern Costume and Museum Documents," *American Museum Journal* (April 1918). Library, Bard Graduate Center. Cat. 24.

A NEW SOURCE OF COSTUME INSPIRATION

Designers Adapt the Beauties of Primitive
Arts to the Actualities of Modern Life

By M. D. C. CRAWFORD
Research Associate in Textiles
American Museum of Natural History

THE relation between artists, art industries, and museums should be a very intimate one, and it has for years been the aim of the American Museum of Natural History to bring about such a condition. During the last year, a gratifying measure of success has been attained. For almost a quarter of a century, the Museum has been preparing for the time when American artists and industries should be ready to do their part, and now that time has come. The illustrations in this article are excellent examples of the results which may be obtained through such cooperation.

INSPIRATION FROM THE MUSEUM

The head of a department in a New York specialty shop recently made a careful survey of certain pieces in the museum, studying these works of art from the viewpoint of a creator of modes, to determine just which particular objects could be adapted to modern costume. After deciding on such points as the ultimate character and silhouette of the costumes, she called in consultation an artist who should carry out her ideas and add to them something of his own. It would be a profitless speculation to apportion the credit; each element was supreme in its own province.

It is not generally known that the collections of ethnological documents in the American Museum of Natural History are the largest and most comprehensive in the world. Especially is this true in regard to what are termed "primitive arts." Every great racial type in the world is represented in this collection, which thus affords an endless source of suggestion for artists and designers. So far, the use of the original material in the museum has been confined largely to the fabric and costume industries, but it is purposed to extend the work as soon as possible to all the decorative industries, with the definite aim of creating in America a true appreciation of decoration and a group of artists capable of independent creative effort in the decorative arts.

In the preceding paragraph, the phrase "primitive arts" was used. This term should never be used in a derogatory sense, for much of the finest that we have in decorative arts comes from peoples and from ages to which it is applied. It always represents a period in the culture of a people when artist and craftsman were synonymous terms.

After all, in the final analysis, this may be chosen as the clear definition: an artist is a craftsman with a trained appreciative faculty, an individual because of whose efforts certain objects acquire beauty or because of whose expressed skill and sensitiveness life takes on an added loveliness. Obviously, the mere medium of expression cannot be used to restrict this definition. It makes no difference whether this loveliness be added to a lump of clay, a piece of canvas, a yard or so of woven silk, a ribbon, or a costume. The spirit of conception and the skill of execution are the sole measures of aesthetic quality. And in those ages and among those peoples where art touched the sublime it has been most democratic in its influence. It has entered into each phase of life; and every object, from the most sacred to the most commonplace, has been influenced by its charm. Only in an age of artistic sterility or decadence has the name of artist been confined to restricted classes.

ARTISTS AND INDUSTRIES MUST COMBINE

There are hopeful signs that America is developing an interesting school of native art, and it is an encouraging indication that the young artists are frankly willing to devote their attention and ambition to every-day objects and materials. To make a yard of silk or a costume or a box-cover or a piece of pottery a delight and a stimulus to good taste is to them a worthy and highly desirable attainment. The powers of reproduction of our modern industries make it possible to spread such missionaries of art appreciation among an enormous population. These things enter into the daily intimate lives of many thousands of people, leading them, without conscious effort, by constant association with good design and colour, to higher aesthetic feeling. The painting or the piece of sculpture in the museum or gallery majestically demands adoration, standing as a thing apart from every-day life, but the gown and fabric are with us in all our waking hours.

(*Continued on page 118*)

This gray charmeuse tea-gown offers visible proof of the gain to the costume designer from cooperation with the museum. An ancient design furnished inspiration for the wool embroidery in dull Indian colours on the sleeves, the neck, and the belt, which buckles with beads and a jade ornament. The train is square at either side

MODELS FROM BONWIT TELLER
POSED BY WINIFRED BRYSON

The aim in studying museum treasures is not to produce copies, but to find inspiration for designs which may be adapted to modern garments. The ancient Koryak garment shown on page 118 inspired this negligée of rose duvetyn, kolinsky, and blue chifon

If we are ever to become an art-loving nation, we must look for beauty in articles of every-day use. To this end, designers are studying the arts of the past. This wool-embroidered negligée of pale yellow chifon over flesh tinted chifon is of Philippine inspiration

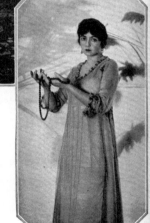

Fig. 39. Jessie Franklin Turner for Bonwit Teller & Co. Tea gown and negligees. From M. D. C. Crawford, "A New Source of Costume Inspiration," *Vogue* (December 1, 1917).

respected and otherwise respectable neighbors and compeers will in all exuberance subscribe to the maleficent policy of prostituting an honorable and thoroughly dead style to the purposes of an up-to-the-minute but equally lifeless vogue."[162]

Although Crawford no doubt did not share these criticisms, the museum's collaboration with designers had engendered a design language that extended beyond his initial vision. Crawford's view, espoused from the inception of the movement, was that the American design community could lay special claim to indigenous artifacts from the Americas and that these objects, which are "inherently our own," should serve as the primary source for design inspiration.[163] Crawford nonetheless acquiesced to the designers' appetites, in part fed by the work of Spinden, for a larger and more diverse selection of indigenous artifacts. While Crawford did not openly criticize the broader typology, the fusing of these diverse cultural aesthetics certainly resulted in an eclectic, unmoored, and at times convoluted American design language. It is not unreasonable to trace this muddied vision, most immediately attributable to the proclivities of the cultural avant-garde and design reformers, to transformative currents amplified and exacerbated by World War I. In *Things American*, Jeffrey Trask describes the war as a catalyst for new and diverse approaches to "art, labor, and democracy," but he continues, "At the end of the war, no one was certain what a modern American style would look like."[164] In the vacuum created by the closure of European design centers, American designers were afforded unprecedented latitude to create with a clean slate. But a singular design language did not coalesce. Drawing upon a staggering diversity of indigenous source materials, designers adopted a tangled panoply of ornament and garment construction that was characterized by both conservative and forward-looking design idioms. These features of the new American style would be on full display at the AMNH *Exhibition of Industrial Art in Textiles and Costumes* in 1919.

GARMENTS FROM THE *EXHIBITION OF INDUSTRIAL ART*

—

1919

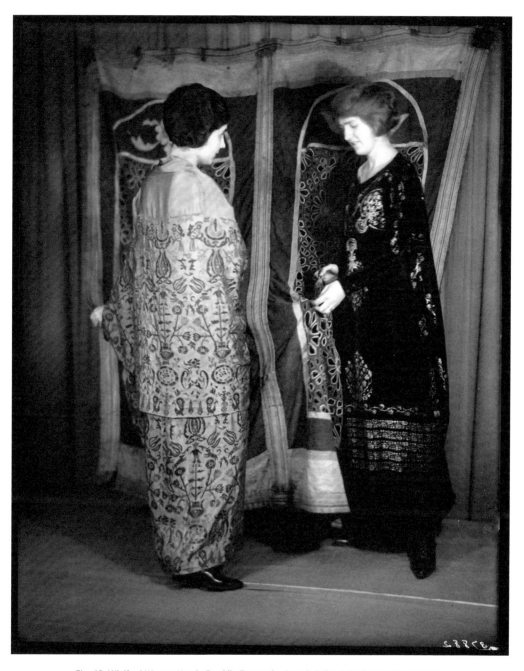

Fig. 40. Winifred Warren (Jessie Franklin Turner) for Bonwit Teller & Co. Taupe silk charmeuse tea gown with red, blue, and yellow embroidery inspired by motifs from Bukhara (left) and a tea gown of black velvet with gold decoration based on ancient Coptic designs (right), 1919. Photograph by Julius Kirschner. Image 37882, American Museum of Natural History Library.

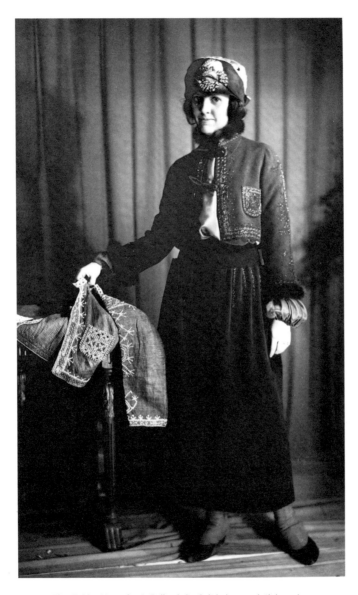

Fig. 41. Max Meyer for A. Beller & Co. Suit in brown cloth based on a Bagobo Philippine *abacá* cloth jacket, 1919. Photograph by Julius Kirschner. Image 37872, American Museum of Natural History Library.

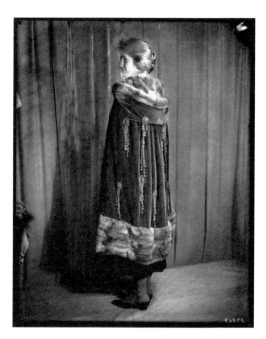

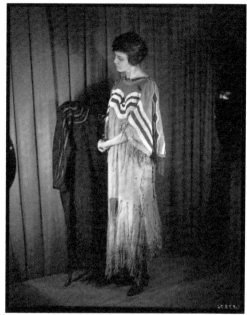

Fig. 42. Max Meyer for A. Beller & Co. Blue chiffon velvet evening wrap with squirrel fur trim and beaded ornament based on a Koryak fur coat, 1919. Photograph by Julius Kirschner. Image 37869, American Museum of Natural History Library.

Fig. 43. Blackfoot dress (on model) and modern counterpart by Harry Collins, 1919. Photograph by Julius Kirschner. Image 37876, American Museum of Natural History Library.

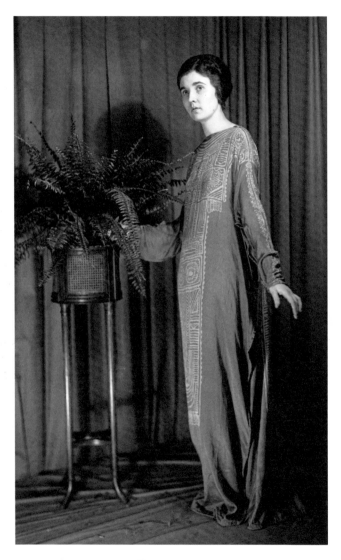

Fig. 44. Mary Tannahill. Batik dress inspired by "South Sea
Island Art," 1919. Photograph by Julius Kirschner. Image
37881, American Museum of Natural History Library.

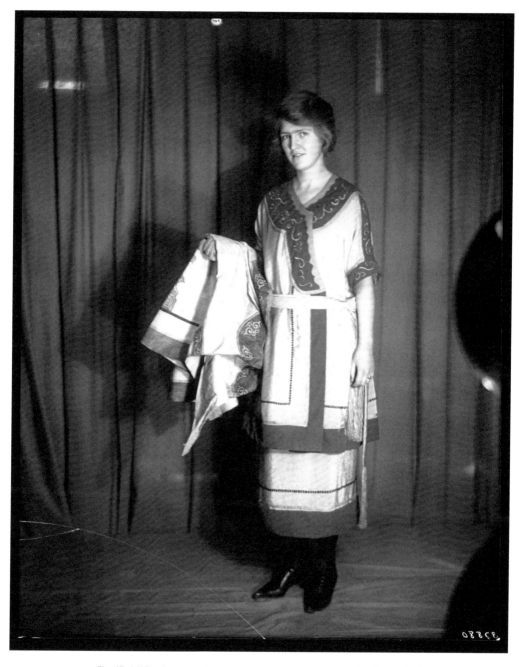

Fig. 45. J. Wise Company. "Sunset Fan-Ta-Si" silk dress with blue duvetyn appliqué based on Nanai fish-skin coat, 1919. Photograph by Julius Kirschner. Image 37880, American Museum of Natural History Library.

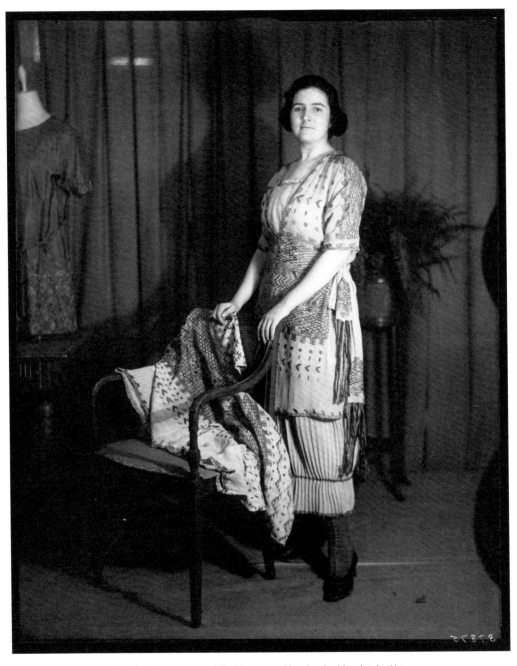

Fig. 46. J. Wise Company. Off-white crepe with red embroidery inspired by a huipil from Guatemala, 1919. Photograph by Julius Kirschner. Image 37875, American Museum of Natural History Library.

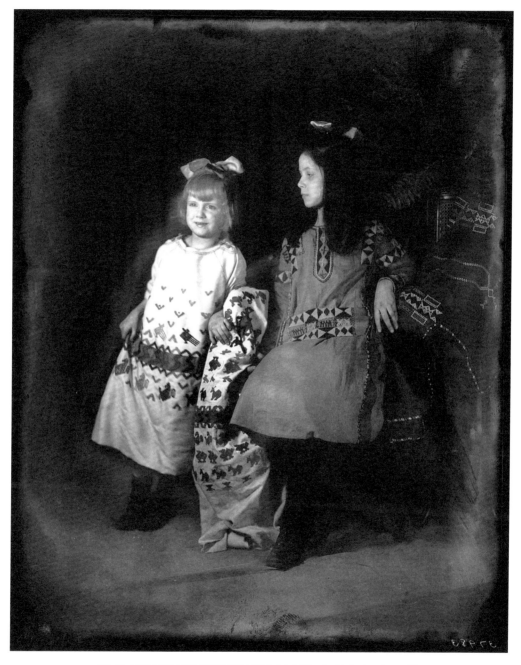

Fig. 47. J. Wise Company. White crepe dress embroidered with Guatemalan motifs
in yellow, navy, green, and red (left) and navy embroidered dress of blue and rose
linen with Philippine motifs (right), 1919. Photograph by Julius Kirschner.
Image 37983, American Museum of Natural History Library.

III

—

THE *EXHIBITION OF INDUSTRIAL ART IN TEXTILES AND COSTUMES,* 1919

Fig. 48. *Women's Wear* posters, illustrations, and books, installation view, *Exhibition of Industrial Art*, 1919. Photograph by Kay C. Lenskjold. Image 37770, American Museum of Natural History Library.

The *Exhibition of Industrial Art in Textiles and Costumes* (1919) was the culmination of the museum's efforts to inspire textile and fashion designers through its ethnographic collections. In its press release, the AMNH would announce the exhibition as a confirmation of the emergence of a bona fide American design idiom: "The period of doubt and experiment is now over, and a pathway of future advancement clearly indicated toward the goal of a truly national art."[165] By displaying both ethnographic specimens and contemporary designs, the exhibition embodied the aims of the Department of Anthropology's educational platform since 1915. It also provided concrete expression to Herbert Spinden's overarching ideology, articulating a more universal "primitive" typology to convey a distinctly American design idiom. This global vantage of American design was evinced in the tea gowns of Jessie Franklin Turner and suits of Max Meyer to name but two.

Spearheaded by Spinden, the exhibition was organized by a self-appointed committee of key figures at the AMNH, including Crawford, Turner, Meyer, and David Aaron, all of whom collaborated with Brooklyn Museum ethnologist and curator Stewart Culin on this ambitious project.[166] In a letter to AMNH president Henry Fairfield Osborn dated June 17, 1919 Spinden outlined his four major aims of the exhibition: first, he stated that the goal was not simply to celebrate the results of the museum-industry relationship but, more ambitiously, to elucidate the similarities between indigenous and modern processes of construction and decoration; second, he stressed the need to illustrate the application of ethnographic motifs drawn from the museum collections; third, he wanted to narrate the history of the campaign to improve American industrial art through contest posters, costume renderings, and published articles (fig. 48); finally, Spinden wanted the exhibition

to impress upon the visitor the importance of "craftsmanship" in design education.[167]

Spinden reiterated these aims in the official exhibition catalogue published just a few months after his letter, but in prose that was saturated with nationalistic and patriotic rhetoric. For example, Spinden transformed the third aim of the exhibition, which initially had been to provide an overview of the broader activities of the movement, into an initiative of national importance: "to emphasize the social and commercial value of a national art that shall express everyday, practical ideas of use and beauty for the American people."[168] Spinden's emphasis on "commercial value" may well have been an attempt to address the economic impulse to foster competition with the looming return of fashionable imports from Europe after recovery from wartime conditions.

Installed for two weeks in November, the exhibition occupied two of the department's permanent exhibition halls.[169] Examples of modern and indigenous technologies were on display in the Plains Indians Hall, while the Eastern Woodlands Hall housed the sartorial exhibits. Screens divided the Woodlands Hall into small alcoves for seven special exhibits by key contemporary designers and manufacturers—namely, David Aaron & Co. Embroideries; H. R. Mallinson & Co.; A. Beller & Co. by Max Meyer; Harry Collins; Winifred Warren for Bonwit Teller; Modern American Batiks by Ruth Reeves, Martha Ryther, Hazel Burnham Slaughter, and Mary Tannahill; and Furs by Otto Kahn.[170] The remaining thirty exhibitors were grouped into smaller alcoves demonstrating a technique or theme, each illustrating a relationship between non-Western art and design and its application to modern use (see full list of exhibitors on page 130).[171] As Spinden noted:

> In this exhibition [the AMNH] hopes to rouse the public imagination as regards a new phase of Americanization and industrial reconstruction. To this end . . . the museum has endeavored to illustrate the

Fig. 49. J. A. Migel, Inc. jacquard loom and non-Western handlooms, installation view, *Exhibition of Industrial Art*, 1919. Photograph by Kay C. Lenskjold. Image 37788, American Museum of Natural History Library.

early history of machines and processes and the range of form and ornament in ethnological collections from all parts of the world.[172]

Textile Technologies on Display

The Plains Indians Hall counterpoised modern machinery, including a jacquard loom presented by J. A. Migel, Inc. and a ribbon loom from Johnson, Cowdin & Co., with displays of pre-industrial handlooms, and vertical and horizontal warp-weighted looms.[173] The modern machines dominated the visual space and the humming of the ribbon loom at work amplified the machinery's presence. In the Plains Hall, non-Western looms were relegated as impotent technology, installed statically in the manner of traditional art forms. In some cases the archaic technologies—such as Philippine and Peruvian looms—were literally hung behind a power loom and blocked from view. Extant photographs reveal that the hall was overwhelmed with display material, suggesting that it did not receive the careful curatorial attention directed to the rest of the exhibition (fig. 49).

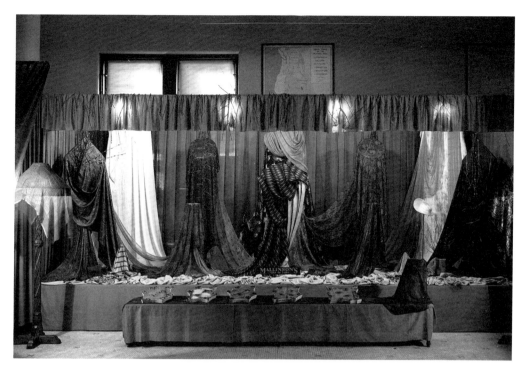

Fig. 50. H. R. Mallinson & Co. silks and printing blocks, installation view, *Exhibition of Industrial Art*, 1919. Photograph by Kay C. Lenskjold. Image 37907, American Museum of Natural History Library.

Anticipating the technology displays in the exhibition, a month earlier Spinden wrote:

> It is hardly possible to separate the facts of construction from the facts of decoration in industrial production In other words the industrial art of our complex civilization is exactly comparable to the ethnological expressions of primitive tribes and the earlier nations. Such art must embody a satisfactory answer to demands that are material, mechanical, esthetic and social: no one set of requirements can be allowed to control the product.[174]

This passage suggests that Spinden had hoped to highlight the connections and similarities between the so-called "primitive" and the modern technologies on display by installing them in such close proximity. In the exhibit, however, the relationships were attenuated by the subordination of indigenous looms to the modern machinery, exposing a disconnect between Spinden's aims and the realized exhibition. Overall, this passage projects the binary nature of the exhibition, inherently linking these technology displays to the artifacts and designs in the adjacent hall.

While the installation in the Plains Indians Hall illustrated weaving technologies, nearby, inside the Woodlands Hall, both pre-industrial and modern printing technologies were exhibited. Block printing and roller printing were both demonstrated. Individual exhibitors each displayed a printing technique: H. R. Mallinson & Co. presented contemporary block printing,

Fig. 51. Detail, Paracas mantle with mythical figures with feline and bird features, Ica, Peru, ca. 800–100 BC; acquired 1915. Camelid fiber and cotton; plain weave and stem stitch embroidery. Courtesy of Division of Anthropology, American Museum of Natural History, 41.0/1508.

Fig. 52. Detail, H. R. Mallinson & Co. Batik-inspired block-printed silk, on sheer Indestructible Voile, ca. 1919. National Museum of American History, Smithsonian Institution, 63914.T4144.

Fig. 53. Marshall Field & Company drapery fabrics, installation view, *Exhibition of Industrial Art*, 1919. Photograph by Julius Kirschner. Image 37760, American Museum of Natural History Library.

Marshall Field & Company included a demonstration of copper cylinders used for roller printing, and batik designs were featured throughout the exhibition. Furthermore, specimens of Tapa bark cloth and teakwood blocks represented the more analog printing methods.

Mallinson presented an array of silk prints inspired by museum objects: a length of Indestructible Voile silk featured an "ear of corn" motif found on pottery recently excavated in Arizona; a sample of a design based on a "Guatemalan" ribbon also printed on Indestructible Voile; and a length of Pussy Willow silk featuring a border derived from the pattern on a Toltec vase.[175] Mallinson's installation also featured a series of five blocks used to print one of its contemporary designs (fig. 50). The presentation effectively styled Mallinson's silk wares but also gave them context, and an anchor in pre-industrial technologies, by demonstrating the evolution of a block-printed design. The presentation illustrated the necessity of creating a separate block for each color. The final design, the "Paracas" print possibly by Hazel Burnham Slaughter, featured Andean mythical figures based on Paracas embroidered plain-weave mantles from Ica, near the southern coast of Peru (fig. 51, see cat. 25).[176] The designer drew inspiration from the embroidered feline figures on the ancient textiles, interpreting the iconography overall, and especially the figures' sinuous appendages terminating in "trophy heads" and the block-color styling of the forms.

The eminent silk company's display also included a sample of an imitation faux-batik print on sheer Indestructible Voile fabric—a nod to the vignette of handmade batik garments also installed in the exhibit (fig. 52). While unattributed, this silk print provides an evocative example of handicraft methods influencing industrial production.

Similar to Mallinson, Marshall Field & Company illustrated the creation of its line, *Canterbury Cretonnes*—cotton drapery fabrics based on a Nell Witters batik design—with the

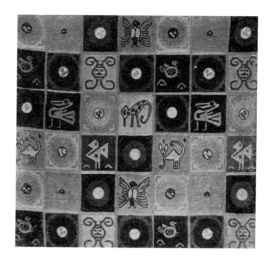

Fig. 54. Martha Ryther. Design based on "Peruvian" sources. From M. D. C. Crawford, "The Designer and the Textile Industry," *House Beautiful* (January 1919). Art and Architecture Collection, Miriam and Ira D. Wallach Division of Art, Prints and Photographs, The New York Public Library, Astor, Lenox and Tilden Foundations.

original blocks alongside their corresponding prints (fig. 53). Hidden in this display is a decorative silk design by Martha Ryther based on feline and bird figures purportedly found on Peruvian artifacts at the museum, a design perhaps more aligned with the underlying aims of the exhibition (fig. 54).[177] The Chicago-based company also exhibited copper cylinders used in modern machine silk printing. These, too, harkened back to indigenous processes, as highlighted by clay cylinders used for textile printing in Central and South America that were installed in various displays throughout the exhibit (see fig. 63 and cat. 17).

These displays of pre-industrial technologies advanced several of Spinden's objectives for the exhibition. On one level, the juxtaposition of so-called primitive and modern technologies exposed elements of indigenous methods that had been incorporated into the processes of modern industrial machinery and cylinder printing. At the same time,

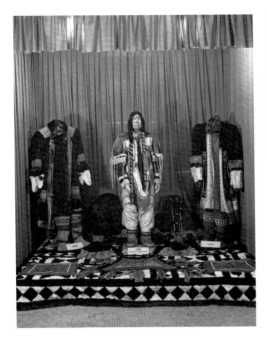 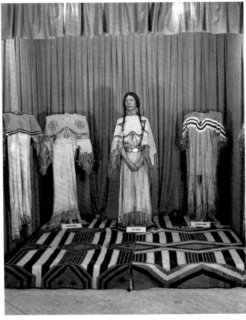

Fig. 55. Eskimo (Carabou, Inuit) and Koryak (Siberian) garments, installation view, *Exhibition of Industrial Art*, 1919. Photograph by Kay C. Lenskjold. Image 37751, American Museum of Natural History Library.

Fig. 56. Cheyenne, Sioux, and Blackfoot Indian garments, installation view, *Exhibition of Industrial Art*, 1919. Photograph by Kay C. Lenskjold. Image 37750, American Museum of Natural History Library.

the displays celebrated the craftsmanship of indigenous modes of production, underscoring a central tenet of the museum's educational platform—that the more intimate pre-industrial methods of production could (and should) be a source of inspiration and experimentation for the modern designer.

Sartorial Installations

The pre-industrial technology displays in the Plains Indians Hall looked almost exclusively to the indigenous cultures highlighted by the AMNH staff in the years preceding late 1916— that is, cultures believed to be more distinctly "our own," or Euro-American. Displays in the Eastern Woodlands Indians Hall were not so limited, reflecting both Spinden's and the

AMNH's later efforts to embrace a broader array of non-Western cultures, as well as the proclivities of fashion designers who canvassed the full breadth of the ethnographic collections for design inspiration.

The installation in the Woodlands Indians Hall best articulated the determined efforts of the AMNH to transform the industrial aesthetic and collaborate with manufacturers. The majority of the exhibition occupied this hall. The exhibition committee, headed by Spinden, draped the permanent North American Indians installations with dyed cotton sheeting and presented garments and fabrics created by at least twenty designers after ethnographic specimens. Spinden compartmentalized the exhibit space into small alcoves well-suited for ethnographic exhibits, as well as displays by both individual designers and larger manufacturing companies.

One of these ethnographic exhibits featured plaster (or wax) figures with Eskimo (Caribou Inuit, Canada) and Koryak (Siberian) jackets accompanied by furs, animal skins, and what appear to be Yakut (Sakha, Siberian) saddle attachments in the foreground (fig. 55). This installation betrayed a perception of a "pan-Arctic" indigenous culture, conflating diverse cultural expressions into a single idiom. A similarly arranged display exhibiting Plains Indians garments, presented examples of Cheyenne, Sioux, and Blackfoot Indian dresses (fig. 56). These dresses—with their distinct silhouettes and ornate beaded yokes—and Koryak fur jackets, had been uniquely popular among designers utilizing the AMNH collections, and modern iterations based on their design elements could be found elsewhere in the exhibition, namely, in the installations of A. Beller & Co. and Harry Collins.

Unlike the rest of the exhibition, these two installations denied an integrative approach and presented ethnographic materials in isolation, without overt reference to modern iterations, in the manner of traditional anthropological modes of display. The models used for these installations were reminiscent of the mannequins used in the anthropological "life groups" common to the museum at the beginning of the century.[178] But the extraction of the ethnographic displays from such contextualizing material placed them in a curatorial limbo—detached from both the complex display of culture and situated outside the larger displays of contemporary objects.

During the planning stages of the exhibition, in a letter to Osborn, Spinden stressed the importance of recruiting key fashion designers: "The principal difficulty is in the matter of costumes. Here a limited number of creative artists wield a tremendous influence that is quite out of proportion to the volume of their business. We have found it wise to make our appeal through these leaders knowing that mass would follow. Each special exhibitor has been asked to bring together a personal exhibit consisting of several pieces, some of which are to be related directly to museum specimens."[179]

Interestingly, Spinden did not mandate that every exhibited design be inspired by objects in the museum, thus diluting the AMNH's role in the larger expression of the exhibition. In the same letter Spinden compiled a list of "creative artists" to be invited to participate in the exhibition, a list that included Jessie Franklin Turner, Harry Collins, and embroiderer David Aaron. These three designers were given priority for the special exhibition spaces in the Woodlands Indians Hall. Turner presented a selection of negligees and tea gowns that were created under her label Winifred Warren and produced by Bonwit Teller & Co. Collins installed an exhibit of dresses and gowns and Aaron displayed a large selection of industrial embroideries. The three remaining special exhibition spaces highlighted the work of Max Meyer, furs by Otto Kahn, and batiked garments by Ruth Reeves, Martha Ryther, Hazel Burnham Slaughter, and Mary Tannahill (grouped together in one space).

Turner was an obvious selection for one of the larger exhibition spaces. She was a frequent visitor to the AMNH collection (as well as to the collections of the Brooklyn Museum, where she forged an enduring relationship with Stewart Culin).[180] Turner's extensive exposure to museum artifacts proved profitable and, at least from 1919, she was able to produce her designs under three separate labels: Bonwit Teller, Winifred Warren, and under her given name.[181] For the negligees and tea gowns displayed at the AMNH, Turner looked at Turkish, Coptic, and Persian sources, at least one of which—a Turkish coat—could be found in the collection of the Brooklyn Museum (fig. 57, see fig. 40).[182] Turner's interest in ancient and indigenous artifacts led her to seek sources outside of the AMNH and the Brooklyn Museum collections; she had recently purchased a pair of Persian blue linen curtains from the Kevorkian Gallery, which served as the basis for a number of her designs.[183] Her exhibit also featured an adaptation of a Persian embroidery reproduced by Blanck & Co. under her direction.[184]

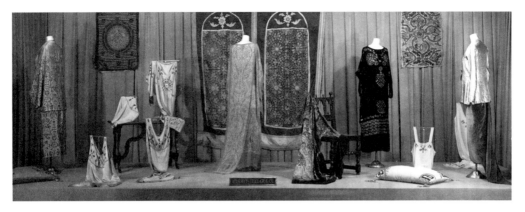

Fig. 57. Winifred Warren (Jessie Franklin Turner) for Bonwit Teller & Co., installation view, *Exhibition of Industrial Art*, 1919. Photograph by Kay C. Lenskjold. Image 37769, American Museum of Natural History Library.

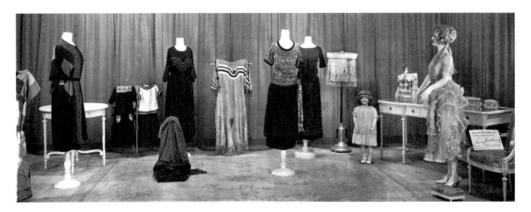

Fig. 58. Harry Collins, installation view, *Exhibition of Industrial Art*, 1919. Photograph by Julius Kirschner. Image 37765, American Museum of Natural History Library.

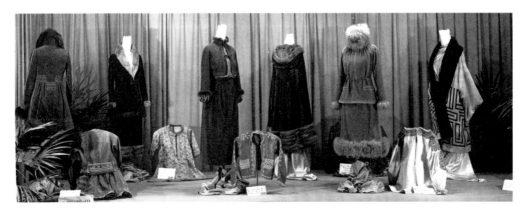

Fig. 59. Max Meyer for A. Beller & Co., installation view, *Exhibition of Industrial Art*, 1919. Photograph by Kay C. Lenskjold. Image 37764, American Museum of Natural History Library.

The nearby installation by Collins contained ethnographic specimens solely from the Americas, perhaps responding to Crawford's notion that these materials were of superior aesthetic and nationalistic value. The designer adapted abstract design elements from garments of the Plains Indians and Andean artifacts to create modern dresses and children's clothing. One example, a long-sleeved full-length dress, cites a Blackfoot Indian woman's dress with a striated beadwork swoop across the chest and "buffalo skull" patch at the center of the skirt (fig. 58, see fig. 43). Yet, departing from the traditional form, Collins gathered the garment at the waist. Another, a dress or wrap featuring a wide fur trim—draped at center—was made from Mallinson's "Paracas" silk print on display nearby (see cat. 25).[185] The inclusion of the original specimen, resulting fabric, and final modern dress in the exhibition most clearly demonstrated the pedagogical aims of the AMNH. Incongruously, at the right of the vignette, Collins exhibited a piece lacking even a subtle reference to ethnographic materials—a sheer dress with a tiered skirt whose silhouette and fabric reflected fashionable French couture. This inclusion of a more European garment betrays the designer's more conservative viewpoint, one that emphasizes more traditional taste and quality over a specifically American expression: "To my mind the truly educational feature of this exhibit is revealing what constitutes the fundamentals of good taste in costume."[186]

The designer who best exemplified the advantages of working with the museum was Max Meyer. His contemporary garments reflected an appreciation for a diverse selection of non-Western sources. His designs for the contemporary clothing manufacturer A. Beller & Co. looked particularly to the hide garments of the Reindeer Tungus (Evenk) and the Koryak tribes of Siberia, the men's *umpak linombos* jacket of the Bagobo people from the Philippines in the collections of the AMNH, as well as to a nineteenth-century Japanese fisherman's coat and an "Ancient Persian" jacket from the Brooklyn Museum for inspiration.[187] Meyer's both stylish and modern-looking garments illustrate a straightforward interpretation of indigenous silhouettes and design motifs (fig. 59). An evening wrap demonstrates how closely Meyer hewed to his source material. The wrap, made of blue chiffon, velvet, and squirrel fur is based on a Koryak fur coat from northeastern Siberia (see fig. 42).[188] In his design, Meyer placed special emphasis on the embroidered roundels representing the sun and beaded tassels, which were traditionally used to offset geometric patterning in fur appliqué, and placed them symmetrically across the back of the wrap.[189]

Modern American Batiks and Industrial Embroidery

Batik was well represented in the exhibition; Modern American Batiks—both original one-off dresses and manufactured batik-inspired textiles—were two of the many highlights on view (see fig. 52). Batiks were seen in designs by Mary Tannahill, Reeves, Ryther, and Slaughter—all frequent visitors to the study room—who created a selection of caftan-shaped dresses that suggested the frocks common to the Greenwich Village set (fig. 60). While the laborious wax-resist process was not presented as part of the display (as was the case with block printing in the Mallinson exhibit), batik demonstrations were held during the exhibition run. In the pamphlet accompanying the exhibition, Spinden expounded on the origins of the batik process, aligning processes used in Javanese textiles to the wax-resist techniques used on pottery from Mexico, Central America, and western South America, as well as Hawaiian gourds. However, he set the contemporary batiks apart from their predecessors, suggesting that they were not limited to the traditional two-color patterns and were superior owing to their variegated and vibrant designs.[190]

The fur wraps of Otto Kahn drew upon Bulgarian and Russian sources, but the silk linings featured batik-inspired prints purportedly

based on sources hailing from the Americas. Loans sent to Kahn in 1919 suggest that his designs derived from Crow saddle stirrups, an Arapaho dancing dress, and quotidian objects from Central America such as carved gourds and rattles (see cat. 20).[191] Kahn created luxurious wraps, one of which the exhibition catalogue described as being "made of the clearest ermine" and exhibiting a "modern batik lining in pleasing colors."[192] Another vignette in the exhibit by Funsten Brothers demonstrated the process of creating the fur garments from animal skins. While there is no extant image of this display it clearly aligned these modern garments with the installation of Inuit and Koryak fur garments nearby.[193]

The pervasive interplay between pre-industrial and modern techniques that characterized the exhibition also could be seen in the frequent application of embroidery by the exhibitors. In preparation for the exhibition, seventeen embroidered items were loaned to J. Wise Company, including a "fine band of fancy needlework Santa Cruz, Mindanao, Philippine Islands," and a "huipil with silk ornamentation, used as a bath robe, Quetzaltenango, Guatemala."[194] J. Wise also looked to the form of a fish-skin coat from the Nanai culture of the Amur River region for the decoration and silhouette of a wrap jacket and skirt (see fig. 45). More directly speaking to the use of hand-wrought ornament, the designer presented a variety of indigenous motifs in her embroidered designs for garments, including children's dresses adorned with "formal animals taken from a Guatemalan hupil," a woman's dress created from similar sources, and clothing citing Philippine and Burmese design motifs (figs. 61, 62).[195] However, the exhibit that displayed the most adept application of embroidery, as well as embodied Spinden's ideology toward non-Western cultures and American design, was the installation by David Aaron.

Aaron produced a wide variety of commercial embroideries with ideas taken from an "African robe, an Ainu coat, a Salvador pot, and from the baskets of California and Arizona" (fig. 63).[196]

Often he conflated diverse ornament into a singular design, for example combining the motifs found on an Ainu coat and a Northern California (from Pomo or Maidu cultures) woven basket. This exhibit, more than those discussed previously, was also tightly aligned with industry's aims of producing clothing and textiles for a broad market. The items produced by the other designers were either singular custom designs or hand-made garments, whereas Aaron's designs were created with a larger production in mind. As Spinden explained, "all [of Aaron's] specimens are adapted to trade requirements, are practical, saleable, and successful examples of industrial embroidery art."[197] In this respect, Aaron's creations exemplified the museum's campaign to put its ethnographic materials to a modern industrial use. To this end, Aaron's exhibit was sent along with the A. Beller & Co. display—including eleven of the corresponding AMNH specimens—to Filene's Sons and Co. department store in Boston for a small in-store exhibition in early January.[198]

Critical Responses

In a sweeping declaration of the movement's success, Spinden proclaimed the exhibition as evidence of the achievements in American design and, more broadly, used it as a platform to expound upon the cultural benefits to such progress: "The exhibition of Industrial Art . . . disclosed the will of the [American] people to work and think together, an ideal of individual satisfaction in the common good, a conception of the nation as the exponent of the philosophy of justice, industry, and well-being, and a recognition of the place of beauty and good craftsmanship in the things that men and women spend their lives to create."[199] But the responses of several AMNH officials were less sanguine. In years leading up to the exhibition Pliny E. Goddard, well-regarded linguist and curator of ethnology, had opposed the museum's lenient policy of loaning fragile specimens to design houses. Focusing on Crawford, in

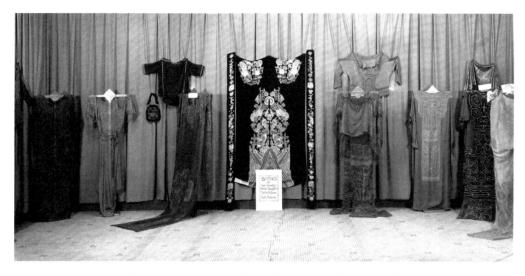

Fig. 60. Modern American Batiks by Ruth Reeves, Martha Ryther, Hazel Burnham Slaughter, and Mary Tannahill, installation view, *Exhibition of Industrial Art*, 1919. Photograph by Julius Kirschner. Image 37771, American Museum of Natural History Library.

Fig. 61. Detail, poncho with animal figures and geometric designs, Totonicapán, Guatemala, purchased 1901. Cotton; plain weave with supplementary discontinuous weft (brocading); single face. Courtesy of the Division of Anthropology, American Museum of Natural History, 65/2194.

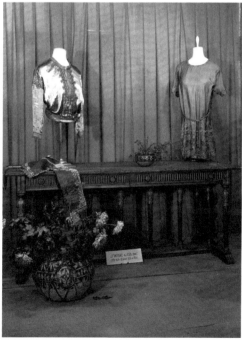

Fig. 62. J. Wise Company, partial installation view, *Exhibition of Industrial Art,* 1919. Photograph by Kay C. Lenskjold. Image 37768, American Museum of Natural History Library.

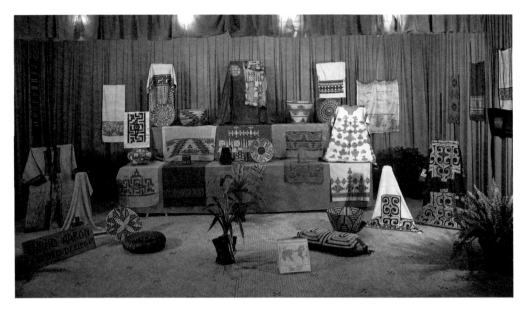

Fig. 63. David Aaron & Co. Embroideries, installation view, *Exhibition of Industrial Art*, 1919. Photograph by Kay C. Lenskjold. Image 37787, American Museum of Natural History Library.

particular, Goddard stated that, "he is extremely heedless in regard to specimens, door keys, and books."[200] Goddard's critiques may have also stemmed from a more territorial position. His research focused on the North American Athabaskan language family, which includes the Hupa of Northern California and the Navajo in the Southwest, some of the very cultures undergoing aesthetic appropriation by designers at this time, and he may have felt protective of their cultural heritage and symbolic expressions.

In regard to the exhibition, Goddard appealed directly to the museum administration, contending that the installation was not in keeping with the scientific aims of the museum.[201] He expressed particular frustration in light of recent budgetary constraints, to the improper allocation of the museum's resources and distribution of space to an exhibit that he perceived to be of little value to the institution and its constituents. Goddard continued that the great potential for the commercial exhibitors to profit far out-

weighed their merit and was disproportionate to what he regarded as their tenuous connections to the museum.[202]

Goddard's criticism was shared, though to a lesser extent, by other museum officials. President Osborn and members of the board of trustees, though pleased with the installation, regarded parts of the exhibit as being "outside of the authorized scope" and "too Parisian" (see fig. 58).[203] These officials felt that both the living models and wax mannequins installed in the two exhibition halls reflected an overarching European quality that muddied the purportedly American aesthetic on view.[204] Interestingly, this critique did not extend to the ethnographic models in the exhibition, representative of the museum's roots in traditional anthropological "life group" displays.[205]

These criticisms were not unfounded. The exhibition did not completely adhere to its mission of demonstrating a legitimate model of progressive American design based on the

ethnographic collections at the museum, presenting material that was only tangentially relevant to this aim. Non-Western objects such as Persian rugs and tapestries were certainly considered antique but spoke to a more European tradition rather than the cultivation of a modern and wholly American design idiom. The inclusion of lacework by Marion Powys (1882–1972) is another example of a more European model. In the catalogue Spinden aligns Powys's contemporary lace designs with fishing nets and mesh bags native to Africa and Central and South America, but that strained connection was not manifest in the display itself (fig. 64).[206] The Cheney Bros. Silks display also appeared to be out of sync with the museum's aims. Rather than a museum installation, it suggested a trade show (fig. 65), perhaps intimating the more commercial concerns underlying the aesthetic or educational aims, presenting products only thinly connected to the museum's collections such as Coulton Waugh's Ye Greenwich Village Prints, which feature floral and abstract patterns with a batik-like crackle effect.[207]

Despite these inconsistencies and criticisms, the exhibition was overwhelmingly popular among designers and museum-goers. The exhibition was well attended, although there are no official figures. According to Crawford, who had a penchant for exaggeration, on a single day in November more than 2,700 people visited the exhibition.[208] In September the *New York Times* announced the upcoming exhibition with a nod to the most "progressive" designers who derived inspiration from the ethnographic collection at the museum.[209] In November, just before the exhibition opened, *New York Times* writer Helen Bullitt Lowry pondered the success of the museum's initiative to create an American idiom that would challenge or replace the creative domination of France. She raised questions about the inevitable return of Parisian influence now that the war had ended, as well as the commercial viability of American-designed garments. Yet, she also celebrated the effort of New York designers and lauded the upcoming AMNH exhibition with dramatic prose: "And behold America discovered that she could design . . . she found herself churning out fascinating textiles . . . Indeed, a résumé of what this country has accomplished in decorative industrial art . . . in the last five years may be had at the Natural History Museum."[210]

That same month just after the exhibition closed in late November, a different *New York Times* reviewer exclaimed, "American women's interest has been captured," suggesting that the American consumer was finally poised to embrace the designs of their compatriots. The author continued "they have seen something that appealed to them as a possible part of their own wardrobe and having realized its own relation to themselves, their national pride has risen within and enlisted their sympathies for American art in American dress."[211]

Other publications praised the efforts of the AMNH. Naturally, Crawford wrote effusive reviews in *Women's Wear*, and *The Nation* published a review that celebrated both the contemporary objects and the ethnographic materials featured in the exhibition. The article, titled "Art: A Right Way to Use Museums," addressed the larger political and industrial

Fig. 64. Marion Powys, installation view, *Exhibition of Industrial Art*, 1919. Photograph by Julius Kirschner. Image 37767, American Museum of Natural History Library.

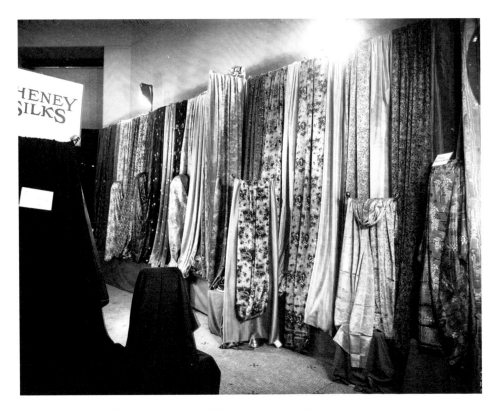

Fig. 65. Cheney Bros. Silks, installation view, *Exhibition of Industrial Art*, 1919. Photograph by Julius Kirschner. Image 37755, American Museum of Natural History Library.

issues reflected by the material on display. The author combined a contemporary criticism of conservative museum outreach, referring to museums as a "national or municipal store-house," with a call for a sustained direct relation-ship between museums and industry similar to that employed by the AMNH. In his discussion of the educational efforts of the museum, the author added an oblique reference to Wissler's manual "Indian Beadwork" noting, "the bead-work alone, modern and primitive, should be an inexhaustible source of inspiration to the student." The article also targeted the specific use of the collection according to Wissler's suggestions: "The museum has fine examples, above all, of Indian ornament in the beadwork

and baskets of the Sioux and of the Apaches, the blankets of the Navajos, the pottery of many tribes, even the pre-historic Pueblos. . . . It is suggestive to see how many Indian motives and color effects have been applied to modern dress, and how free from vulgarity or crudeness are the results. The beauty of the ornament is in its appropriateness."[212] With the reference to "appropriateness," the author implied a sarto-rial critique of the myriad design sources pre-sented in the exhibition while also acknowledg-ing the aims of the movement for an American design identity.

Interestingly, the article also addressed the relationship of indigenous garment construction to "necessity," and the need to accommodate

the lifestyles of the increasingly active modern woman: "The clothing of the Sioux and Eskimos is beautiful in its way because necessity has shaped it. Civilized woman, when she set the fashions was not guided by necessity, made of her dress a hindrance and a burden . . . for women [now] lead more active lives than they did [in centuries past] and cannot afford to be cramped and hindered by their dress. And the unexpected outcome of it is that models for the 'latest things' in jackets and blouses, cloaks and skirts, come from the Philippines or the Wild West, from the land of the hairy Ainu or from remote Siberia."[213] By merging appropriateness and necessity, the author succinctly argued for a new clothing design idiom (including a "primitive"-inspired silhouette) as a result of the confluence of design initiatives and nationalist prerogatives. Furthermore, this call for necessity or functionality suggests a desire to accommodate the mobilization of progressive "New Women" and lesser-educated, working-class women into the labor market.[214] Thus, this review confirmed that the exhibition effectively demonstrated the possibilities of an American design aesthetic based on the collections of the AMNH, as well as the demand for such a mode to meet the needs of the modern woman. Or, as Spinden proclaimed, "The record is complete and no one can fail to see the factors of careful workmanship that go into these products of American hands and minds."[215]

As both the positive reviews and the criticisms attest, larger tensions within the museum and anthropological communities were on display at the exhibition. The exoticizing and acculturation of indigenous artifacts were particularly pervasive in the installation. The display simultaneously lauded these non-Western objects as powerful source materials, while appropriating key design elements, and then relegating the artifacts themselves to a secondary status, as they were often installed on the floor and subordinated to the contemporary designs. Even the exhibition's overriding commercial message— the arrival of a new design identity—relegated

these cultures' inherent authority to an afterthought. However, regardless of the exhibition's complicated legacy, as many of the reviewers were apt to highlight, it did seem to suggest that American women could finally depend upon domestic designers and manufacturers for an American style.

IV

—

ABANDONED PLANS AND SHIFTING PRIORITIES

The *Exhibition of Industrial Art* demonstrated the dynamic potentiality of museum-industry collaborations, and its progenitors were anxious to capitalize on its success. To this end, a conference was held on November 20, 1919 in conjunction with the exhibition. The priority of this meeting—which featured presentations by James P. Haney, director of art for New York high schools, and Leon Winslow of the state board of education—was to discuss the future of the movement and, in particular, how the AMNH could continue to impact the development of American commercial and industrial art.[216] Perhaps emboldened by these discussions, AMNH curators would in the following months advance an ambitious resolution to support textile and fashion design in New York, which would have altered, had it come to fruition, the AMNH's mission for years to come.

Crawford took the lead. In November 1919, he wrote to AMNH president Henry Fairfield Osborn to advocate for the creation of a textile and sartorial arts department, something he considered central to fostering enduring ties between the ethnographic collections and industrial art education.[217] Spinden was in agreement. In December 1919 the museum's journal, *Natural History*, published his enthusiastic call for an entire museum devoted to the commercial arts. Spinden situated such an institution outside the "competitive activities of commerce" and placed it above "criticism," continuing that it would be an authority on the form and ornament of ancient and non-Western textiles and clothing.[218] President Osborn, surely pleased by the response to the exhibition, was persuaded. He called for a committee to research and propose a new department aligned with the Department of Anthropology that would be tasked with promoting "advances of pure science and the application of scientific principles to all phases of textile activity, to collect and to house scientific data and illustrative materials, and to promote the dissemination of knowledge pertaining to its field."[219]

Osborn asked Wissler, along with Spinden, Crawford, Hanson, and industrial magnates Charles Cheney and Albert Blum, to discuss the possibility of such a department. It would be funded with an adequate endowment and expand the public education policies for the utilization of the museum's collections for applied arts.[220] After at least one meeting of the committee, the tentative plan was cast aside in favor of a more sweeping proposal to establish a separate museum of broad industrial scope that would include not just textiles and clothing (as initially envisioned) but also ceramics, interior decoration, furniture, and jewelry.[221] This vision evinced the influence of the Philadelphia Commercial Museum—the repository for materials collected between 1893 and 1926 from the great world's fairs, which sought to stimulate manufacture and encourage American commercial expansion overseas—but the committee at the AMNH imagined it anew with an explicit mission to educate and stimulate industrial arts with the ethnographic collections.[222]

These ambitious plans were never realized; neither the new museum (in any form), nor the new research department at the AMNH was ultimately developed. Crawford and Spinden did not address the failed project in subsequent writings or correspondence. Having languished in this state, the project, despite its grand aims, simply vanishes from the historical record. It is possible that the project failed for want of financial resources. Suggesting a certain desperation, Crawford had attempted to solicit donations for the project through *Women's Wear*.[223] Perhaps more likely, the AMNH board of trustees, which had been critical of the *Exhibition of Industrial Art*, felt that such a department was not relevant to the museum's mission. Notably in this respect, in an April 1920 letter to Richard Bach of the Metropolitan Museum, Spinden observed that the AMNH administration did not formally recognize *any* relationship between the Department of Anthropology and industrial arts at that time.[224] This comment, coming just months after the proposal for a museum devoted to fostering

that very relationship, suggests a confirmation of the museum's overall focus.

Whatever its cause, the failed attempt to expand the AMNH's commitment to industrial arts education precipitated the departure of the curators most devoted to that project. Spinden was hired as the curator of Mexican anthropology at Harvard's Peabody Museum in 1921. Stanley Freed suggests that Spinden's dissatisfaction with his position at the museum began in late 1918, but even if that is true, Spinden certainly applied himself during that interim period, indeed with great enthusiasm, to the more sartorially minded activities at the museum, especially in mounting the *Exhibition of Industrial Art*.[225] Wissler became more involved in research and teaching and was increasingly distant to the project to inspire designers during this period, and divested many of the administrative and authoritative tasks to Goddard's charge until his death in 1928.[226]

Crawford also left the museum in 1921, resigning due to increased friction with Goddard, as well as the dissolution of the planned department of textile and fashion design.[227] In her comprehensive biography of Crawford, Lauren Whitley has chronicled his activities after leaving the AMNH, specifically his continued personal pursuit to elevate American textile and fashion design through the pages of *Women's Wear*, as well as through his lasting relationship with Stewart Culin at the Brooklyn Museum Institute.[228] Even by late 1918, the editorial attention Crawford previously afforded to artifacts and documents from AMNH's Anthropology Collection was increasingly directed to the Brooklyn Museum's expansive array of artifacts from more Eastern cultures such as Persia, Russia, Japan, and India.[229] This naturally occurred in conjunction with the opening of Culin's study room in Brooklyn. The success of the Brooklyn Museum's study room would spark a progressive resolution by the president of the board of aldermen, Fiorello La Guardia. In 1921 he presented the resolution by the Board of Estimate and Apportionment to oblige The Metropolitan Museum of Art and the AMNH to include in their respective facilities a room with ample space and resources for industrial designers.[230] Proposed on April 15, 1921 and adopted on July 1 of the same year, the official resolution of the City of New York cites the Brooklyn Museum as the example to be followed.[231]

Given changes in the institution's focus, the AMNH's initial response to the resolution was less than enthusiastic. In a letter to La Guardia in April 1921, Osborn emphasized the museum's previous efforts to extend "special courtesies and privileges to artists and designers."[232] He stated that until recently a room at the museum had been exclusively reserved for designers, but that given space limitations, the room had been reapportioned for collections care and management. Osborn maintained that the museum would continue to cooperate with designers though he did not offer a concrete alternative to the shuttered study room. Museum director Frederic Lucas (1852–1929) again echoed this argument after the official adoption of the resolution in July, "Unfortunately our congregation is so great that we have no special room that we can set apart for this purpose but we are so desirous of making our collections useful to the public that we have allowed artists the use of some of our offices of our staff."[233]

The issue of the AMNH study room resurfaced in 1923 when William Laurel Harris wrote to Osborn seeking support for industrial art education in museums. Advocating specifically for a study room filled with ethnological specimens, Harris sought to create a research department for the industrial art education of high school students.[234] Harris was unable to persuade museum officials. The museum maintained that it lacked available space for such a room, and Wissler—no longer shepherding an industry-museum relationship at the AMNH—along with Sherwood and Lucas asserted that the "maintenance of the exhibition halls was the best contribution" the museum could offer.[235]

Although no longer a primary objective of the institution, the AMNH's collections were still utilized by students and designers through the

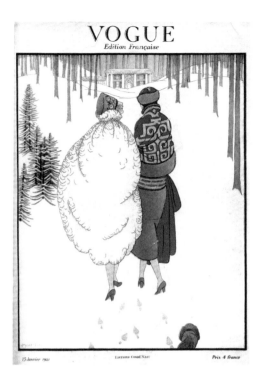

VOGUE
Edition Française

Fig. 66. Harriet Meserole. Cover for French *Vogue*, January 15, 1921. ©Harriet Meserole / Vogue Paris.

In regards to the continued use of the collections, the Department of Anthropology still approved a small number of loans to designers such as J. Wise and department stores like Bonwit Teller, and even lent items to Crawford himself.[238] Wissler reported in late 1926, "The number of students of design giving serious attention to our collections, steadily increases, constant use being made of the specimens on exhibition, and the more advanced students of the decorative arts making demands upon our study material. The responsibility for meeting the demands falls chiefly to honorary curator Charles Mead, who maintains his unfailing interest and enthusiasm for the study and appreciation of primitive art."[239] That is, with the departures of Crawford and Spinden in 1921, and with Wissler taking on a more administrative role, the task of assisting designers fell exclusively to Mead, a charge he likely relished until his death in November 1928.

Despite the museum's diminishing engagement with the design industries, examples of the project's lasting impact remain. In early 1921 Harriet Meserole, former *Women's Wear* employee and now illustrator for *Vogue*, embellished her illustrations with references to ethnographic materials that she had intimate exposure to only a few years earlier. One interesting example is the January 15, 1921 cover of French *Vogue*, where she clearly cites Ainu decoration on the back of a wrap (fig. 66). Another illustration, more directly targeting American readers, trumpets the utility of ethnographic collections for design education: a 1925 *American Silk Journal* illustration by Phoebe Wilhoit features a series of sport silk designs interpreting Zuni and Hopi weavings and pottery motifs for modern garments (fig. 67). Wilhoit was a student of Ethel Traphagan, notable designer and founder of her eponymous fashion design school in New York. A longtime supporter of design education in museums, an article accompanying Wilhoit's drawing quotes Traphagan with crediting student exposure to museum collections of "American aboriginal

end of the decade. A corpus of letters dating from 1921 to 1923 between AMNH administrators (including Wissler) and Metropolitan Museum officials (including secretary Henry W. Kent and associate in industrial arts Richard Bach) document the Department of Anthropology's continued support of students and designers at the AMNH, albeit in truncated form.[236] Particularly, the Metropolitan inquired about the AMNH's policy toward students and designers to ascertain whether it was "too generous in the freedom given in the use of our study collections," and to confirm if "slighting remarks [on the AMNH policy] which appear frequently in a certain newspaper" were justified.[237] Given the terms of Crawford's departure, one suspects that the newspaper in reference must be *Women's Wear.*

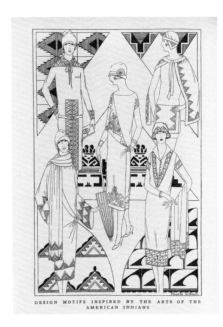

Fig. 67. Phoebe Wilhoit. Illustration for "Design Motifs Inspired by the Arts of the American Indians." From *American Silk Journal* (May 1925). Science, Industry & Business Library, The New York Public Library, Astor, Lenox and Tilden Foundations.

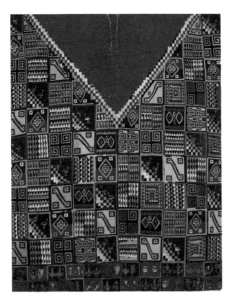

Fig. 68. Double-sided man's tunic with *tocapu*. Lake Titicaca, Bolivia, mid- to late 16th century. Cotton, camelid fiber, silk, and metal; tapestry weave. Courtesy of the Division of Anthropology, American Museum of Natural History, B/1500.

design" for increasing the quality and ingenuity of American design and the resulting "near panic" of Parisian dressmakers.[240]

Only months later, in October, the Stehli Silk Co. released its Americana Prints silk collection to much acclaim. The company hired contemporary artists and designers—such as photographer Edward Steichen (1879–1973) and *Vogue* illustrator and costume designer Helen Dryden (1887–1981)—to produce designs with American themes. K. L. Green, the art director of Stehli Silk Co., stated in an editorial announcement in the *American Silk Journal* that the "purpose of the Americana Prints is to capture all that is truly American and distinctively American and write it into designs which shall be beautiful and national."[241] Two designs by illustrator Charles B. Falls for the Americana line exemplified this "distinctively American" quality. Falls, a graphic designer and muralist, actively studied ethnographic textiles to produce the "Inca" and "Maya" designs for the Stehli Silk Co.'s series. "Inca" clearly cites the rectangular geometric designs, or *tocapu*, from an early colonial sixteenth-century Inca tunic from the AMNH collection (fig. 68, see cat. 31).[242] Lola McKnight has indicated that Falls's "Maya" also cites an item hailing from the museum but no specific object has been identified (see cat. 30).[243] The scrolling ornament is, however, certainly representative of a common decorative scheme on Mayan ceramic art easily found at the museum. On par with Crawford's ideal, these two patterns for printed silks drew from the rich decorative traditions of Central America to construct fresh contemporary designs.

Three years later H. R. Mallinson & Co. responded to Stehli's Americana Prints with the American Indian series (released spring 1928). The company purchased (or commissioned) the prints from independent designer Walter Mitschke in 1927.[244] The series comprised more than fifteen designs, including a repeating pattern of a Sioux headdress, a collage featuring Blackfoot drums and cow skulls, and a print with abstracted knife sheaths and beadwork

inspired by Comanche artifacts (fig. 69, see cat. 33).[245] In a particularly artful adaptation, Mitschke looked to intricate Shoshoni beadwork for inspiration and the source object—a hide and glass bead bag—was also published in the promotional booklet that accompanied the line's release (see cats. 34, 35). These roller-printed silks are impressive in their intricacy and innovation of design. Mitschke exhaustively studied Native artifacts that he recorded in charcoal, tempera, and pastel drawings, resulting in design sketches exemplified by the drawing for the "Zuni" print (fig. 70, see cat. 36). Notations on the backs of photographs at the Museum of Fine Arts, Boston, identify sources hailing from the AMNH and the Museum of the American Indian, Heye Foundation (now the National Museum of the American Indian).[246] However, indicative of the AMNH's waning relationship with industry, when Mallinson looked to style the showroom for the American Indian series release, it called upon the Brooklyn Museum to lend the indigenous artifacts.[247]

These new American silks were utilized by fashion designers for both day and casual dress, however, like the garments displayed in the *Exhibition of Industrial Art*, few exist today. Surviving examples include an unattributed day dress made of a sheer version of the "Sioux War Bonnet" print from the American Indian series and a pair of silk pajamas dating from around 1924, worn by the Ziegfeld Follies performer Imogene Wilson (fig. 71, see cat. 32).[248] The conventionalized pattern of the fabric on the top of the tunic and at the lower leg suggests Peruvian motifs included in Mead's manual for designers.

Despite these examples, it is apparent that after 1919, the museum movement—comprising study rooms and industrial art exhibitions— would instead be the purview of the Brooklyn Museum. Stewart Culin would still aggressively collect artifacts with the American designer in mind; however, his material interests would lay in the folk traditions of Eastern Europe and Asia, particularly Japan.[249] He remained

Fig. 69. Walter Mitschke. Drawing for "Blackfoot Sun Dance" for the American Indian series by H. R. Mallinson & Co., ca. 1927. Pencil on tracing paper. Museum of Fine Arts, Boston, Gift of Robert and Joan Brancale, 2008.1950.12.

engaged with many of the designers who had frequented the AMNH, including Jessie Franklin Turner, Ruth Reeves, and Edward Mayer, to name a few. Betraying the growing influence of Culin, Mayer's fashion sketches from 1918 to 1923 document a perceptive shift from Native American and pre-Hispanic-inspired designs to those more obviously informed by Asian artifacts.[250]

The Metropolitan Museum remained dedicated to its more conservative agenda for the

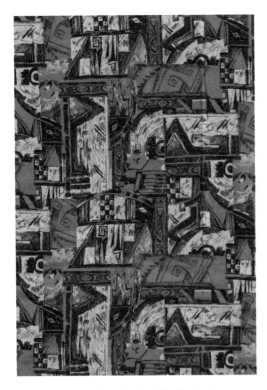

Fig. 70. Walter Mitschke. "Zuni" print for the American Indian series by H. R. Mallinson & Co., ca. 1928. Roller-printed silk. National Museum of American History, Smithsonian Institution, 101285 T.5749E.

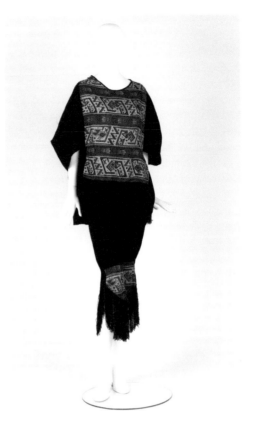

Fig. 71. Pajamas, worn by Imogene Wilson, ca. 1924. Collection of the Museum of the City of New York, 01.55.Lab.

applied arts, and continued to present exhibitions featuring modern designs based on its collection that ran the gamut of industrial arts—furniture, lighting, wallpaper, and textiles—into the late 1920s.[251] Many of the contributors to the activities at the AMNH would later participate in these exhibitions, particularly Ruth Reeves, Martha Ryther, and H. R. Mallinson & Co. But by this point the AMNH itself, having returned to a more traditional focus that served the research needs of the Department of Anthropology staff, remained somewhat aloof to the museum-industry relationship, showing little of its prior avidity for deepening the museum's ties with industry.

Conclusion

It is difficult to calculate the ultimate influence of the efforts of the AMNH Department of Anthropology on American textile and fashion design but, unquestionably, the museum curators provided a new and invigorating source of inspiration to designers from 1915 to 1919, and continued in an abbreviated form until 1928. If the AMNH's effort to create a lasting American style drawn from indigenous sources never came to complete fruition, the movement succeeded in exhibiting the value of museums to designers and manufacturers. While the project

at the AMNH has failed to get the scholarly attention that has been afforded to the roles of other New York area museums such as the Brooklyn Museum, The Metropolitan Museum of Art, the Newark Museum, and even later the Museum of Modern Art, in working with the design industries, it was an early contributor to American design culture that, while short lived, demonstrated the potential and limitations of forging a distinctively American aesthetic from a kaleidoscope of ethnographic materials.

The outbreak of World War I provided the catalyst for the determined efforts of the AMNH staff—curators Mead, Spinden, Wissler, and research associate Crawford. Forcing the closure of European design centers on which American manufacturers had historically relied, the war resulted in a dire design void. But the war also invigorated the nationalistic impulse to populate this void with a markedly American design language. AMNH curators' efforts to fashion a national idiom from ethnographic materials was a direct and pioneering response to these conditions. At the outset, the curators' endeavor drew from the conceptual underpinnings of the preceding American Arts and Crafts movement, as well as the work of educators and theorists such as Dow, Batchelder, and Kissell. Dow's call for an American design identity based on the formal cultural expressions of "Primitive American Art" was critical to fusing early American modernism with industrial art education in the teens. Together, these sources laid fertile ground for the project at the AMNH.

Endorsing Dow's thesis wholesale, members of the Department of Anthropology actively promoted the interpretation of non-Western motifs to support a national design language. The curators were at least initially drawn to the cultural artifacts of the Americas, proposing that Euro-American culture could lay special claim to these objects, and in so doing, develop a design aesthetic that was uniquely non-European and thus "our own." This appropriative vision of the nation's cultural heritage subverted the individual character of a wide range of indigenous cultures—combining, for example, Ojibwa beadwork, Colombian cylinder stamps, and Peruvian weavings—in service of a singular pre-industrial American vocabulary that designers could plumb randomly for inspiration. But while imperialistic in its assumptions, the movement was driven by an appreciation for pre-modern forms and techniques—perhaps in reaction to the sterility of mass manufacture—and a certain romanticization of indigenous ways of life and modes of production.

Imbued with the aura of the war, the efforts of the curators crystallized in the fall of 1916, when their ideological thrust to educate designers resulted in a vigorous campaign of lectures, articles, and guidebooks targeting industrial artists, especially textile designers and students. The redoubled efforts were not limited to outreach practices: the curators also collected specimens of significant value to the initiative and the department often reorganized its research facilities to accommodate the growing body of interested designers and manufacturers.

Paralleling the nation's entry into World War I and the globalization of the national consciousness, in 1917 the museum began to embrace a more diverse array of indigenous artifacts. This transition reflected Spinden's universalistic "primitive" typology, which adopted not just artifacts from the Americas, but a global selection of indigenous source material thought to be of a transcendent "primitive" language that could inform a national style. In conjunction with this shift, fashion designers such as Jessie Franklin Turner and Edward Mayer embraced an even wider range of ethnographic material—Koryak furs from Siberia or Philippine embroidered garments—for design inspiration. The project's broadening scope was also inflected with an increasingly commercial perspective as the war neared its end and the need to demonstrate the ongoing ingenuity and creativity of American designers and manufacturers, who would soon be competing with their historically dominant European counterparts, became paramount.

This potent mix of global objects and modern designs for commercial aims was most evident in the *Exhibition of Industrial Art*. With both non-Western and contemporary objects on display, the AMNH unabashedly sought cultural and consumer validation of its efforts to educate designers with the ethnographic collections. Though the decultured so-called primitive aesthetics were undermined by the inclusion of more traditionally French designs and mannequins, as well as more classical idioms, the exhibition was a milestone for design education in museums and would be a harbinger of the promise for a new American industrial identity in the following decades. The exhibition's success prompted Spinden to pen "Creating a National Art," where he expounded patriotically on the accomplishments of American design and proposed new ground for a lasting national imprint on future industrial products.[252] The exhibition also unleashed a flood of publicity for Crawford, *Women's Wear*, and to a lesser degree, the AMNH in the popular press.

Despite the critical success of the exhibition, the movement at the AMNH foundered in the 1920s owing to shifting institutional priorities for the Department of Anthropology. After Crawford and Spinden left the museum in 1921, the task of ushering designers and students through the collections was left to Wissler and Mead. During this period, a few significant designers and manufacturers trumpeting nationalistic aims utilized the collections to great fanfare, but ultimately with Mead's passing in 1928, the AMNH's declining engagement with the textile and fashion industries came to an end.

While the project to create an American textile and fashion design aesthetic based on the AMNH ethnographic collections was ultimately abandoned, the relationship between New York museums and the textile and fashion industries continued to foster design innovation in the following decades. Under the guidance of Stewart Culin, the Brooklyn Museum encouraged the use of its ethnographic collections by design-

ers, manufacturers, and department stores. Taking a cue from the display practices in the *Exhibition of Industrial Art*, Culin presented an exhibition of African Art in 1923, *Primitive Negro Art: Chiefly from the Belgian Congo*, featuring modern garments designed by Edward Mayer and Bonwit Teller that aligned with the art and artifacts on display.[253]

The Metropolitan Museum of Art continued to cultivate progressive American design through the use of study rooms and the annual installation of Designer and the Museum exhibitions, which began in 1917 and culminated in the exhibition *The Architect and Industrial Arts* in 1929. This seminal installation of American industrial design and architectural interiors foreshadowed the mission of the Museum of Modern Art to promote modernist design in the ensuing decades.[254]

Although other institutions continued to foster ties with the design industries after the AMNH's efforts had waned, it is evident that from the beginning in 1915, with its extensive and groundbreaking efforts to inspire students and designers through intimate exposure to its ethnographic collections, the AMNH nonetheless laid an important foundation to what would become a prolonged engagement between New York museums and industry in the years to follow.

Notes

1 Anne Lewis Pierce, "The Man, the Maid and the Machine," *New-York Tribune*, 4 Feb. 1917.

2 M. D. C. Crawford, "True Democracy Means Good Art for All," *Women's Wear*, 26 Nov. 1919.

3 Elizabeth Miner King christened the group this in her article "War, Women, and American Clothes," *Scribner's Magazine* 62, no. 5 (Nov. 1917): 593.

4 M. D. C. Crawford, *The Ways of Fashion* (New York: G. P. Putnam, 1941), 118.

5 Anne Rittenhouse, "Couturiers Under Arms," *Vogue* 44, no. 8 (15 Oct. 1914): 44.

6 M. D. C. Crawford, *The Heritage of Cotton* (New York: Fairchild Publishing Company, 1948), 197. The publisher of *Women's Wear*, E. W. Fairchild, called upon Crawford for "swift action . . . to fill the [design] gap" in reaction to the critical situation of textile design in America. See also Lauren D. Whitley, "Morris De Camp Crawford and American Textile Design, 1916–1921" (master's thesis, Fashion Institute of Technology, 1994), 8–9; Kristin L. Hoganson, *The Global Production of American Domesticity, 1865–1920* (Chapel Hill: University of North Carolina Press, 2007), 58. Hoganson adopts Anderson's term, which represents a shared affinity among different peoples across different geographic regions. See also Marlis Schweitzer, "American Fashions for American Women: The Rise and Fall of Fashion Nationalism," in *Producing Fashion: Commerce, Culture, and Consumers*, ed. Regina Lee Blaszczyk (Philadelphia: University of Pennsylvania Press, 2008), 131 note 2.

7 Mary Clark, *Dyeing for a Living: A History of the American Association of Textile Chemists and Colorists, 1921–1996* (North Carolina: American Association for Textile Chemists and Colorists, 2001), 7. By 1915 the "dye crisis" had commenced; crucial chemical components for bright colors disappeared, resulting in a range of dull colors. See Regina Lee Blaszczyk, "The Colors of Modernism," in *Seeing High and Low*, ed. Patricia Johnston (Berkeley: University of California Press, 2006), 228–46; and Suzanne Benton, "The Silk Industry at War" (master's thesis, Fashion Institute of Technology, 1994), 57.

8 "Making Designers," *Women's Wear*, 19 July 1915.

9 "Making Designers," *Women's Wear*, 22 Oct. 1915.

10 Caroline Rennolds Milbank, *New York Fashion: The Evolution of American Style* (1989; New York: Harry N. Abrams, 1996), 62.

11 "Exhibition of Models by Members of the Designer's Association," *Women's Wear,* 28 July 1915; and "Fashion under Fire," *Vogue* 44 (1 Oct. 1914): 40. See also Jacqueline Field, "Dyes, Chemistry and Clothing," *Dress* 28 (2001): 77–91.

12 Ida M. Tarbell, "An Appeal to American Women," *Silk* 7, no. 12 (Dec. 1914): 59. See also Benton, "The Silk Industry at War."

13 William Laurel Harris, "Industrial Art & American Nationalism," *Good Furniture* 6 (Feb. 1916): 74.

14 Schweitzer, "American Fashions for American Women," 137.

15 As Wendy Kaplan has observed, the movement in the United States embraced the social theories of John Ruskin and William Morris but its idealistic and pre-industrial paradigms often fell prey to industrial modes across diverse markets. Objects could be mechanically produced or handmade and purchased from catalogues, department stores, or through specialty workshops and exhibition societies. See Wendy Kaplan, "America: The Quest for Democratic Design," in *The Arts and Crafts Movement in Europe & America*, ed. Wendy Kaplan (New York and Los Angeles: Thames & Hudson in association with the Los Angeles County Museum of Art, 2004), 246–83.

16 Schweitzer, "American Fashions for American Women," 138–49. Outspoken editor Edward Bok was the driving force behind the campaign that explicitly published American-designed clothing and accessories to rouse national interest for moral and aesthetic aims.

17 William Laurel Harris, "The Varied Industries—What Germany Teaches Us," *Good Furniture* 4 (Nov. 1914): 77; William Leach, *Land of Desire: Merchants, Power, and the Rise of American Culture* (New York: Pantheon, 1994), 94; Whitley, "Morris De Camp Crawford and American Textile Design, 1916–1921," 3; and Whitney Blausen, "In Search of a National Style," in *Disentangling Textiles*, ed. Mary Schoeser (London: Middlesex University Press, 2002), 146. In the first decades of the twentieth century, American silk mills used more raw silk than all the mills of Europe combined, and the clothing industry rapidly increased its production of ready-to-wear garments, but the primary creative direction was still dictated from Paris.

18 Christine Stansell, *American Moderns: Bohemian New York and the Creation of a New Century* (New York: Metropolitan Books, 2000), 15.

19 Jeffrey Trask, *Things American: Art Museums and Civic Culture in the Progressive Era* (Philadelphia: University of Pennsylvania Press, 2012), 104–5.

20 Elizabeth Hutchinson, *The Indian Craze: Primitivism, Modernism, and Transculturation in American Art, 1890–1915* (Durham, NC: Duke University Press, 2009), 112; and Frederick C. Moffatt, "Arthur Wesley Dow and the Ipswich School of Art," *New England Quarterly* 49, no. 3 (Sept. 1976): 348. According to Moffatt, Dow was influenced by the experiences and theories of the ethnologist Frank Hamilton Cushing. Two ideas of particular influence were Cushing's "desire to blend scientific and mystical approaches in the study of ethnographic history and his belief in the cosmic uniformity of art expression." For more on Cushing see Diana Fane, Ira Jacknis, and Lise M. Breen, *Objects of Myth and Memory: American Art at the Brooklyn Museum*, exh. cat. (Brooklyn Museum

in association with University of Washington Press, 1991).

21 W. Jackson Rushing, *Native American Art and the New York Avant-Garde* (Austin: University of Texas Press, 1995), 41.

22 Arthur Wesley Dow, *Composition* (1899; Berkeley and Los Angeles: University of California Press, 1997), 8.

23 Arthur Wesley Dow, "Designs from Primitive American Motifs," *Columbia Teachers College Record* 16, no. 2 (March 1915): 29–34. See also Rushing, *Native American Art*, 43.

24 Ibid., 33. For more on Paul Poiret, see Nancy Troy, *Couture Culture: A Study in Modern Art and Fashion* (Cambridge: MIT Press, 2003); and Harold Koda and Andrew Bolton, *Poiret* (New York and New Haven: The Metropolitan Museum of Art in association with Yale University Press, 2007).

25 Dow, "Designs from Primitive American Motifs," 31. See also Hutchinson, *The Indian Craze*, 117.

26 Rushing, *Native American Art*, 6; and Stansell, *American Moderns*, 45.

27 Holger Cahill, *American Sources of Modern Art*, exh. cat. (New York: Museum of Modern Art, 1933), 8.

28 In his introduction to the 1933 exhibition catalogue, Holger Cahill identifies Weber and the Zorachs as visitors to the AMNH collections ca. 1916. Cahill, *American Sources of Modern Art*, 9; and Letter of Introduction for Winold Reiss, M. D. C. Crawford to Clark Wissler, 24 Nov. 1917, folder 727, Division of Anthropology Archives, American Museum of Natural History (hereafter cited as AA, AMNH). Reiss was interested in sketching models in Sioux warrior garments. For more on Weber's use of the AMNH, see Rushing, *Native American Art*, 43–49.

29 Hutchinson, *The Indian Craze*, 97: The author cites Stella Tillyard for crediting the contributions of the British Arts and Crafts movement to early twentieth-century modernism.

30 Leah Dilworth, *Imagining Indians in the Southwest: Persistent Visions of a Primitive Past* (Washington, DC: Smithsonian Institute Press, 1996), 175.

31 James Clifford, *The Predicament of Culture* (Cambridge and London: Harvard University Press, 1988), 193.

32 Alison Griffiths, *Wondrous Difference* (New York: Columbia University Press, 2002), 4–5.

33 Henry Fairfield Osborn to M. D. C. Crawford, 1 Nov. 1915, Central Archives 10, AMNH Archives. Osborn offered the position as "a token of our appreciation of your interest in this institution and of the important researches that you have already made." See also Whitley, "Morris De Camp Crawford and American Textile Design, 1916–1921," 10.

34 Ibid. *Women's Wear* had chronicled the commercial and social activities of the textile and fashion industries since 1910.

35 George Kubler, "Herbert Spinden," in *Esthetic Recognition of Ancient Amerindian Art* (New Haven: Yale University Press, 1991), 133.

36 J. Eric S. Thompson, introduction to *A Study of Maya Art, Its Subject Matter and Historical Development*, by Herbert J. Spinden (New York: Dover, 1975), vii.

37 Ibid., 132. His theories of culture development based on the chronological ordering of designs would attract criticism by Franz Boas in the preface of *Primitive Art* (1927; New York: Dover Publications, 1955).

38 The curators' use of artifacts from "ancient" American cultures—that is, material derived solely from actual (and perceived) temporally distant societies—created a conceptual space that allowed for a direct appropriation of indigenous materials without competing with the current production of Native art made for the tourist trade. This conforms with Philip Deloria's definition of an "exterior Other" as one "outside of the temporal (and societal) boundaries of modernity . . . representing positive qualities of authenticity and purity" as the "underpinning for a new, specifically modern American identity." By contrast, the "interior Other" represented the "savage qualities" of modern life and by association the integration and acculturation of "primitive" peoples into modern society, see Philip J. Deloria, *Playing Indian* (New Haven and London: Yale University Press, 1998), 103.

39 M. D. C. Crawford, "Creative Textile Art and the American Museum," *American Museum Journal* 17, no. 3 (March 1917): 253.

40 For more contemporary interpretations of American Imperialism from the seventeenth to the end of the twentieth century, see Amy Kaplan and Donald E. Pease, eds., *Cultures of United States Imperialism* (Durham, NC, and London: Duke University Press, 1993).

41 Kris James Mitchener and Marc Weidenmier, "Empire, Public Goods, and the Roosevelt Corollary," *Journal of Economic History* 65, no. 3 (Sept. 2005): 65; and Serge Ricard, "The Roosevelt Corollary," *Presidential Studies Quarterly* 36, no. 1, Presidential Doctrines (March 2006): 18. With the proposal of the Roosevelt Corollary, President Theodore Roosevelt aimed simultaneously to uphold the major tenets of the Monroe Doctrine; assert U.S. dominance in Central America (which included the construction of the Panama Canal), South America, and the Caribbean; and to check any military expansion by Europeans.

42 Richard H. Collin, *Theodore Roosevelt's Caribbean* (Baton Rouge: Louisiana State University Press, 1990), 99. Collin posits that political theories of the United States combined to form a uniquely non-European blend of expansionist, imperialist, and democratic philosophies.

43 Wendy Kaplan, *Designing Modernity: The Arts of Reform and Persuasion, 1885–1945*, exh. cat. (New York: Thames and Hudson; Miami: Wolfsonian Foundation, 1995), 19. Kaplan calls this the National Romantic Movement; in its very nature it was political, though neither conservative nor progressive, and would lead to an intolerance of those not inculcated in native culture.

44 Collin, *Theodore Roosevelt's Caribbean*, xiii. For example Japan and Germany cast their imperialist gaze on Latin America.

45 Harlan I. Smith reflected on Canadian manufactures using "Prehistoric Canadian Art" to impart a national flavor to their commercial products: see Harlan I. Smith to M. D. C. Crawford, 3 March 1920, folder 727, AA, AMNH. Other proponents of this Canadian movement were Marius Barbeau and Edward Sapir. I am grateful to Aaron Glass for this reference.

46 Dilworth, *Imagining Indians in the Southwest*, 185. The author refers to the "postcolonial dilemma" of painters and writers seeking "American" roots to draw upon in opposition to European traditions. However, this position is muddied by the United States' perspective toward the indigenous cultures of the Americas. In this relationship it is perhaps more classically colonial.

47 Herbert J. Spinden to M. D. C. Crawford, 26 March 1919, folder 727, AA, AMNH.

48 Herbert J. Spinden, "Creating a National Art," *Natural History: Journal of the American Museum of Natural History* 19, no. 6 (Dec. 1919): 629 (formerly the *American Museum Journal*).

49 Nicholas Mirzoeff notes Spinden's universal albeit hierarchical approach, which places African cultures at the bottom of seven types of civilizations; see Nicholas Mirzoeff, "Photography at the Heart of Darkness: Herbert Lang's Congo Photographs (1909–15)," in *Colonialism and the Object: Empire, Material Culture and the Museum*, ed. Tim Barringer and Tom Flynn (London and New York: Routledge, 1998), 177.

50 Crawford, "Creative Textile Art and the American Museum," 253.

51 George Herbert Sherwood, "Free Education by the American Museum of Natural History in Public Schools and Colleges," *Miscellaneous Publications of the American Museum of Natural History* 13 (New York: American Museum of Natural History, 1920): 15.

52 Stanley A. Freed, *Anthropology Unmasked: Museums, Science, and Politics in New York City* (Wilmington, OH: Orange Frazer Press, 2012), 2: 653.

53 Ira Jacknis, "Franz Boas and Exhibits," in *Objects and Others*, ed. George W. Stocking, Jr. (Madison: University of Wisconsin Press, 1985), 90.

54 Ibid., 90–94.

55 Jeffrey Trask, "American Things: The Cultural Value of Decorative Arts in the Modern Museum" (PhD diss., Columbia University, 2006), 8; and see Simon J. Bronner, "Object Lessons, The Work of Ethnological Museums and Collections," in *Consuming Visions: Accumulation and Display of Goods in America 1880–1920* (New York: W. W. Norton, 1989), 226.

56 Bronner, "Object Lessons," 224.

57 Ibid.

58 Steven Conn, *Museums and American Intellectual Life, 1876–1926* (Chicago: University of Chicago Press, 1998),

21. Goode's six classes were: "A. museums of art; B. historical museums; C. anthropological museums; D. natural history museums; E. technological museums; F. commercial museums."

59 Hutchinson, *The Indian Craze*, 97; and Leila Mechlin, "Primitive Arts and Crafts Illustrated in the National Museum Collection," in "The Scrip," *International Studio* 35 (Aug. 1908): LXI–LXVI.

60 Elizabeth Cromley, "Masculine/Indian," *Winterthur Portfolio* 31, no. 4 (Winter 1996): 270; and Hutchinson, *The Indian Craze*, chapter 1.

61 Mechlin, "Primitive Arts and Crafts," LXVI.

62 Mary Lois Kissell, "The Textile Museum, Its Value as an Educational Factor" (master's thesis, Teachers College, Columbia University, 1913), 3–4. See also Mary Lois Kissell, "Aboriginal American Weaving," paper presented at The National Association of Cotton Manufacturers, 88th Meeting at the Mechanics Fair Building, Boston, 27 April 1910. For a discussion of the merits of German design education and their application in the U.S., see Ezra Shales, *Made in Newark: Cultivating Industrial Arts and Civic Identity in the Progressive Era* (New Brunswick, NJ, and London: Rivergate Books, 2010).

63 Clark Wissler, "The New American Decorative Art" (1917), folder 26, Division of Anthropology Quarterly and Annual Reports, AA, AMNH.

64 Dow, "Designs from Primitive American Motifs," 29. For more on salvage anthropology, see Diana Fane, "Stewart Culin as Collector," in *Objects of Myth and Memory*, 19.

65 "Costume Exhibition Opens," *New York Times*, 13 Nov. 1919; Freed, *Anthropology Unmasked*, 2: 615.

66 "Museum Notes," *American Museum Journal* 15, no. 1 (Jan. 1915): 32. The accession files in the AMNH Division of Anthropology Archives identifies this as a permanent loan and included the highly regarded Pettich Collection.

67 "Silk Now Less a Luxury than Wool," *New York Times*, 6 Jan. 1918.

68 Department of Anthropology, AMNH, *The Annual Report of the American Museum of Natural History* (New York: American Museum of Natural History, 1916), 47.

69 Clark Wissler, "Report for 1917," 3–4, folder 26, Division of Anthropology Quarterly and Annual Reports, AA, AMNH.

70 "Museum Notes," *American Museum Journal* 17, no. 4 (April 1917): 279. Spinden, along with Sylvanus G. Morley of the Carnegie Institution, partook in an archaeological survey in Central America. By December of that year he sent his collected specimens to the museum; see "Museum Notes," *American Museum Journal* 17, no. 12 (Dec. 1917): 580. Morley and Spinden were also stationed in Central America as U.S. Naval Intelligence agents; see Thompson, introduction to Herbert Spinden, *A Study of Maya Art*.

71 Division of Anthropology Collections Database, AMNH, online. http://anthro.amnh.org/central (accessed 28 Dec. 2010).

72 Ethelwyn Miller, "Americanism the Spirit of Costume

Design," *Journal of Home Economics* 10, no. 5 (May 1918): 208. In this article Miller identifies Mexican, Central American, and South American cultures as American.

73 "Silk Now Less a Luxury Than Wool," *New York Times*, 6 Jan. 1918, and Charles W. Mead, "Peruvian Art: A Help for Students of Design," guide leaflet, no. 46 (New York: American Museum of Natural History, 1917), 3.

74 Sherwood, "Free Education," 15.

75 Frederic A. Lucas, et al., *General Guide to the Exhibition Halls of the American Museum of Natural History* (New York: American Museum of Natural History, 1920), 128.

76 Whitney Blausen, "Textiles by Ruth Reeves" (master's thesis, Fashion Institute of Technology, 1992), 16.

77 "Museum Notes," *American Museum Journal* 18, no. 7 (Nov. 1918): 622.

78 Blausen, "Textiles by Ruth Reeves," 16; and Esther A. Coster, "Decorative Value of American Indian Art," *American Museum Journal* 16, no. 5 (May 1916): 304. A selection of Keramic Society wares, particularly those expressing modern decorative schemes based on the AMNH collection, were featured in an AMNH exhibition in April 1917; see "Seen in New York," *Good Furniture* 8 (June 1917): 322. According to Mira Burr Edson, O'Hara's work was purchased by the AMNH; see Edson, "The Keramic Society of Greater New York," *International Studio* 61 (June 1917): CXXIX.

79 Fry was a student of Dow's and also taught at Columbia and Alfred University; see Nancy E. Green and Jessie J. Poesch, *Arthur Wesley Dow and the American Arts and Crafts* (New York: American Federation of Arts in association with Harry N. Abrams, 1999), 113, 123; and Hutchinson, *The Indian Craze*, 108, 126.

80 Coster, "Decorative Value of American Indian Art," 304; Edson, "The Keramic Society of Greater New York," CXXIX; and "Museum Notes," *American Museum Journal* 17, no. 5 (May 1917): 360.

81 Coster, "Decorative Value of American Indian Art," 304–5. However, the use of indigenous ornament by potters and ceramicists was not novel; the *Keramic Studio* had been publishing articles on the topic since the beginning of the century.

82 Ibid., 307.

83 Griffiths, *Wondrous Difference*, 11.

84 Charles W. Mead, "Techniques of Some Andean Featherwork," *Anthropological Papers of the American Museum* 1 (1907): 1–17.

85 Charles W. Mead, "The Conventionalized Figures of Ancient Peruvian Art," *Anthropological Papers of the American Museum of Natural History* 7, no. 5 (1915): 195–217; and Mead, "Peruvian Art."

86 "Museum Notes," *American Museum Journal* 18, no. 1 (Jan. 1918): 71. The manual was printed in five editions, with the final printing in 1929.

87 Virginia Gardner Troy illustrates Mead and Karasz in *The Modernist Textile* (Hampshire, UK: Lund Humphries, 2006), 80–81.

88 George Peter Murdock, "Clark Wissler, 1870–1947," *American Anthropologist* 50, no. 2 (April–June 1948): 294. Clark Wissler published "Riding Gear of the North American Indians" and "Costumes of the Plains Indians" in 1915 and "Structural Basis to the Decoration of Costumes Among the Plains Indians" in 1916. These three articles were published together in *Anthropological Papers of the American Museum of Natural History* 17 (1917) with "The Basketry of the Papago and Pima," by Mary Lois Kissell.

89 "Indian Bead Motifs are Woven into Modern Designs," *Women's Wear*, 8 Nov. 1919.

90 Hutchinson, *The Indian Craze*, 118. Hutchinson compares Batchelder's texts to Otis T. Mason, *Indian Basketry: Studies in Textile Arts without Machinery* (1904; New York: Dover, 1988). Mason included diagrams of isolated motifs and emphasized weave structure, whereas Batchelder mostly analyzed ornament and symbolism.

91 Dianne Ayres, Timothy Hansen, Beth Ann McPherson, and Tommy Arthur McPherson II, *American Arts and Crafts Textiles* (New York: Harry N. Abrams, 2002), 47. A 1911 article in *Vogue* suggests the popularity of applying isolated Native American designs to modernize the domestic interior; see "Decorating: The Historic in Stenciling," *Vogue* 38, no. 12 (15 Dec. 1911): 90, 92.

92 Hutchinson, *The Indian Craze*, 117–18.

93 Coster, "Decorative Value of American Indian Art," 1916; Clark Wissler, "Moccasin Exhibit in the American Museum," *American Museum Journal* 16, no. 5 (May 1916): 309–14; M. D. C. Crawford, "The Loom in the New World," *American Museum Journal* 16, no. 6 (Oct. 1916): 381–88; Charles W. Mead, "Ancient Peruvian Cloths," *American Museum Journal* 16, no. 6 (Oct. 1916): 389–94; M. D. C. Crawford, "Design and Color in Ancient Fabrics," *American Museum Journal* 16, no. 7 (Nov. 1916): 417–32; Clark Wissler, "A Suggested Study of Costumes," *American Museum Journal* 16, no. 7 (Nov. 1916): 465–67. Crawford also wrote "Peruvian Textiles," *Anthropology Papers of the American Museum of Natural History* 12 (1915): 52–104.

94 Crawford, "Design and Color in Ancient Fabrics," 420.

95 Wissler, "A Suggested Study of Costumes," 467.

96 M. D. C. Crawford to Clark Wissler, 11 April 1916, folder 727, AA, AMNH. Multiple sources name Wissler in addition to Crawford for organizing the lectures, for example, Marion Nicholl Rawson, "American Textile Designs," *American Review of Reviews* 58 (Aug. 1918): 189. Crawford credits Wissler with the initial conception for the lectures; see Crawford, "Design and Color in Ancient Fabrics," 417.

97 M. D. C. Crawford to Clark Wissler, 20 July 1916, folder 727, AA, AMNH: "Doctor Spinden has expressed himself as perfectly willing to do his part. Indeed he has already commenced. He gave the designers for the biggest silk printing industry in the world, a half hour's talk on Mexican Art that made the astute gentleman's mouth water. Well as I know the Doctor's versatility, he arose to

height of which I had not dreamed."

98 Wissler's lecture had a particular influence on fashion designer Ben Kern, who quotes the curator in a letter of gratitude, Ben Kern to Clark Wissler, 24 Dec. 1916, folder 784, AA, AMNH.

99 "Museum Notes," *American Museum Journal* 16, no. 10 (Oct. 1916): 411; and "Specimens from Storage," 7 Sept. 1916, folder 784 (12), AA, AMNH.

100 M. D. C. Crawford to Clark Wissler, 31 Aug. 1916, folder 727, AA, AMNH.

101 See folder 784, AA, AMNH for the documents in this note: "Requests for Lecture Tickets up to Sept. 12th" (Curren requested 15 tickets). See also J. Engel to *Women's Wear,* 17 June 1916; Henry Goldwater to Clark Wissler, 17 June 1916; Georgia Moreland to M. D. C. Crawford, 22 June 1916. Moreland's request included five tickets for a contingent of designers.

102 However, to be clear, the American Arts and Crafts movement was less cohesive than its British counterpart and was defined by diverse activities such as subsistence farming, the mass-production of craft goods, and collecting objets d'art; see Lears, *No Place of Grace*, 61.

103 "Panama Designs for Handkerchief and Tie Silks," *American Silk Journal* 34, no. 5 (May 1915): 33.

104 M. D. C. Crawford, "Producing the Goods in Original American Design," *Women's Wear*, 27 Sept. 1916. MacCurdy illustrated a variety of artifacts and presented an analysis of isolated designs; see George Grant MacCurdy, *A Study of Chiriquian Antiquities,* Memoirs of the Connecticut Academy of Arts and Sciences (New Haven: Yale University Press, 1911).

105 "Panama Designs for Handkerchief and Tie Silks," 33. While the exposition's primary purpose was to celebrate the completion of the Panama Canal, some members of the planning committee had "hoped to develop a cult of prehistoric American art" presented in a new array of textiles, ceramics, and metalwork. See Dow, "Designs from Primitive American Motifs," 33.

106 Blausen, "In Search of a National Style"; Whitney Blausen and Mary Schoeser, "Wellpaying Self Support: Women Textile Designers," in *Women Designers in the U.S.A. 1900-2000*, ed. Pat Kirkham (New Haven and London: Yale University Press in association with Bard Graduate Center, 2000), 146; and Whitley, "Morris De Camp Crawford and American Textile Design, 1916-1921," chapter 4. Blausen and Schoeser articulate the gendered slant to these contests, with 75 percent of the frequent contributors being women, 145-47.

107 Blausen, "In Search of a National Style," 151. For Dow, see Ada Rainey, "An Inspiring Exhibition of American Textiles," *Art and Archaeology* 6 (Nov. 1917): 252.

108 "Designs receiving first, second and third prizes must be adapted from, or inspired by, some specimen or illustration which is accessible to all designers. Designs must be accompanied by statement giving museum number of specimen, or if from library, volume and page," see

"Suggestions For Design Competition," undated (ca. 1916), folder 784, AA, AMNH.

109 See Blausen, "In Search of a National Style"; and Whitley, "Morris De Camp Crawford and American Textile Design, 1916-1921."

110 "Art Notes," *New York Times*, 27 Oct. 1917.

111 M. D. C. Crawford, "Professor Dow Offers to Aid Design School," *Women's Wear*, 22 Jan. 1917. Teachers College had already been substantially working in this direction, including classes, lectures, and workshops (held both at the college and at the Metropolitan Museum) on textile and fashion design taught by Ruth Wilmot and Grace Cornell and "Dyestuffs of the Ancients" by Charles E. Pellew; see Miller, "Americanism the Spirit of Costume Design," 209.

112 Maxwell Armfield, "American Art as an Alphabet for the Entire World," *Women's Wear*, 5 Nov. 1916. While taking a staunch patriotic position in this article, Armfield, like Kissell and Harris before him, also cited Germany as a useful model for design education.

113 Crawford, "Creative Textile Art and the American Museum," 258.

114 For more on the culture of Greenwich Village in the first quarter of the twentieth century, see Deborah Saville, "Freud, Flappers and Bohemians," *Dress* 30 (2003): 63-79.

115 William Laurel Harris, "Mobilization in the World of Art and Industry," *Good Furniture* 8 (May 1917): 249-58.

116 Crawford, "Creative Textile Art and the American Museum," 255; and M. D. C. Crawford, "Industrial Art Exhibition Portrays Progress of Costume and Fabric Designing," *Women's Wear*, 7 Nov. 1919. See also Whitley, "Morris De Camp Crawford and American Textile Design, 1916-1921," 55.

117 Crawford, "Industrial Art Exhibition Portrays Progress of Costume and Fabric Designing."

118 Madelyn Shaw, Jacqueline Field, and Marjorie Senechal, *American Silk, 1830-1930: Entrepreneurs and Artifacts*, Costume Society of America Series (Lubbock: Texas Tech University Press, 2007), 202.

119 "New All-American Silks Shown in the National Museum," *American Silk Journal* 33, no. 3 (March 1914): 63: "The designs comprise the Aztec moon in rainbow tones on blues and taupe; the Aztec armadillo and arrow pattern in colors on peacock-blue; Kortez—[inspired by] an Aztec hieroglyph—on dark green and satin-striped white taffeta; the Aztec coat-of-arms on navy blue; and an allover design of Mexican feathers in shades of blue, green, and brown." See also Shaw, *American Silk, 1830-1930*, 214; and Charles W. Hurd, "Mallinson Campaign to Popularize American-made Styles," *Printers' Ink* 92, no. 10 (2 Sept. 1915): 74. M. C. Migel & Co. was renamed H. R. Mallinson & Co. on 1 Jan. 1915; see Shaw, *American Silk, 1830-1930*, 179, and biography in this volume, page 115. The Mexixe series was released under the Migel name.

120 Crawford, "Creative Textile Art and the American Museum," 255.

121 M. D. C. Crawford to Clark Wissler, 28 June 1916, folder 727, AA, AMNH.

122 M. D. C. Crawford to Clark Wissler, 31 Jan. 1917, folder 727, AA, AMNH. Design Director C. A. Frutchey promised half-yard samples of the designs to the museum "as part of the permanent exhibit we are planning." It is possible that the some of the series was inspired by Frutchey's tenure as a judge for the textile competitions at the Panama-Pacific Exhibition two years earlier, "Business Notes," *New York Times*, 24 April 1915.

123 Clark Wissler to M. D. C. Crawford, 22 Oct. 1917, folder 727, AA, AMNH.

124 Stansell, *American Moderns*, 215.

125 King, "War, Women, and American Clothes," 596: "From the American buyer's viewpoint the Parisian models on the American market now are weak, weak in inspiration and freshness, and at higher prices In the first years of the war the grip was not so keenly felt along the Rue de la Paix. To-day the couturiers are in temperamental straits. Their touch is sadly dulled."

126 Ibid., 594.

127 Troy, *Couture Culture*, 32–33, 133. See also Hoganson, *The Global Production of American Domesticity*, 66–72, where the author observed the appropriation of "Eastern" and European folk styles by French designers beginning in the late nineteenth century.

128 King, "War, Women, and American Clothes," 594.

129 M. D. C. Crawford to Clark Wissler, 30 Nov. 1917, folder 727, AA, AMNH. Crawford sent Wissler a copy of his *Vogue* article "A New Source of Costume Inspiration," on how the museum could influence design.

130 Emil Her Many Horses, "Portraits of Native Women and Their Dresses," in *Identity by Design*, exh. cat. (New York and Washington, DC: HarperCollins in association with the Smithsonian National Museum of the American Indian, 2007), 44. From the 1870s on, yokes covered in beadwork were trademarks of dresses by Sioux women.

131 Dress Up Bureau Advertisement, "Lady or Squaw," *Women's Wear*, 22 Sept. 1916.

132 Dress Up Bureau Advertisement, "Dress Up," *Women's Wear*, 6 Oct. 1916.

133 "Imperialist Nostalgia occurs . . . where civilized nations stand duty bound to uplift so-called savage ones. In this ideologically constructed world of ongoing progressive change, putatively static societies become a stable reference point for defining . . . civilized society. . . . Such forms of longing thus appear closely related to secular notions of progress." Renato Rosaldo, "Imperialist Nostalgia," *Representations* 26 (Spring 1989): 108.

134 William H. Sabine to Frederic Lucas, 25 Aug. 1916, Central Archives 10, AMNH Archives. Sabine credits Mr. Lew Hahn with overseeing the photography session.

135 Arguably the artifacts hailing from the Philippines could fall under the curators' definition of American, as the islands were annexed by the United States in 1898. However, research has not confirmed that they viewed them as equal to those from indigenous cultures of the Western Hemisphere.

136 Frank Spencer, "Some Notes on the Attempt to Apply Photography to Anthropometry during the Second Half of the Nineteenth Century," in *Anthropology & Photography: 1860–1920*, ed. Elizabeth Edwards (New Haven: Yale University Press, 1994), 99.

137 Johanna C. Scherer, "The Photographic Document: Photographs as Primary Data in Anthropological Inquiry," in *Anthropology & Photography: 1860–1920*, ed. Elizabeth Edwards (New Haven: Yale University Press, 1994), 35.

138 Christa C. Mayer Thurman, "Textiles: As Documented by the Craftsman," in *The Ideal Home: The History of Twentieth-Century American Craft, 1900–1920*, ed. Janet Kardon (New York: Harry N. Abrams, Inc., 1993), 101, 105.

139 Deborah Saville, "Dress and Culture in Greenwich Village," in *Twentieth-Century American Fashion*, ed. Patricia A. Cunningham and Linda Welter (Oxford and New York: Berg, 2005), 38.

140 Saville, "Freud, Flappers and Bohemians," 67. Saville defines artistic dress as garments of long robes of silk and sandals, often including peasant embroideries.

141 "Dressing on a Limited Income," *Vogue* 54, no. 9 (1 Nov. 1919): 92.

142 N. N., "Art: A Right Way to Use Museums," *The Nation* (20 Dec. 1919): 804.

143 Saville, "Freud, Flappers and Bohemians," 65–67.

144 Confidential Report to Dr. Wissler on the Movement to Create Design in America, n.d., folder 727, AA, AMNH. Also, classes given by The Metropolitan Museum of Art were held in the New York store. Henry W. Kent to Charles Caldwell, 11 April 1916, folder Crawford, Morris De Camp correspondence file, Office of the Secretary Records, The Metropolitan Museum of Art Archives.

145 I would like to thank Ashley Callahan for bringing this sketchbook to my attention. In her book *Modern Threads: Fashion and Art by Mariska Karasz* (Athens: Georgia Museum of Art, 2007), 24 note 20, Callahan addresses the challenges of attributing a date to this sketchbook, but assigns these drawings to the period where Karasz was engaged in the activities at the AMNH.

146 Karasz was likely citing Kenneth Milton Chapman, "The Evolution of the Bird in Decorative Art," *Art and Archaeology* 4, no. 6 (Dec. 1916): 307–16.

147 Negatives of illustrations from Herbert Spinden's March 1917 lecture. Images 220896–220899, AMNH Library.

148 Callahan, *Modern Threads*, 24.

149 Ibid., 22–26.

150 "Maya Designs the Latest Vogue," *American Silk Journal* 36, no. 3 (March 1917): 39; "A Modern Maya Maid," *Women's Wear,* 31 Jan. 1917. See also Whitley, "Morris De Camp Crawford and American Textile Design, 1916–1921," 50. *Women's Wear* illustrated the series release almost daily at the end of January and into early Feb. 1917.

151 "Launches a Style," *Merchants Record and Show Window*

40, no. 3 (March 1917): 11; "Maya Designs the Latest Vogue," 39; Leach, *Land of Desire*, 103.

152 Hutchinson, *The Indian Craze*, 40.

153 "Launches a Style," 11.

154 M. D. C. Crawford to Frederic Lucas, 9 Aug. 1917, Central Archives 10, AMNH Archives.

155 "Loaned to Edgar [sic] L. Mayer," 15 June 1918, folder 846, AA, AMNH.

156 David Aaron to Herbert J. Spinden, 8 Nov. 1918, folder 702, AA, AMNH, and "Loaned to Otto Kahn," 6 Oct. 1919, folder 872, AA, AMNH.

157 Clark Wissler to Richard Bach, 6 Dec. 1923, folder 745, AA, AMNH.

158 "Museum Notes," *American Museum Journal* 18, no. 1 (Jan. 1918): 74; and M. D. C. Crawford, "Museum Documents and Modern Costume," *American Museum Journal* 18, no. 4 (April 1918), 286. Crawford notes the influence of an AMNH 1918 temporary exhibition of over 150 African, Southeast Asian, and American Indian garments on fashion designers in a letter to Wissler, M. D. C. Crawford to Clark Wissler, 9 Jan. 1918, folder 727, AA, AMNH.

159 Crawford, "Museum Documents and Modern Costume," 288–90; and Callahan, *Modern Threads*, 22. The illustrations are credited to John Wanamaker; no individual designer is identified. Whitley notes a special department under the direction of "Miss Moreland" created "artistic costumes," to be sold at Wanamaker stores; see Whitley, "Morris De Camp Crawford and American Textile Design, 1916–1921," 52–53.

160 Crawford, "Museum Documents and Modern Costume," 295.

161 M. D. C. Crawford, "A New Source of Costume Inspiration: Designers Adapt to the Beauties of Primitive Arts to the Actualities of Modern Life," *Vogue* 50, no. 11 (1 Dec. 1917): 88.

162 Richard Bach, "The Artificial Vogue in Decoration," *Good Furniture* 10 (Feb. 1918): 111.

163 Crawford, "Creative Textile Art and the American Museum," 253.

164 Trask, *Things American*, 123.

165 Geo. N. Pindar, press release, 25 Sept. 1919, folder 874, AA, AMNH.

166 "Department of Anthropology Report," 1 Oct.–31 Dec. 1919, folder 874, AA, AMNH.

167 Herbert J. Spinden to Henry Fairfield Osborn, 17 June 1919, Central Archives 130, AMNH Archives. Also included in the exhibition was the prototype for a circulating loan collection of specimen photographs, technical illustrations of weaving processes, and drawings of "primitive" designs from a global set of cultures. This is now housed in the AMNH Library, "Spinden Collection of Art Designs."

168 Herbert J. Spinden, *American Museum of Natural History Exhibition of Industrial Art in Textiles and Costumes* (New York: American Museum of Natural History, 1919), 3.

169 Both halls were located on the first floor of the museum near the 77th Street entrance; see Stanley A. Freed,

Anthropology Unmasked, 1: 410.

170 Herbert J. Spinden to M. D. C. Crawford, 8 July 1919, folder 727, AA, AMNH.

171 Henry Fairfield Osborn, "The Coming Fifty Years: Report of the President," *The Annual Report of the American Museum of Natural History* (New York: American Museum of Natural History, 1920), 50.

172 Spinden, *Exhibition of Industrial Art in Textiles and Costumes*, 5.

173 M. D. C. Crawford, "Industrial Art Exhibition to Feature Important Displays," *Women's Wear*, 8 Oct. 1919. Included was a small array of vegetable-dyed yarn by Emile Bernat, conservator for the Museum of Fine Arts, Boston, and offering a striking alternative to the much sought-after chemical dyes. Looms described in the exhibition catalogue; see Spinden, *Exhibition of Industrial Art in Textiles and Costumes*, 12.

174 Herbert J. Spinden, "The Teaching of Industrial Art," *Harvard Alumni Bulletin* 22 (23 Oct. 1919): 103.

175 "Lecture read by Mr. Bond to members of the Forum, Biltmore," 20 Nov. 1919, folder 874(5), AA, AMNH.

176 Textile historian Madelyn Shaw notes that Burnham Slaughter donated a small group of Mallinson textiles to the Brooklyn Museum but that there is no evidence she authored the designs; see Shaw, *American Silk, 1830–1930*, 204.

177 The design is attributed to Ryther in M. D. C. Crawford, "The Designer and the Textile Industry," *House Beautiful* (Jan. 1919): 15, 17. This article also features a design by Coulton Waugh inspired by the Peruvian collection.

178 Jacknis, "Franz Boas and Exhibits," 98.

179 Herbert J. Spinden to Henry Fairfield Osborn, 19 July 1919, Central Archives, AMNH Archives.

180 Patricia Mears, "Jessie Franklin Turner: American Fashion and 'Exotic' Textile Inspiration," in *Creating Textiles: Makers, Methods and Markets; Proceedings of the Sixth Biennial Symposium of the Textile Society of America, Inc.* (New York, 1998), ed. Madelyn Shaw (Earleville, MD: Textile Society of America, 1999), 433.

181 Ibid., 435.

182 "Received from Brooklyn Institute Museum," 11 Nov. 1919, folder 874, AA, AMNH.

183 "Modern Design Technique Based on Ancient Ornament," *Women's Wear*, 10 April 1920. Clipping from Culin Archival Collection, General Correspondence [1.4.010], 4/1920, Brooklyn Museum Archives. The Kevorkian Gallery was also a lender to the exhibition; their examples of Coptic, Persian, and Turkish textiles, garments, and rugs were installed in Turner's display as well as others, like Otto Kahn.

184 Spinden, *Exhibition of Industrial Art*, 7.

185 Ibid., 6.

186 M. D. C. Crawford, "Design Department," *Women's Wear*, 16 Oct. 1919, unpaginated clipping, Culin Archival Collection, General Correspondence [1.4.004], 9/1919–10/1919, Brooklyn Museum Archives.

187 Spinden, *Exhibition of Industrial Art*, 6. Evenk was previously called Lamut, the latter being how the garment was identified in the exhibition image.

188 M. D. C. Crawford, "Design Department," *Women's Wear*, 12 Nov. 1919.

189 William W. Fitzhugh and Aron Crowell, *Crossroads of Continents: Cultures of Siberia and Alaska* (Washington, DC and London: Smithsonian Institution Press, 1988), 298.

190 Spinden, *Exhibition of Industrial Art*, 7.

191 "Loaned to Otto Kahn," 6 Oct. 1919, folder 702, AA, AMNH.

192 M. D. C. Crawford, "Design Department," *Women's Wear*, 18 Nov. 1919; and Spinden, *Exhibition of Industrial Art*, 7.

193 Spinden, *Exhibition of Industrial Art*, 7.

194 Loan to J. Wise, 22 Oct. 1919, folder 872, AA, AMNH.

195 Spinden, *Exhibition of Industrial Art*, 8.

196 Ibid., 10.

197 Ibid.

198 Herbert J. Spinden to Frank Phillips, 6 Dec. 1919, folder 874, AA, AMNH; and "Loan to Wm. Filenes Sons Company," 26 Dec. 1919, folder 872, AA, AMNH.

199 Herbert J. Spinden, "Series of Photographs from the First Exhibition of American Textiles, Costumes, and Mechanical Processes," *Natural History: Journal of the American Museum of Natural History* 19, no. 6 (1919): 632.

200 P. E. Goddard to Frederic Lucas, 11 Aug. 1917, Central Archives 10, AMNH Archives.

201 P. E. Goddard to Frederic Lucas, 11 Nov. 1919, Central Archives 130, AMNH Archives.

202 Ibid.

203 Director Dr. [Frederic] Lucas to Herbert J. Spinden, 13 Nov. 1919. Central Archives 130; AMNH Archives. These elements were quickly removed from the exhibit, see also Leach, *Land of Desire*, 166.

204 Director Dr. [Frederic] Lucas to Herbert J. Spinden, 13 Nov. 1919, Central Archives 130, AMNH Archives.

205 For more on life groups at the AMNH, see Griffiths, *Wondrous Difference*; and Jacknis, "Franz Boas and Exhibits," 1985.

206 Spinden, *Exhibition of Industrial Art*, 10. Other exhibitors that fell outside of the exhibition's scope were the Paterson Chamber of Commerce, with its array of silk products, and the local textile manufacturer Sidney Blumenthal and Co.'s plain and decorative velvets.

207 However Cheney Bros. did include a roller-printed silk with a design based on a malachite stone specimen in the museum. Coulton Waugh was mentioned by name in the exhibition catalogue to the dismay of Cheney Bros. representatives who wanted to preserve the illusion of the manufacturer as the designer, see Herbert Spinden to M. L. Havey, 15 Dec. 1919, folder 874, AA, AMNH.

208 M. D. C. Crawford, "Design Department," *Women's Wear*, 14 Nov. 1919.

209 "Notes on Current Art," *New York Times*, 28 Sept. 1919.

210 Helen Bullitt Lowry, "High Art Home-Made, or Paris Robbed of Her Prey," *New York Times*, 9 Nov. 1919.

211 "American Art and American Fashions," *New York Times*, 30 Nov. 1919.

212 N. N., "Art: A Right Way to Use Museums," 804.

213 Ibid. The issue of American industry is again addressed later in a discussion of the competency of the American silk producers, notably the expediency with which their products were able to compete with German dyes.

214 Stansell, *American Moderns*, 241–46. The "New Woman" was coined to describe the burgeoning class of late nineteenth- and early twentieth-century feminist, educated, sexually liberated, and career-minded women.

215 Spinden, *Exhibition of Industrial Arts*, 8.

216 Division of Anthropology, Quarterly Report, 1 Oct.–31 Dec. 1919, folder 28, AA, AMNH.

217 M. D. C. Crawford to Henry Fairfield Osborn, 17 Nov. 1919, Central Archives 10, AMNH Archives.

218 Spinden, "Series of Photographs from the First Exhibition of American Textiles, Costumes, and Mechanical Processes," 633.

219 Henry Fairfield Osborn to Clark Wissler, 5 Feb. 1920, folder 878, AA, AMNH; and Whitley, "Morris De Camp Crawford and American Textile Design, 1916–1921," 15.

220 Henry Fairfield Osborn to Clark Wissler, 5 Feb. 1920, folder 878, AA, AMNH.

221 M. D. C. Crawford, "Completely Equipped and Modern Commercial Museum Planned," *Women's Wear*, unpaginated clipping, Women's Wear correspondence file, Office of the Secretary Records, The Metropolitan Museum of Art Archives.

222 For more on the Philadelphia Commercial Museum, see Conn, *Museums and American Intellectual Life*, chapter four.

223 M. D. C. Crawford, "Completely Equipped and Modern Commercial Museum Planned."

224 Herbert Spinden to Richard Bach, 2 April 1920, folder 745, AA, AMNH. Bach initiated the correspondence to foster more transparent cooperation between the two institutions' design education initiatives. Spinden was supportive, acknowledging the complementary nature of the two collections, however, he was quick to distinguish anthropology from fine art, stating that the latter considers "art in an absolute sense and are perfectly willing to neglect all historical or cultural problems in presenting objects of beauty. We [anthropologists] feel that this attitude is entirely false." See Richard Bach to Herbert Spinden, 24 March 1920; and Herbert Spinden to Richard Bach, 2 April 1920, both folder 745, AA, AMNH.

225 Freed, *Anthropology Unmasked*, 2: 763.

226 Ibid., 2: 787, 869.

227 M. D. C. Crawford to Henry Fairfield Osborne, 15 Feb. 1921, Central Archives 10, AMNH Archives.

228 See Whitley, "Morris De Camp Crawford and American Textile Design, 1916–1921."

229 Ibid., 22. For more on Culin, see Freya Van Saun, "The Road to Beauty: Stewart Culin and the American Clothing and Textile Industries" (master's thesis, Bard Graduate Center, 1999); and Deirdre E. Lawrence, "Fashion World and How it Has Been Influenced by Ethnographic

Collections in Museums," *Documentation of Nordic Art* (Paris: K. G. Saur, 1993), 140–53.

230 Board of Estimate and Apportionment, City of New York, "No. 96," 15 April 1921, AMNH Central Archives 171.642d, AMNH Archives.

231 The resolution requested that the museums "extend the same assistance and courtesies now being extended to other branches of scientific work." Board of Estimate and Apportionment, City of New York, "Cal. No. 115," 1 July 1921, Women's Wear correspondence file, Office of the Secretary Records, The Metropolitan Museum of Art Archives.

232 Henry Fairfield Osborn to Fiorello La Guardia, 27 April 1921, Central Archives 171.642d, AMNH Archives.

233 Frederic Lucas to James Matthews, Assistant Secretary, Board of Estimate and Apportionment, 13 July 1921, Central Archives 171.642d, AMNH Archives.

234 William Laurel Harris to Henry Fairfield Osborne, 12 April 1923, Central Archives 53.120, AMNH Archives.

235 Clark Wissler to George H. Sherwood, 17 April 1923; and George H. Sherwood to William Laurel Harris, 26 April 1923, both in Central Archives 46.120, AMNH Archives.

236 See for example, Richard Bach to F. A. Lucas, 15 Feb. 1921; Clark Wissler to H. W. Kent, 19 Sept. 1923; H. W. Kent to George Sherwood, 12 Nov. 1923; H. W. Kent to Clark Wissler, 20 Nov. 1923; Bach to Sherwood, 4 Dec. 1923; and Wissler to Bach, 8 Dec. 1923, all in folder 745(2), AA, AMNH.

237 Henry W. Kent to Clark Wissler, 20 Nov. 1923, folder 745(2), AA, AMNH.

238 "Loaned to Mrs. A. Rice," 24 May 1922; and "Loaned to Miss E. Hamburger, Bonwit Teller & Co.," 1 June 1922, both folder 702, AA, AMNH. Bonwit Teller used these loan objects as props for a window display; however it is unclear if they were also used in the design of the garments. "Loan to M. D. C. Crawford," 22 July 1922, folder 727, AA, AMNH.

239 Department of Anthropology, "Report for the Department of Anthropology for the Year 1926," Annual Report—1926, folder 35, AA, AMNH.

240 "Indian Designs and Colors for Silks," *American Silk Journal* 44, no. 5 (May 1925): 43.

241 K. L. Green, "American Silk Designs by Prominent Artists," *American Silk Journal* 44, no. 11 (Nov. 1925): 47.

242 Lola S. McKnight, "The Americana Prints: A Collection of Artist-Designed Textiles" (master's thesis, Fashion Institute of Technology, 1993), 101. The line was presented alongside the initial drawings and a line of dresses created from the textiles at the New York Art Center on 31 Oct. 1925. Helen Sargeant Hitchcock to Stewart Culin, 31 Oct. 1925, Culin Archival Collection, General Correspondence [1.4.100], 11/1925, Brooklyn Museum Archives.

243 McKnight, "The Americana Prints," 101.

244 Joan Brancale, interview with the author, 4 March 2010.

245 Michelle Boardman, *All That Jazz: Printed Fashion Silks of the '20s and '30s*, exh. cat. (Allentown, PA: Allentown Art Museum, 1998), 17.

246 See for example, "Design made after a sketch of little Indian girl's dress (Cheyenne Indian) Plains Tribe, at AMNH." Notations on another photograph included "Iroquois Indian Pattern, after Museum of the American Indian objects." Both photographs are in a box of archival material related to Walter Mitschke in the Museum of Fine Arts, Boston, Department of Prints, Drawings, and Photographs.

247 Madelyn Shaw, "American Silk from a Marketing Magician: H. R. Mallinson & Co.," in *Silk Roads, Other Roads: Proceedings of the 8th Biennial Symposium of the Textile Society of America, Inc.* (Northampton, MA, 2002): 8.

248 The designer of the pajamas and textile manufacturer are unidentified. The slubbed quality of the silk and likeness to their 1917 textile design suggest the Central Textile Co. as a manufacturer, but an accurate attribution is not possible.

249 M. D. C. Crawford, "Museum of Costumes, New School of Designer," *Women's Wear*, 1 Oct. 1918, 3; and Van Saun, "The Road to Beauty." Interestingly, when Spinden succeeded Culin as head of the department in 1929, he sought to develop the collections from "the Mayas and the Peruvians of Central and South America and the Old World from the tribes of Siberia and Indonesia . . . that the Brooklyn Museum shall have balanced collections of applied art." See Nancy B. Rosoff, "As Revealed by Art: Herbert Spinden and the Brooklyn Museum," *Museum Anthropology* 28, no. 1 (March 2005): 44–56.

250 Edward L. Mayer, "Costume Sketches," vols. 1–7, the Brooklyn Museum Library. Special Collections. Fashion and Costume Sketch Collection.

251 See Christine Wallace Laidlaw, "The Metropolitan Museum of Art and Modern Design: 1917–1929," *Journal of Decorative Arts and Propaganda Arts* 8 (Spring 1988): 88–103.

252 See Spinden, "Creating a National Art," 622–29.

253 Stewart Culin, *Primitive Negro Art, Chiefly from the Belgian Congo*, exh. cat. (Department of Ethnology, Brooklyn Museum, 1923), 51. Blanck and Co. and David Aaron & Co. also supplied "Congo-inspired" textiles and embroidery. Naturally, Crawford featured these designs in *Women's Wear*, "Cotton Frocks Shown by Bonwit Teller & Co. Related in Design to African Art," *Women's Wear*, 14 April 1923.

254 Trask, *Things American*, 211–23; and Laidlaw, "The Metropolitan Museum of Art and Modern Design."

Mariska Karasz. Sketchbook featuring Indigenous American bird motif, ca. 1917. Courtesy of Solveig Cox. Cat. 23.

Evolution of bird design

K. M. Chapman

Pueblo [?]

adala de
Chamberlain

Selected Biographies

Ann Marguerite Tartsinis
with Alison Kowalski and Sophia Lufkin

M. D. C. Crawford
(1883–1949)

A native of New York City, M. D. C. (Morris De Camp) Crawford dedicated his career to connecting designers with museums. After attending Williams College, he worked for the wholesalers Horace B. Caflan & Co. and Lawrence Taylor & Co., agents for cotton converters Lonsdale Mills and W. B. Conrad & Co.[1] In 1915 Fairchild Publications hired Crawford as a research editor for *Women's Wear*—a position he would hold for most of his career. An amateur historian of Peruvian textiles, he was a research associate at the American Museum of Natural History (AMNH) from 1915 to 1921. During this period he also formed a lasting relationship with Stewart Culin, curator of ethnology at the Brooklyn Museum.

After his departure from the AMNH, Crawford immersed himself in design-related activities at the Brooklyn Museum until Culin's death in 1929. From 1939 to 1948 he was honorary advisor of the Industrial Arts Division and helped establish the influential Edward C. Blum Laboratory.[2] He was a cofounder of the Museum of Costume Art in 1937 (now The Costume Institute at The Metropolitan Museum of Art) and was its vice president from about 1938 to 1939.[3] He also held a research position at the Rosenwald Foundation's Museum of Science and Industry in Chicago and headed the Fairchild Fashion Library.[4] In addition to a series of articles for the AMNH's *American Museum Journal*, he contributed to numerous publications on women's fashion and the textile industry.[5]

Charles W. Mead
(1845–1928)

Born in Boston, Charles Williams Mead worked with Frederic Ward Putnam at the Harvard Peabody Museum of Archaeology and Ethnology. When Putnam became head of the AMNH Department of Archaeology and Ethnology in 1894, Mead followed him to New York,[6] working first as a cataloger in 1897, assistant in the Department of Ethnology by 1905, and assistant curator of Peruvian archaeology by 1912.[7] In 1905 he was also appointed head of the South American collection by Clark Wissler.

Mead was a key figure in making the ethnographic collections accessible to designers and artists. His *American Museum Journal* articles and design manual, "Peruvian Art: A Help for Students of Design" (1917), garnered interest in the AMNH collections. In 1926, at the age of eighty, he was required to retire, and was named honorary curator of Peruvian archaeology. He continued to work at the museum and welcomed interested students, designers, and artists to his office to view Andean and Peruvian textiles until his death in 1928.

Herbert J. Spinden
(1879–1967)

Herbert Joseph Spinden was born in Huron, South Dakota. He studied anthropology with Roland Dixon, Frederick Putnam, and Alfred Tozzer at Harvard University (1902–9). During this period, he excavated Mandan mounds in North Dakota for the Harvard Peabody Museum of Archaeology and Ethnology, which later published his revised thesis, *A Study of Maya Art*, in 1913.[8] In 1909 he was appointed assistant curator of anthropology at the AMNH, where he participated in the Archer M. Huntington Survey (1909–13) and research trips to Central America (1914–18). He also promoted design education

at the museum from 1916 to 1920, lecturing on Mesoamerican art and design, and organizing the 1919 *Exhibition of Industrial Art in Textiles and Costumes*. He was curator of Mexican archaeology at the Harvard Peabody Museum (1921–25), curator of anthropology at the Buffalo Museum of Natural Sciences (1925–29), and curator of ethnology and director of education at the Brooklyn Museum (1929–35).[9] At Brooklyn he inherited a collection of predominantly Native American, Asian, and Eastern European artifacts amassed by his predecessor, Stewart Culin. Spinden tailored his collecting to Central and South America. In 1935 he renamed the Brooklyn Museum's ethnology department the Department of American Indian Art and Primitive Cultures.[10] He continued his efforts to inspire American designers with artifacts from the Americas by crafting his permanent displays expressly to highlight universal design principles.[11] Spinden also developed a local outreach program, the Brooklyn School Service, and participated in numerous cultural projects with the Office of the Coordinator of Inter-American Affairs, including a six-month lecture tour to South America (1941) and traveling exhibitions on Latin American art.[12] He co-organized the 1931 *Exposition of Indian Tribal Arts* with painter John Sloan and collector and philanthropist Abby Aldrich Rockefeller, among others.[13] He retired from the Brooklyn Museum in 1951.

Clark Wissler
(1870–1947)

Clark Wissler was curator of anthropology at the AMNH for thirty-five years. Born in rural Indiana, he studied experimental psychology at Indiana University (BA 1897, MA 1899).[14] After graduation, he was employed by Columbia University as an assistant in psychology (1899–1900), followed by an appointment as a university fellow in psychology (1900–1) and later received his PhD in psychology (1901). While studying at Columbia, Wissler took several courses with anthropologists Franz Boas and

Livingston Farrand and shortly after graduating, his professional focus shifted from psychology to anthropology. From 1903 to 1909, Wissler served as an assistant and lecturer in anthropology at Columbia. In 1902 he was appointed assistant in the Department of Ethnology at the AMNH, becoming assistant curator, department chair (1905), and eventually curator of ethnology in 1906. A year later he became curator of anthropology, a position he held until he retired in 1942. From 1924 to 1940 he also taught in the anthropology and psychology departments at Yale University.

Wissler's chief contributions to anthropological theory related to the development of a more nuanced definition of culture, resulting in the concepts of age-area, culture area, and the universal pattern of culture. Despite his more socio-anthropological interests, he sponsored research and collecting expeditions, an ambitious publication program, and supported his department's educational activities, especially the courting of industry and designers from 1915 to 1919. He published on the symbolism, clothing, and decorative arts of the Blackfoot and Plains Indians—potent sources of inspiration for American designers—as well as children's education, physical anthropology, archaeology, material culture, and indigenous mythology until his death in 1947.[15]

Designers

———

Harry Collins
(active ca. 1914–48)

A leading dressmaker in New York from the 1910s to the 1940s, Harry Collins believed that good taste should be accessible to all and sought to cultivate a unique American expression through his custom designs. He gained early prominence for his garments' originality—billing himself as "creator of art in dress"—and

his emphasis on elegant lines and form.[16] As his career developed, he was increasingly active in the New York design community, hosting fashion shows, benefits, and conferences.[17] He also designed costumes for large Broadway performances in the late 1910s.[18] In 1919 Collins participated in the *Exhibition of Industrial Art in Textiles and Costumes*, presenting dresses featuring Andean-inspired fabrics and Native American Blackfoot motifs.

Collins achieved national recognition, especially after designing the inaugural dress for First Lady Florence Harding in 1921.[19] Two years later, he published the home-sewing guide *The ABC of Dress*. He also worked as a designer for the Universal Film Manufacturing Company and in 1928, despite his successful New York–based career, he moved to Los Angeles to focus on costume design for Hollywood film studios.[20] Seven years later Collins returned to New York and resumed his custom atelier, receiving critical praise into the late 1940s.

Ilonka Karasz
(1896–1981)

Ilonka Karasz was a Hungarian-born designer known for her contributions to the fields of textiles, illustration, furniture, and decorative arts. She was one of the first women accepted into the Royal School of Arts and Crafts in Hungary.[21] In 1913 she immigrated to New York, quickly immersing herself in the bohemian culture of Greenwich Village, and establishing a reputation as a vibrant and accomplished artist. She taught at the Modern Art School in New York with textile artists Marguerite Zorach and Martha Ryther.[22] She contributed illustrations to *Modern Art Collector* (*M.A.C.*, 1915–18), a journal produced by the Society of Modern Art, which she had co-founded in 1914; *Bruno's Weekly* (1915–16); and *Playboy: A Portfolio of Art and Satire* (1919–24).

Items in the AMNH collections inspired several of Karasz's fabric designs that featured handicraft techniques such as batik, block prints,

and embroidery. H. R. Mallinson & Co. purchased and produced a number of her submissions to the *Women's Wear* design contests.[23] From the 1920s on, she became more involved in industrial design, including interiors, furniture, silver, book covers, and lighting. In the 1930s, Karasz became increasingly recognized for her interiors, such as the Fifth Avenue Playhouse and the Junior League's reception room at the Barbizon Hotel. She continued to design textiles that were used by designers such as Gilbert Rohde and Donald Desky, and created wallpaper designs after the late 1940s. Karasz is also known for her 186 covers for *The New Yorker* from 1925 to 1973, which serve as yet another milestone in a long and varied career.

Mariska Karasz
(1898–1960)

Born in Budapest, Hungary, Mariska Karasz was an émigré fashion designer during the first half of the twentieth century.[24] Younger sister of Ilonka Karasz, Mariska began sewing at an early age.[25] She joined her mother and sister in New York in 1914 and soon studied under Ethel Traphagen at the Cooper Union Art School. In the mid-1910s she worked in the design department of the John Wanamaker department store and then for Jessie Franklin Turner's custom salon at Bonwit Teller & Co. She participated in the project at AMNH to stimulate American design at the encouragement of M. D. C. Crawford. Karasz independently sold her blouse designs in small downtown shops and, after a spate of success, she left Bonwit Teller to open her own studio on Madison Avenue.[26]

With the birth of her daughters in 1931 and 1932, she shifted her focus to children's clothing to much acclaim. After World War II, she began producing embroidered fiber art and was featured in over sixty solo exhibitions throughout the 1950s. Karasz was also a prolific author, writing the children's book *See and Sew, a Picture Book of Sewing* (1943), the slightly more advanced *Design and Sew* for teenagers (1946),

Adventures in Stitches: A New Art of Embroidery (1949), and *How to Make Growing Clothes for Your Baby* (1952).

Edward L. Mayer
(1865–1953)

Born in Davenport, Iowa, Edward Mayer was a highly regarded wholesale designer of ready-to-wear garments in the early twentieth century. At fourteen Mayer was employed as a button sorter in Philadelphia.[27] He later worked at Mandel Brothers and Marshall Field & Company in Chicago, before moving to New York in 1902 to found his eponymous wholesale design and manufacturing firm,[28] where he became known for his creative style and attention to form and fit.[29] A frequent *Women's Wear* design contest juror, he was an active proponent of the utility of museums for designers and drew upon the collection of the Brooklyn Museum through the late 1910s and 1920s.[30] His company contributed contemporary clothing designs to the Brooklyn Museum's exhibition *Primitive Negro Art: Chiefly from the Belgian Congo* in 1923.[31]

Heralded as one of the highest quality firms in the industry, Edward L. Mayer wholesale designs were sold by such exclusive stores as Jay Thorpe in New York.[32] By 1927 Mayer expanded his firm and factory to Woodside, Queens, where he employed 350 workers.[33] In 1930 *Vogue* dubbed him the "dean of American manufacturers" for his smart, fashion-forward garments and innovative textile printing techniques.[34] He retired a year later, focusing on women's labor reform and philanthropy until his death in 1953.[35]

Harriet Meserole
(1893–1989)

Harriet Meserole attended Pratt Institute in New York beginning in 1912.[36] After graduating three years later, she worked at the John Wanamaker department store designing ephemera, housewares, and fashion accessories. She spent most of her career engaged in freelance work for a number of publications and firms, producing illustrations for *Women's Wear* and newspaper advertisements for Bonwit Teller & Co., Franklin Simon, and Lord & Taylor. While working for *Women's Wear* she was an active participant in the activities at the AMNH. Most notable were Meserole's numerous covers and illustrations for *Vogue* from 1919 to 1930. Reflecting on her career in 1981, she acknowledged the influence of Paul Poiret, Raul Dufy, and the *Gazette du Bon Ton*. During the Depression, high production costs and the preference for photographic covers caused *Vogue* and other magazines to abandon their traditional cover styles, making it harder for professional illustrators like Meserole to find work. However, beginning in 1930 and continuing to 1952 she worked for the magazine's sister company, *Vogue Patternbook*.

In 1941 Meserole entered the Museum of Modern Art's Industrial Design Contest for Home Furnishings, later renamed the *Organic Design in Home Furnishings* contest and exhibition, where two of her textile designs were shown, one winning honorable mention.[37] She also illustrated the home furnishing guide *Furniture for Your Home* (1946) with Gladys Miller. Shortly before her death in 1989, a selection of her *Vogue* covers were included in the Whitney Museum's 1984 exhibition *The Feminine Gaze: Women Depicted by Women, 1900–1930*.[38]

Max Meyer
(1876–1953)

A prominent German-American fashion designer, Max Meyer was a partner and designer for the wholesale fashion house A. Beller & Co. until he retired in 1929.[39] Born in Alsace, Meyer immigrated to the United States as a child and at fourteen began working at A. Beller.[40] Founded in 1890,[41] A. Beller was famous for its luxurious evening coats, feminine suits, and tweed ensembles.[42] Located on West 26th Street in New York, exclusive shops and department stores such as Bonwit Teller & Co. and Neiman Marcus stocked

A. Beller wares.[43] With Meyer at the helm, A. Beller was one of the preeminent manufacturers of women's ready-to-wear clothing at a time when custom design houses dominated the industry.[44] Although wholesale garments were typically sold under a retailer's own label, the company was so prestigious that even the more discerning stores willingly marketed these garments under the A. Beller name.[45]

Meyer was involved with the campaigns at the AMNH and, later, at the Brooklyn Museum to educate designers. An ardent industry reformer, Meyer supported progressive minimum wage laws, worker's compensation, and better workplace standards for the garment industry. In 1931, New York Governor Franklin D. Roosevelt appointed him to a special commission on medical compensation for workers.[46] He was a member of the Labor Board of the National Recovery Administration (1933), chairman of the Millinery Code Authority (1934), chairman of the Millinery Stabilization Commission (1937), and a member of the New York Board of Mediation (1937). He supported the establishment of the Central High School of Needle Trades and was one of the founders of the Fashion Institute of Technology (FIT), where he served as chairman of the board of trustees (1951) and president of the college (1952).[47]

Ruth Reeves
(1892–1966)

The project of the AMNH to inspire designers with ethnographic objects had a profound impact on designer and artist Ruth Reeves. Born in Redlands, California, Reeves studied at Pratt Institute in Brooklyn (1910), The California School of Design in San Francisco (1911–13), and the Art Students League in New York (1913–14), after which she worked as a batik artist.[48] Bonwit Teller & Co. purchased her designs and Mary Mowbray-Clarke likely sold her textiles at her New York bookstore, the Sunwise Turn. Mowbray-Clarke's husband, John, introduced Reeves to M. D. C. Crawford around 1916. This

led her to work as an illustrator for *Women's Wear* and facilitated her use of the study collections of AMNH and the Brooklyn Museum. She also contributed to the Metropolitan Museum's Annual Exhibitions of American Industrial Art in 1920 and 1921.[49] Soon after, she moved to Paris to study with painter and sculptor Fernand Léger.[50]

Reeves returned to the United States in 1927, after which H. R. Mallinson & Co. and W. & J. Sloane of New York produced a number of her textile designs. In 1932 she designed carpets and wall-coverings for Radio City Music Hall. Two years later she studied in Guatemala with a travel grant from the Carnegie Institution.[51] This fruitful period of research resulted in an ambitious exhibit in 1935 of Guatemalan textiles and costumes, photographs by Henry Clay Gipson, watercolors by Honor Spingarn, and woven and printed textiles of Reeves's design.[52]

That year, with Romana Javitz, head of the New York Public Library Picture Collection, Reeves helped establish the Index of American Design, a vast catalogue of American art and craft traditions predating 1890, under the Federal Art Project of the Works Progress Administration.[53] Reeves taught at Columbia University School of Painting and Sculpture and The Cooper Union School of Art. In 1956 Reeves relocated to India and spent the next ten years cataloging traditional handicraft techniques for the Indian government until her death in 1966.

Martha Ryther (Kantor)
(1896–1981)

Born in Boston, Martha Ryther moved to New York at the age of nineteen. At the suggestion of her former art teachers Charles and Maurice Prendergast she began studying under sculptors William Zorach and Hugo Robus at the Modern Art School in Greenwich Village, where she would later teach batik (1917–18).[54] Ryther used the batik technique to push the limits of scale and representation. Like many of her contemporaries, she sold her designs at the local progres-

sive bookshop, the Sunwise Turn.[55] She exhibited at the Carnegie Institution's exhibition of Modern Applied Art in 1918,[56] won a number of prizes in *Women's Wear* design contests, worked for Belding Brothers, and was a staff designer for H. R. Mallinson & Co. from 1918 to the mid-1920s.[57] Ryther, who was also recognized for her oil painting and theater costumes,[58] served in the mid-1930s as vice president of the progressive New York Society of Women Artists[59] and was a founding member of the American Designers Gallery.[60] After the 1940s she became known for her paintings on glass.[61]

Ryther's first husband was an artist and the editor of *Art News,* Jock Fulton.[62] In 1928 she married the artist Morris Kantor.[63] The couple lived in Manhattan and in the artists' enclave of South Mountain Road in New City, New York, (at times also home to Ruth Reeves, Henry Varnum Poor, and the Robuses), where in nearby Rockland, Ryther taught art for twenty-five years.[64]

Hazel Burnham Slaughter
(1888–1979)

From Hartford, Connecticut, Hazel Burnham Slaughter originally pursued a career in fine art in New York City, but after winning many awards in the *Women's Wear* design contests she embarked on a career in textile design.[65] Beginning in the late 1910s, Slaughter's batik designs for dress fabrics received particular acclaim. Her batik dresses were exhibited at the AMNH *Exhibition of Industrial Art in Textiles and Costumes*. To better acquaint herself with the use of novelty or patterned textiles by fashion designers, she worked for a year for manufacturer Edward L. Mayer.[66] Cheney Bros. Silks produced many of her designs, and in 1923 the company sent Slaughter to Egypt to study the recent excavations of Tutankhamen's Tomb in an effort to further stimulate innovative American design.[67] Slaughter later returned to oil and watercolor painting, which she exhibited in New York galleries from the 1930s until at least 1960.[68]

Mary Tannahill
(1863–1951)

Born in North Carolina, as a child Mary Tannahill moved with her family to New York City, where she was exposed to many of the celebrated artists and educators of her time, notably American impressionist painter J. Alden Weir, painter Harry Siddons Mowbray, Arts Students League artist and teacher Kenyon Cox, and educator Arthur Wesley Dow.[69] Before World War I, she studied in Germany and beginning in 1916, had a studio in Provincetown, Massachusetts.[70] Around September 1919 she was the head of the "batik group" at Columbia University's Teachers College.[71] Her paintings and designs for textiles, garments, and hooked rugs were shown in numerous exhibitions, including the Modern Applied Art exhibition at the Carnegie Institution in 1918, and shows at the Art Alliance of America in New York, the Brooklyn Museum, and Knoedler Galleries.[72] From at least 1927 to 1942 she was active in the New York Society of Women Artists.[73]

Jessie Franklin Turner
(1881–1956)

Originally from Saint Louis, Jessie Franklin Turner worked as a lingerie clerk at a Peoria, Illinois department store while she attended junior college, and then as a lingerie buyer for the St. Louis department store Scruggs, Vandervoort & Barney.[74] Around 1910, she moved to New York City, where she worked for James McCutcheon and Company, a lingerie and linens firm.

By 1915 Turner had joined the design staff of Bonwit Teller & Co. and from 1919 to 1923 she produced garments for an eponymous label, Winifred Warren, Inc., and Bonwit Teller.[75] She frequented the study rooms at the AMNH and the Brooklyn Museum and was a member of the committee for the AMNH's 1919 *Exhibition of Industrial Art in Textiles and Costumes*, where she exhibited garments under the Winifred

Warren label. Her exposure to non-Western objects inspired designs for her luxurious tea gowns and negligees citing Coptic, Turkish, Southeast Asian, and Persian motifs. Turner continued to draw inspiration from non-Western sources throughout her career and her garments were often featured in *Vogue* in the early 1920s.[76]

After leaving Bonwit Teller, in 1923 Turner opened her own salon at 410 Park Avenue. Known for her custom dress fabrics and flowing, sinuous tea gowns and evening dresses, her designs were noted as the height of style in the 1930s.[77] African and Koryak (Siberian) garments from the AMNH anthropology collection, which she had first used in 1917, also influenced her designs for the 1940 Museum of Costume Art (now The Costume Institute at The Metropolitan Museum of Art) exhibition, *A Designer's Exhibition of Costume and Millinery Designs Derived from Museum Documents*.[78] Turner retired two years later in 1942.

J. Wise
(active ca. 1915–22)

Little is known about J. Wise, who ran her own fashion design company specializing in women's, misses', and children's dresses and waists located on 33rd Street in New York. Both the AMNH and the Brooklyn Museum loaned museum artifacts to the company from 1919 to 1922.[79] The J. Wise Company exhibited embroidered garments based on AMNH artifacts at the 1919 *Exhibition of Industrial Art in Textiles and Costumes* a selection of which was illustrated in the accompanying issue of *Natural History* in December 1919.[80]

Manufacturers and Department Stores

―――

Bonwit Teller & Co.
(est. 1895)

American department store chain Bonwit Teller & Co. experienced its peak successes in the early twentieth century. Founded by Paul Bonwit (1862–1939) in 1895, the firm went through several iterations until Bonwit joined with Edmund D. Teller (1867–1916) in 1898.[81] By 1907, specializing in high-end women's clothing, the store was officially incorporated as Bonwit Teller & Co., and occupied a prominent retail location on New York's so-called Ladies' Mile on Sixth Avenue.[82]

Paul Bonwit was friendly with M. D. C. Crawford and supported his efforts to promote American industry.[83] After a widely publicized all-American design contest by the *New York Times* in 1913, the store proudly advertised "American-made Bonwit creations" as a selling point for those interested in promoting American fashion.[84] In the mid-1920s Bonwit Teller continued to support American manufacturers by marketing their garments alongside French models.[85]

Bonwit Teller was successful nationwide, with branches from Miami to Newport, Rhode Island.[86] By the 1950s, however, Bonwit Teller had begun to lose ground to competitors, and after decades of slipping profits and several buyouts, the store filed for bankruptcy in 1990.[87]

Cheney Bros. Silks
(est. 1841)

One of the leading producers of silk upholstery, drapery, and clothing of the late nineteenth and early twentieth centuries, the Cheney Brothers silk mill was founded in 1841 in Mt. Nebo, Connecticut.[88] The firm ran a large-scale operation; as of 1922 they employed over 4,000 workers in their Manchester, Connecticut mills.[89]

In the 1910s, Cheney began employing artists

as product designers and sought to align its silk designs with the fine arts.[90] Representatives from the company frequently visited the AMNH study collections, and the firm produced a line of silks inspired by Peruvian and Siberian artifacts, as well as a line based on malachite samples in the mineral collection, examples of which were exhibited at the 1919 *Exhibition of Industrial Art in Textiles and Costumes*. They also exhibited designs at each of the Metropolitan Museum's nine annual industrial art exhibitions from 1917 to 1925.[91] The firm opened a new showroom on Madison Avenue in 1925.[92] A year later, Cheney eschewed its more conservative reputation and commissioned painter Georgia O'Keefe to contribute to an advertising campaign for a new line of silks by art director Henri M. Creange.[93] After World War II, Cheney Brothers struggled under mounting production and labor costs as well as the arrival of synthetic fabrics. Faced with rising prices and competition, the firm was sold to J. P. Stevens in 1955 and ultimately closed in 1984.[94]

David Aaron & Co. Embroideries (est. ca. 1885)

David Aaron (1865–1930) was a German-American manufacturer who ran a successful embroidered textile firm in New York in the early twentieth century.[95] He immigrated to Birmingham, Alabama, and later relocated to New York by 1885. Shortly thereafter he opened the embroidered textile firm David Aaron & Co. at 115 West 26th Street.

David Aaron & Co. contributed to the activities of the AMNH and the Brooklyn Museum in the late 1910s and early 1920s and exhibited at the 1919 *Exhibition of Industrial Art in Textiles and Costumes.* Aaron served on the exhibition planning committee.[96] In 1923 the company designed embroidered textiles based on African art displayed in the *Primitive Negro Art: Chiefly from the Belgian Congo* exhibition at the Brooklyn Museum.[97] The company closed shortly before Aaron's death in 1930.

H. R. Mallinson & Co. (est. 1915)

Hiram Royal Mallinson (1871–1931) joined Newitter & Migel Silk Company in 1897, and after numerous changes in partnership the company was reincorporated as H. R. Mallinson & Co. in 1915.[98] The firm then went on to become one of the largest and most productive American silk manufacturers of the early twentieth century.

Many of Mallinson's designs reflect the influence of museum collections. Beginning with its 1914 Mexixe series of printed silks, the firm's creative director, E. Irving Hanson (1879–1955), regularly visited the AMNH study rooms for design inspiration. Mallinson participated in many of the Designed in America activities. Most notably it purchased and produced many of the submissions to the *Women's Wear* design contests and went on to hire winners Alfred J. Heinke (1884–1956) and Martha Ryther. Mallinson also displayed silks at the 1919 *Exhibition of Industrial Art in Textiles and Costumes* and the Metropolitan Museum's annual Exhibitions of American Industrial Art from 1920 to 1925.[99]

In 1928 the company released its American Indian series of silk prints based on the pottery, beadwork, feather work, and costumes of fifteen different Native American cultures. Independent designer Walter Mitschke (1886–1972) designed the series except for "Hopi Indian Motives," a pattern conceived by Leon Bakst just before his death in 1924.[100] Mitschke, a German-American freelance illustrator and designer for textiles, wallpaper, and advertisements, immigrated to the United States in 1893 and had a successful New York studio into the 1960s.[101] In addition to the American Indian series, he designed prints for both the Mallinson Playgrounds of the World and Early American series.

Mallinson's influence in contemporary fashion cannot be overstated. French designers imported their wares and countless American stage performers dressed exclusively in Mallinson silks; their garments were routinely shown in fashion shows and museum exhibi-

tions. Much of the firm's success derived from its effective advertising campaigns, which included glamorous trade names, sumptuous print advertisements, and their trademark *Blue Book* catalogues. Despite such early successes, rising production costs precipitated the firm's bankruptcy in 1936.

Johnson, Cowdin & Co. (est. before 1898)

Johnson, Cowdin & Co. was a ribbon firm based in Paterson, New Jersey. The firm had a large silk mill and weaving school in Phoenixville, Pennsylvania, and a showroom on 30th Street in New York.[102] The company exhibited a ribbon loom and its wares in the *Textile Industries of New Jersey* exhibition at the Newark Museum in 1916.[103] The firm also participated in the activities at the AMNH as early as 1917, sending its business manager Mr. MacLaren, mill expert Mr. Jacobs, and designer Emil Speck to assess the utility of the museum's collection.[104] The relationship was fruitful and continued through the 1919 *Exhibition of Industrial Art in Textiles and Costumes*, which featured a Johnson, Cowdin & Co. ribbon loom and contemporary designs. In 1922 the firm merged with three other ribbon firms—Walter Emmerich, Tremont Mills, and Bay View Ribbon Co.—which significantly consolidated the industry.[105]

John Wanamaker (Philadelphia, est. ca. 1876; New York, est. 1896)

John Wanamaker was a Philadelphia-born garment retailer. In 1896, he bought the A. T. Stewart Emporium department store in New York, and expanded the property as the New York branch of his Philadelphia John Wanamaker department store.[106] Much of the store's success came from Wanamaker's effective marketing and retail strategies. The Wanamaker store featured numerous departments, ranging from antiques to dry goods to

Ford automobiles, and later, in 1925, airplanes.[107] Capitalizing on the cachet of French fashion, Wanamaker created a "Coin de Paris" (Parisian Corner) section of the store, which featured Parisian designs in American sizes, designed for the American figure.[108]

Wanamaker also was active in promoting American design, and displayed New York–based and in-house designs alongside fashionable European imports.[109] He was a strong supporter of the relationship between New York museums and the design industry. Under the guidance of silk department design director Charles A. Frutchey and fashion designer Mary Walls, Wanamaker's designers frequently visited the study collections at the AMNH and in 1916 The Metropolitan Museum of Art held a textiles workshop at Wanamaker's store to engage designers with museum objects. The most pronounced evidence of Wanamaker's use of the museum was its series of "Maya" fashions released with typical Wanamaker theatrical flair in 1917.

In the late 1920s, the New York store expanded to open new branches throughout the city.[110] After the death of Wanamaker in 1922 and his son Rodman in 1928, the store underwent a short period of success and suburban expansion, then a slow decline marked, for example, by the closing of its flagship New York store in 1954 and numerous changes of ownership until its ultimate sale to Hecht's Department Store in 1995.[111]

1 "Morris Crawford, Fabrics Authority," obituary, *New York Times*, 25 June 1949.

2 M. D. C. Crawford to Edward Cahill, 1 Sept. 1944, Crawford, Morris De Camp correspondence file, Office of the Secretary Records, The Metropolitan Museum of Art Archives; and Brooklyn Museum, Guide to the Department of Costumes and Textiles, 1911–2004. Crawford was assisted in his many pursuits by his wife, Elizabeth Goan Crawford, who also worked at Fairchild Publications and inherited his duties at the Brooklyn Museum.

3 "Costume Exhibit Closes," *New York Times*, 7 June 1938; "Morris Crawford, Fabrics Authority."

4 "Morris Crawford, Fabrics Authority."

5 See Lauren D. Whitley, "Morris De Camp Crawford and American Textile Design, 1916–1921" (master's thesis, Fashion Institute of Technology, 1994).

6 "Charles W. Mead, Archaeologist, Dies," obituary, *New York Times*, 4 Feb. 1928.

7 Stanley A. Freed, *Anthropology Unmasked: Museums, Science, and Politics in New York City* (Wilmington, OH: Orange Frazer Press, 2012), 2: 867.

8 J. Eric S. Thompson, introduction to Herbert J. Spinden, *A Study of Maya Art, Its Subject Matter and Historical Development* (New York: Dover, 1975), v.

9 Nancy B. Rosoff, "As Revealed by Art: Herbert Spinden and the Brooklyn Museum," *Museum Anthropology* 28, no. 1 (2005): 47.

10 Ibid., 51.

11 Jane Corby, "Curators of Culture," *Brooklyn Eagle*, 5 Apr. 1939, unpaginated clipping, Brooklyn Museum Library Collection. BMA Institutional Files. Herbert J. Spinden File.

12 Rosoff, "As Revealed by Art," 53.

13 Thompson, introduction, vii; and W. Jackson Rushing, *Native American Art and the New York Avant-Garde* (Austin: University of Texas Press, 1995), 98.

14 Unless otherwise noted, the information for this biography is from Freed, *Anthropology Unmasked*, 2: 607.

15 George Peter Murdock, "Clark Wissler, 1870–1947," *American Anthropologist* 50, no. 2 (April–June 1948): 296–303.

16 Harry Collins advertisement, *Vogue* 51, no. 7 (7 April 1918): 19.

17 "The Ritz-Carlton Fashion Fête: Harry Collins Models for Two Lenten Matinees," *American Cloak and Suit Review* 21 (March 1921): 138–39; "American Designer's Fashions for Spring: Influences which Will Determine the Trend," *American Silk Journal* 33 (Dec. 1914): 31–32.

18 Harry Collins, *Internet Broadway Database* ibdb.com/person.php?id=414360 (accessed 31 May 2013).

19 Harry Collins, preface, *The ABC of Dress* (New York: Modern Modes Corporation, 1923).

20 Michelle Tolini Finamore, *Hollywood before Glamour: Fashion in American Silent Film* (New York and Basingstoke, Hampshire: Palgrave Macmillan, 2013), 115; Lois Shirley, "Your Clothes Come from Hollywood," *Photoplay* 35, no. 3 (Feb. 1929): 131; Barbara Scott Fisher, "Harry Collins' Emphasis on 'Line' Important in His Career as Designer," *Christian Science Monitor*, 19 Sept. 1946.

21 Unless otherwise noted the information in this biography is from Ashley Callahan, *Enchanting Modern: Ilonka Karasz (1896–1981)*, exh. cat. (Athens: University of Georgia Press, 2003).

22 Roberta K. Tarbell, *Hugo Robus (1885–1964)*, exh. cat. (Washington, DC: Smithsonian Press for the National Collection of Fine Arts, 1980), 42.

23 Callahan, *Enchanting Modern*, 41.

24 Unless otherwise noted, the information in this biography is from Ashley Callahan, *Modern Threads: Fashion and Art by Mariska Karasz*, exh. cat. (Athens: Georgia Museum of Art, 2007), 15–27.

25 Beryl Williams, *Fashion is Our Business* (Philadelphia and New York: J. B. Lippincott Company, 1945), 175.

26 Ibid., 176.

27 Gabriel Goldstein and Elizabeth Greenberg, eds., *A Perfect Fit: The Garment Industry and American Jewry, 1860–1960* (New York: Yeshiva University Press, 2005), 54.

28 Ibid.; "Edward L. Mayer," obituary, *New York Times*, 14 May 1953.

29 Caroline Rennolds Milbank, *New York Fashion: The Evolution of American Style* (New York: Harry N. Abrams, 1996), 54.

30 M. D. C. Crawford, *The Heritage of Cotton* (New York: Fairchild Publishing, 1948), 201.

31 Stewart Culin, *Primitive Negro Art: Chiefly from the Belgian Congo*, exh. cat. (Brooklyn: Department of Ethnology, Brooklyn Museum, 1923), 51.

32 Milbank, *New York Fashion*, 77; "The Unseen Label: The Contribution of the American Wholesale Designers," *Vogue* 76, no. 9 (27 Oct. 1930): 66.

33 Goldstein and Greenberg, *A Perfect Fit*, 54.

34 "The Unseen Label: The Contribution of the American Wholesale Designers," 102.

35 "Edward L. Mayer," 29; "Devise Intercode Plan," *New York Times*, 27 Jan. 1935.

36 Unless otherwise noted the information in this biography is from John Touhey (interviewer), "The Reminiscences of Harriet Meserole," 21 Oct. 1981, in the Oral History Collection of The Fashion Institute of Technology.

37 MoMA press release 41130-7, 1 Feb. 1941, online press release archive, www.moma.org (accessed 6 June 2013).

38 William Zimmer, "Female Artists Depict Shifting View of Women," *New York Times*, 23 Sept. 1984.

39 Milbank, *New York Fashion*, 64; Goldstein and Greenberg, *A Perfect Fit*, 52–53.

40 Goldstein and Greenberg, *A Perfect Fit*, 52–53.

41 Milbank, *New York Fashion*, 64.

42 Goldstein and Greenberg, *A Perfect Fit*, 53.

43 Milbank, *New York Fashion*, 96; Goldstein and Greenberg, *A Perfect Fit*, 53.

44 Milbank, *New York Fashion*, 59.

45 Goldstein and Greenberg, *A Perfect Fit*, 53.

46 "Max Meyer Dies; Labor Mediator," obituary, *New York Times*, 1 Feb. 1953.

47 FIT, Special Collections (x-146) Finding Aid, Biography of Max Meyer.

48 Unless otherwise noted, the information in this biography is from Whitney Blausen, "Textiles Designed by Ruth Reeves" (master's thesis, Fashion Institute of Technology, 1992).

49 The Metropolitan Museum of Art, Exhibitions of Work by Manufacturers and Designers: 1917–1923, continued as American Industrial Art: Annual Exhibitions, 1924–26 (New York: Metropolitan Museum of Art, 1917–26).

50 Karen Davies, *At Home in Manhattan*, exh. cat. (New Haven, CT: Yale University Art Gallery, 1983), 54.

51 "Designers Borrow Patterns from Ancient America," *Science News Letter*, 6 April 1935.

52 See Ruth Reeves, *Guatemalan Exhibition of Textiles and Costumes*, exh. cat. (New York: National Alliance of Art and Industry, 1935).

53 Virginia Clayton Tuttle, Elizabeth Stillinger, and Erika Doss, *Drawing on America's Past: Folk Art, Modernism, and the Index of American Design* (Chapel Hill: University of North Carolina Press, 2002), 5.

54 Hilton Kramer, "Martha Kantor, 84; Painted on Glass," *New York Times*, 10 Jan. 1981; John Caldwell, "Martha Ryther Retrospective to Provide Aid to Fund," *New York Times*, 22 Nov. 1981; Martha Ryther, "Artist Biographical Profile," Martha Ryther, Brooklyn Museum Library Collection. Clark S. Marlor Artist Files. Roberta Tarbell interviewed Ryther (Kantor), 25 Feb. 1978, see Tarbell, *Hugo Robus*, 42 note 129.

55 Tarbell, *Hugo Robus*, 42.

56 Ibid., 43.

57 Theodore Lynch Fitzsimons, "The Revival of Batik," *International Studio* 61 (June 1917): 110–12; and "Art at Home and Abroad," *New York Times*, 27 Jan. 1918.

58 Madelyn Shaw, "Mallinson Silk and the Fabrics de Luxe," in *American Silk: 1830–1930*, ed. Jacqueline Field, Marjorie Senechal, and Madelyn Shaw (Lubbock, TX: Texas Tech University Press, 2007), 204; Whitney Blausen and Mary Schoeser, "Wellpaying Self Support: Women Textile Designers," in *Women Designers in the U.S.A. 1900–2000*, ed. Pat Kirkham, exh. cat. (New Haven and London: Yale University Press and the Bard Graduate Center, 2000), 146–47.

59 Sheldon Cheney, "News of Theatre Art and Artists," *Theatre Arts* 1 (1917): 143; Edward Alden Jewell, "Exhibition Opened by Women Artists," *New York Times*, 25 March 1941.

60 "Women Radicals Open Art Exhibit," *New York Times*, 3 Feb. 1935; "Art Notes: News of Activities Here and There," *New York Times*, 3 Jan. 1937.

61 Jewell, "Exhibition Opened by Women Artists."

62 Caldwell, "Martha Ryther Retrospective"; and Tarbell, *Hugo Robus*, 42 note 129.

63 Kramer, "Martha Kantor, 84; Painted on Glass."

64 Caldwell, "Martha Ryther Retrospective"; and Tarbell, *Hugo Robus*, 44–45.

65 Peter H. Falk, Audrey M. Lewis, Georgia Kuchen, Veronika Roessler, "Hazel Burnham Slaughter," in *Who was Who in American Art 1564–1975: 400 Years of Artists in America* (Madison, CT: Sound View Press, 1999), 3059; M. D. C. Crawford, "Cheney Designer Being Sent to Egypt, Won Many Women's Wear Design Award," *Women's Wear*, 15 Feb. 1923. Unpaginated clipping from Culin Archival Collection, General Correspondence [1.4.045], 2/1923, Brooklyn Museum Archives.

66 A Mayer design from 1918 features a textile by Slaughter; see M. D. C. Crawford, "Museum Documents and Modern Costume," *American Museum Journal* 18, no. 4 (April 1918): 292.

67 "Girl Designer Here Wins Scholarship to Study Fashions from the Tomb of Tut-ankh-Amen," *New York Times*, 13 Feb. 1923.

68 "Small Paintings on View," *New York Times*, 5 May 1932; and "Art: Decorative Action," *New York Times*, 23 Jan. 1960.

69 William S. Powell, "Tannahill, Mary Harvey," in *The Dictionary of North Carolina Biography*, vol. 6 (Chapel Hill: University of North Carolina Press, 1996), 1.

70 Ibid.

71 "Batik Applied to Modern Dress and Interior Decoration," *American Cloak and Suit Review* 18 (September 1919): 133.

72 "Art at Home and Abroad," *New York Times*, 27 Jan. 1918; Powell, "Tannahill, Mary Harvey," 1; "Museum Acquisitions," *New York Times*, 22 July 1928.

73 "Women Artists," *New York Times*, 13 March 1927; "Women Radicals," *New York Times*, 3 Feb. 1935; Edward Alden Jewell, "Exhibition Opened by Women Artists," *New York Times*, 12 Jan. 1937.

74 Unless otherwise noted, the information for this biography is from Patricia E. Mears, "Jessie Franklin Turner: American Fashion and 'Exotic' Textile Inspiration," paper presented at the Sixth Biennial Symposium of the Textile Society of America, Inc., The Fashion Institute, New York, 23–26 Sept. 1998, as reproduced in *Creating Textiles: Makers, Methods and Markets*, The Textile Society of America, 1998, 432.

75 Milbank, *New York Fashion*, 86.

76 See, for example, "Robes D'Interieurs," *Vogue* 58 (1 Dec. 1921): 64; and "For Hours of Ease," *Vogue* 59 (1 May 1922): 51.

77 Milbank, *New York Fashion*, 86, 122.

78 *A Designer's Exhibition of Costume and Millinery Designs Derived from Museum Documents*, held from 15 Oct– 2

Nov. 1940, exhibition folder, The Costume Institute Library, The Metropolitan Museum of Art.

79 Arthur Rice to Brooklyn Museum, 16 May 1922, Culin Archival Collection, General Correspondence [1.4.034], 5/1922, Brooklyn Museum Archives.

80 Herbert J. Spinden, "Series of Photographs from the First Exhibition of American Textiles, Costumes, and Mechanical Processes," *Natural History: Journal of the American Museum of Natural History* 19, no. 6 (Dec. 1919): 643, 647, 653.

81 Isadore Barmash, "Company News; Australians Buy Bonwit Teller," *New York Times*, 1 May 1987; and "Edward Teller," obituary, *New York Times*, 16 Feb. 1916.

82 Milbank, *New York Fashion*, 32.

83 Crawford, *The Ways of Fashion*, 232.

84 Milbank, *New York Fashion*, 61.

85 Ibid., 96.

86 Crawford, *The Ways of Fashion*, 239–40.

87 Isadore Barmash, "The Decline of Bonwit Teller: Did Time Pass Retailer By?" *New York Times*, 14 Apr. 1990.

88 Marjorie Senechal, "From Jamestown to Northampton," in *American Silk: 1830–1930*, ed. Jacqueline Field, Marjorie Senechal, and Madelyn Shaw (Lubbock, TX: Texas Tech University Press, 2007), 28.

89 H. H. Manchester, *The Story of Cheney Silk* (New York: Cheney Brothers, 1924), 44.

90 Regina Lee Blaszczyk, "The Colors of Modernism," in *Seeing High and Low*, ed. Patricia Johnson (Berkeley: University of California Press, 2006), 230–31.

91 The Metropolitan Museum of Art, Exhibitions of Work by Manufacturers and Designers.

92 "New Silk Showroom for Cheney Brothers," *New York Times*, 15 Oct. 1925.

93 Blaszczyk, "The Colors of Modernism," 228.

94 Susan Barlow, "The Cheney Silk Mills," Manchester Historical Society, http://www.manchesterhistory.org/reprints/MHS3_CheneySilkMills.html (accessed 5 June 2013).

95 Unless otherwise noted, the information in this biography comes from "David Aaron Dies in Vienna: Retired Manufacturer of Embroidery Victim of Heart Disease," *New York Times*, 24 June 1930.

96 David Aaron to Herbert J. Spinden, 8 Nov. 1918, folder 702, AA, AMNH; David Aaron to Stewart Culin, 3 Jan. 1919, Culin Archival Collection, General Correspondence [1.4.001], 11/1918 to 2/1919, Brooklyn Museum Archives.

97 Stewart Culin, *Primitive Negro Art*, 51.

98 Unless otherwise noted the information in this biography is from Madelyn Shaw, part 3, in *American Silk: 1830–1930*, 171–251; and "M. C. Migel & Co. Change Name to H. R. Mallinson & Co.," *American Silk Journal* 34 (Jan. 1915): 34.

99 The Metropolitan Museum of Art, Exhibitions of Work by Manufacturers and Designers.

100 Katherine Gibson, "Textile Designs by Leon Bakst,"

Design-Keramic 31, no. 6 (Nov. 1929): 111.

101 Joan Brancale, interview with the author, 10 June 1913.

102 "Industrial Notes," *Trenton Evening Times*, 7 Oct. 1898; and "J. C. Ribbons: America's Best," advertisement, Johnson, Cowdin & Co., Inc., 1920.

103 Ezra Shales, *Made in Newark: Cultivating Industrial Arts and Civic Identity in the Progressive Era* (New Brunswick, NJ: Rivergate Books, 2010), 194.

104 M. D. C. Crawford, "Creative Textile Art and the American Museum," *American Museum Journal* 17, no. 3 (March 1917): 255.

105 "4 Big Ribbon Makers in $5,000,000 Combine," *New York Times*, 12 July 1922.

106 Milbank, *New York Fashion*, 32, 64.

107 Gene Boyo, "Wanamaker to Close Main Store after 58 Years on Broadway," *New York Times*, 26 Oct. 1954.

108 Milbank, *New York Fashion*, 97.

109 Ibid., 64.

110 William Leach, *Land of Desire: Merchants, Power, and the Rise of a New American Culture* (New York: Pantheon, 1994), 283.

111 Jane M. Von Bergen, "Wanamakers Will Become Hecht's," *Philadelphia Inquirer*, 9 Aug. 1995.

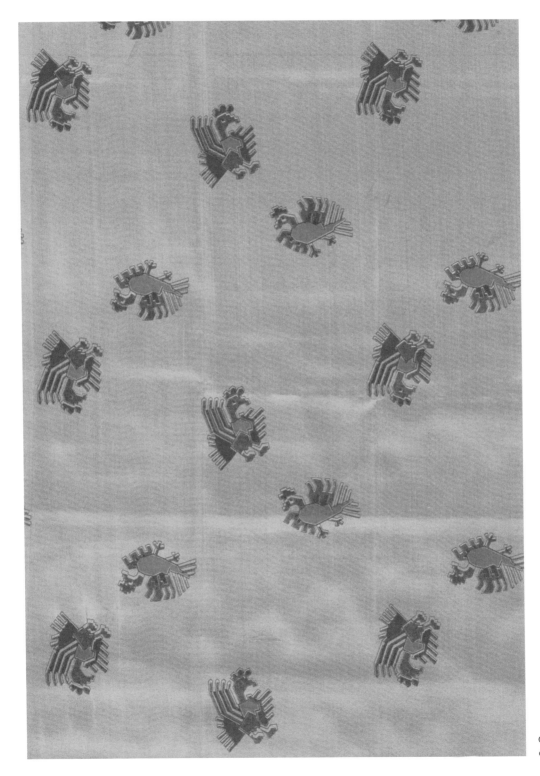

Checklist of the Exhibition

1

"Navajo" design from Mexixe series
M. C. Migel & Co.
(renamed H. R. Mallinson & Co., 1915)
1914
Printed silk
35 ½ × 38 ¾ in. (90.2 × 98.4 cm)
National Museum of American History,
Smithsonian Institution, 57318 T.1990

3

"Kortez" design from Mexixe series
M. C. Migel & Co.
(renamed H. R. Mallinson & Co., 1915)
1914
Printed silk
38 ⅛ × 39 ⅛ in. (97.5 × 100 cm)
National Museum of American History,
Smithsonian Institution, 57318 T.1992

2

"Mexican Hummingbird" design from Mexixe series
M. C. Migel & Co.
(renamed H. R. Mallinson & Co., 1915)
1914
Printed silk
38 ⅛ × 40 ½ in. (96.8 × 102.9 cm)
National Museum of American History,
Smithsonian Institution, 57318 T.1983

4

"Rattlesnake Symbol" design from Mexixe series
M. C. Migel & Co.
(renamed H. R. Mallinson & Co., 1915)
1914
Printed silk
35 ½ × 40 ½ in. (90.2 × 102.8 cm)
National Museum of American History,
Smithsonian Institution, 57318 T.1984

5

Principles of Design
Open to plate V
Ernest Batchelder
Second edition, 1906
6 × 8⅞ × 1 in. (15.2 x 22.5 x 2.5 cm)
Private collection

6

Design in Theory and Practice
Open to p. 168
Ernest Batchelder
Third edition, 1914
5¾ × 8⅛ × 1 in. (14.6 × 20.6 × 2.5 cm)
Private collection
See fig. 12

7

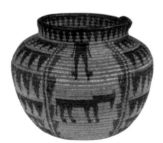

Bottle-neck basket
Lone Pine vicinity, Inyo County, California
Acquired 1901
Plant fiber
5⅜ × 4⅛ in. (13.5 × 10.4 cm)
Division of Anthropology, American Museum
of Natural History, 50/2800

8

"Peruvian Art: A Help for Students of Design"
Open to plate III
Charles W. Mead
1917, fourth edition, 1925
Guide leaflet series, no. 46
6¾ × 9¾ in. (17.1 × 24.8 cm)
Private collection

9

"Indian Beadwork: A Help for Students of Design"
Open to p. 25
Clark Wissler
First edition, 1919
Guide leaflet series, no. 50
6¾ × 9¾ in. (17.1 × 24.8 cm)
Private collection
See fig. 11

10

"Costumes of the Plains Indians"
in *Anthropological Papers of the
American Museum of Natural History* 17,
no. 2 (1915)
Open to pp. 54–55
Clark Wissler
5¾ × 8¾ in. (14.6 × 22.2 cm)
Private collection

11

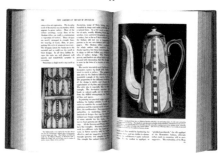

"Decorative Value of American Indian Art"
in *American Museum Journal* 16, no. 5 (May 1916)
Open to pp. 302–3
Esther A. Coster
9 ¾ × 6 ¾ × 2 in. (24.8 × 17.1 × 5.1 cm)
Bard Graduate Center, Library

12

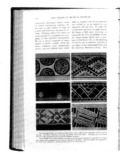

"Creative Textile Art and the American Museum"
in *American Museum Journal* 17, no. 4 (April 1917)
Open to pp. 258–59
M. D. C. Crawford
9 ¾ × 6 ¾ × 2 in. (24.8 × 17.1 × 5.1 cm)
Bard Graduate Center, Library
See also fig. 21

13

Pre-Hispanic Motifs
Ilonka Karasz
ca. 1917
Gouache over graphite on paper
5 ⅞ × 6 in. (14.9 × 15.2 cm)
Museum of Art, Rhode Island School of Design,
Providence, Helen M. Danforth Acquisition Fund, 2006.42.4
See page 124

14

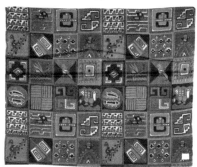

Hand block-printed sample
Possibly H. R. Mallinson & Co.
ca. 1920
Silk
32 ¾ × 26 ¼ in. (83.2 × 66.7 cm)
Brooklyn Museum Collection, X290.9

15

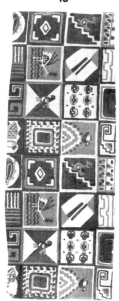

Hand block-printed fragment
Possibly H. R. Mallinson & Co.
ca. 1920
Silk
32 ¾ × 13 in. (83.2 × 66.7 cm)
Brooklyn Museum Collection, X290.10

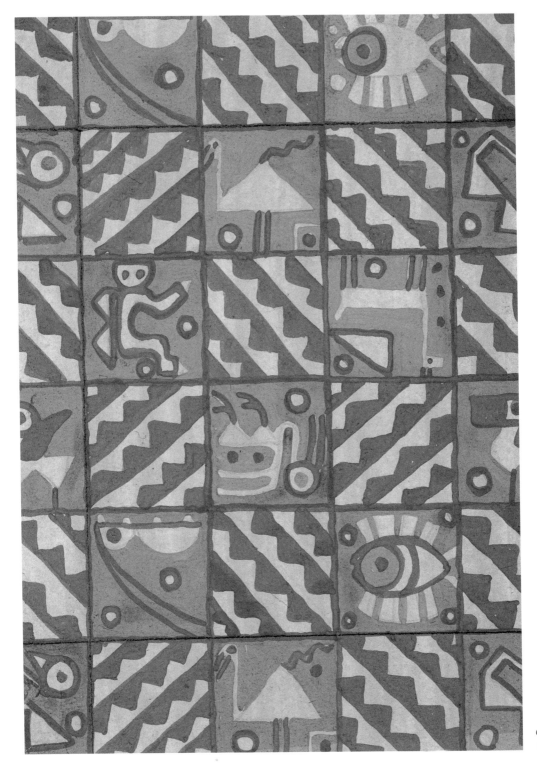

16

"Mandarin Crepe" sample
with manufacturers tag
H. R. Mallinson & Co.
Early 20th century
Printed silk crepe
17 × 18 in. (43.2 × 45.7 cm)
Brooklyn Museum Collection, X1200.1

17

Roller stamp
Atlantic Watershed, Costa Rica
5th–6th century
Ceramic; carved and incised
3 ¾ × diam. 2 ⅛ in. (9.4 × diam. 5.4 cm)
The Metropolitan Museum of Art,
The Michael C. Rockefeller Memorial Collection,
Bequest of Nelson A. Rockefeller, 1979
(1979.206.1193)

18

Stamps
Mexico
Collected 1897
Terracotta; carved, incised, and stamped
Largest: 1 ⅞ × 1 ½ in. (4.6 × 3.6 cm);
smallest: 1 ⅜ × 1 in. (3.2 × 2.3 cm)
Division of Anthropology, American Museum
of Natural History, 30/2541 AB

19

Loop stick loom for weaving colored strips
Chama (Shipibo/Conibo)
Northeast Peru, Middle Rio Pisqui
Collected 1934
Wood
19 ⅜ × 13 ½ × 1 ⅝ in. (49 × 34.3 × 4 cm)
Division of Anthropology, American Museum
of Natural History, 40.0/2859

20

Gourd rattle
Guatemala
Acquired 1901
Gourd, wood; incised
8 ⅔ × 2 ¾ in. (22 × 7 cm)
Division of Anthropology, American Museum
of Natural History, 65/2327

21

Huipil
Guatemala
Acquired 1913
Cotton; plain weave, continuous
supplementary warps and wefts
43 ⅜ × 23 ¼ in. (110 × 59 cm)
Division of Anthropology, American Museum
of Natural History, 65/3639

22

Reproductions of six slides from Herbert Spinden's
lecture "Textile Arts of Mexico and Central America"
Aztec "snake" and "flower" motifs
October 1916
Archival negative
Image 219782 and 219786, American Museum
of Natural History Library
See also fig. 13

23
Sketchbook
Mariska Karasz
ca. 1917
Pencil on paper, bound
6 ¾ × 9 in. (12.2 × 22.9 cm)
Courtesy of Solveig Cox
See page 106–107

24
"Museum Documents and Modern Costume"
in *American Museum Journal* 18, no. 4 (April 1918)
Open to pp. 286–87
M. D. C. Crawford
9 ¾ × 6 ¾ × 2 in.
(24.8 × 17.1 × 5.1 cm)
Bard Graduate Center, Library

25

Textile fragment
Possibly Hazel Burnham Slaughter
for H. R. Mallinson & Co.
ca. 1919
Printed silk
38 ½ × 39 ½ in. (97.8 × 100.3 cm)
Brooklyn Museum Collection, X2003.2109a

26

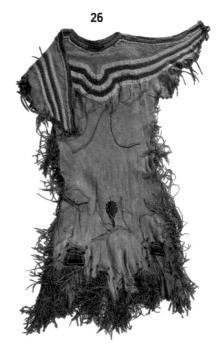

Woman's two-hide dress
Blackfoot
Glacier County, Montana
Acquired 1952
Hide, fur, "Hudson Bay" beads, appliquéd flannel,
cloth, sinew, thread, pigment
52 × 40⅛ × 1¼ in. (132 × 122 × 3 cm)
Division of Anthropology, American Museum
of Natural History, 50.2/5828

27

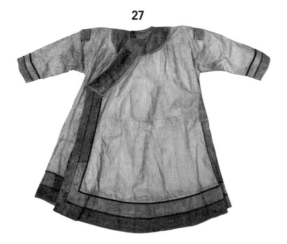

Decorated fish-skin coat
Nivkhi
Siberia
Acquired 1898
Salmon skin, pigment, reindeer sinew, hair
Cut out, appliqué, painted
50 ⅞ × 42 ⅝ × 2 ⅜ in. (129 × 108 × 6 cm)
Division of Anthropology, American Museum
of Natural History, 70/83

28

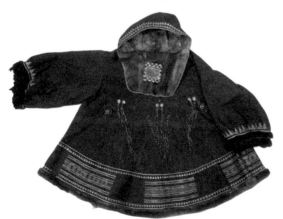

Woman's dancing coat
Possibly Koryak
Kushka, Siberia
Acquired 1901
Fur, hide, bead, cloth, sinew
59 ⅛ × 47 ¼ in. (150 × 120 cm)
Division of Anthropology, American Museum
of Natural History, 70/3599

29
Evening dress
American or European
Silk; with both woven and batik decoration
ca. 1920
Center back: 50 ¾ in. (127 cm)
Brooklyn Museum Costume Collection at
The Metropolitan Museum of Art, Gift of the
Brooklyn Museum, 2009; Gift of Mrs. Frank L.
Babbott, 1954 (2009.300.3151)
See page 128

30

"Maya" design from the Americana Prints series
Charles B. Falls for the Stehli Silk Co.
1925
Printed silk
27 × 39 in. (68.6 × 99.1 cm)
The Metropolitan Museum of Art,
Gift of Stehli Silk Corp., 1927 (27.150.7)

31

"Inca" design from the Americana Prints series
Charles B. Falls for the Stehli Silk Co.
1925
Printed silk
27 × 39 in. (68.6 × 99.1 cm)
The Metropolitan Museum of Art,
Gift of Stehli Silk Corp., 1927 (27.150.6)

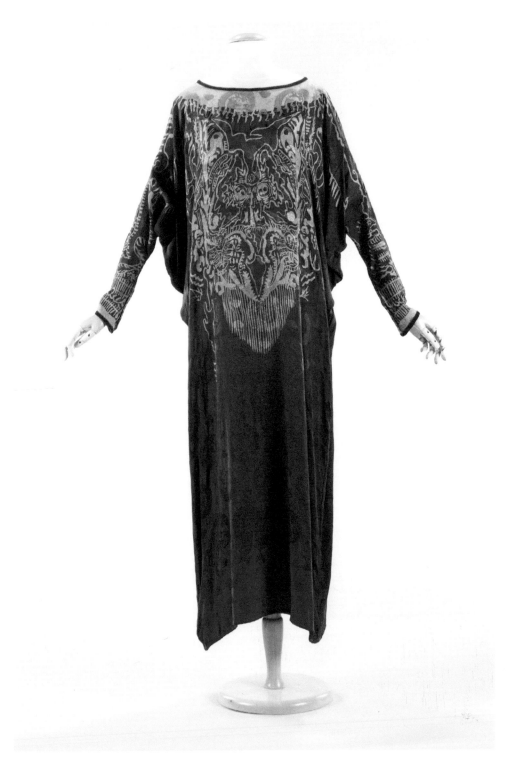

Cat. 29

32

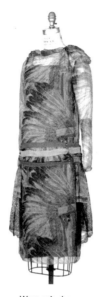

Woman's dress
"Sioux War Bonnet" print from
the American Indian series
Walter Mitschke for H. R. Mallinson & Co.
ca. 1928
Printed silk
Center back: 41 in. (104.1 cm)
Museum of Art, Rhode Island School of Design,
Providence, Edgar J. Lownes Fund, 2006.6

33

**"Blackfoot Sun Dance" print
from the American Indian series**
Walter Mitschke for H. R. Mallinson & Co.
1927
Printed silk
39 ¼ × 34 ½ in. (99 × 87.6 cm)
Allentown Art Museum,
Gift of Kate Fowler Merle-Smith, 1978

34

Shoshoni bag
Fremont County, Fort Washakie, Wyoming
Elk hide, glass beads, cloth, thread
13 ⅝ × 8 ⅔ × 1 ⅛ in. (34 × 22 × 2.8 cm)
Acquired 1901
Division of Anthropology, American Museum
of Natural History, 50/2347

35

**"Shoshoni Tribe" samples from the American
Indian series with manufacturer's tag**
Walter Mitschke for H. R. Mallinson & Co.
1927
Printed silk
30 ⅞ × 39 ¾ in. (78.4 × 101 cm)
National Museum of American History,
Smithsonian Institution, 101284 T.5749 F

36

Drawing for "Zuni Tribe"
Walter Mitschke for H. R. Mallinson & Co.
ca. 1927
Pencil and gouache on paper
22 ⅟₁₆ × 28 ⅜ in. (56 × 72 cm)
Museum of Fine Arts, Boston, Gift of Robert
and Joan Brancale, 2008.1950.35

Exhibitors at the *Exhibition of Industrial Art in Textiles and Costumes*, 1919

This list has been compiled from the American Museum of Natural History exhibition catalogue and archival documents for the loans from the AMNH Division of Anthropology Archive. Only some of the exhibitors were documented and photographed; this list aims to offer a complete listing of known contributors and lenders.

American-Made Costumes

A. Beller & Co. (Max Meyer)
 Cloaks and suits
Harry Collins
 Costumes
B. C. Faulkner
 Blouses
A. H. Flanders and Company
 Blouses
Funsten Brothers, St. Louis
and New York
 Alaskan sealskin furs
Otto Kahn
 Furs
Ruth Reeves
 Batik garments, fashion
 illustrations for *Women's Wear*
Martha Ryther
 Batik garments
Hazel Burnham Slaughter
 Batik garments
Mary Tannahill
 Batik garments
Winifred Warren
(Jessie Franklin Turner)
 Tea gowns and negligees
J. Wise Company
 Misses' and children's dresses

———

Beadwork and Embroidery

American Bead Company
 Contemporary beadwork
David Aaron & Co.
 Embroidery
Blanck & Co.
 Embroidery
John E. Conner
 Crimean embroideries on linen

Weaving and Printing Techniques

Elizabeth Austin
 Textile sample, Italian
Emile Bernat
 Tapestry weaving and yarn dying
Sidney Blumenthal & Co.
 Cut velvet samples and weaving
 process
Chamber of Commerce, Patterson,
New Jersey
 Silk industry in New Jersey
Cheney Bros. Silks
 Silk yarns and printed textiles
Crawshaw Carpet Company
 Series of rugs based on
 Peruvian designs
Lockwood de Forest
 Teakwood printing blocks
Johnson, Cowdin & Co.
 Ribbon loom with samples
Kevorkian Gallery
 Examples of Persian, Coptic,
 and Turkish garments, textiles,
 and rugs
H. R. Mallinson & Co.
 Dress silks and block printing
Marshall Field & Company
 Cretonnes, block and cylinder
 printing
J. A. Migel, Inc.
 Jacquard weaving
Marion Powys (Devonshire Lace Shop)
 Lace samples, history of lace
 and lacemaking
Miss Simonds
 Teakwood block-printed bags
Coulton Waugh
 Greenwich Village prints by
 Cheney Bros. Silks
Nell Witters
 Batik-style design produced
 by Marshall Field & Company

Additional Exhibitors

John Held
 Unknown
Laura Moses
 Unknown
A. M. Tozzer
 Unknown
Women's Wear
 Fashion illustrations
 and contest posters

———

Loans from the Brooklyn Museum Institute

Dolls
"East-Indian" coat
"Turkish" coat
Man's dress from India

———

Bibliography

Archival Sources

American Museum of Natural History Special Collections Library, New York

Central Archives, American Museum of Natural History, New York

Crawford Study Collection, Records of the Department of Costumes and Textiles, Brooklyn Museum

Department of Anthropology Archive, American Museum of Natural History, New York

Division of Home and Community Life, Museum of American History, Smithsonian Institution, Washington DC

Office of the Secretary Archives, The Metropolitan Museum of Art, New York

Oral History Collection of the Fashion Institute of Technology, New York

Stewart Culin Archival Collection, Brooklyn Museum

William H. Fox Records, Brooklyn Museum

Bibliography

"American Designer's Fashions for Spring: Influences Which Will Determine the Trend." *American Silk Journal* 33 (Dec. 1914): 31–32.

Armfield, Maxwell. "American Art as an Alphabet for the Entire World." *Women's Wear*, 5 Nov. 1916.

"Art: Decorative Action." *New York Times*, 23 Jan. 1960.

Ayres, Dianne, Timothy Hansen, Beth Ann McPherson, and Tommy Arthur McPherson II. *American Arts and Crafts Textiles*. New York: Harry N. Abrams, 2002.

Bach, Richard F. "The Artificial Vogue In Decoration." *Good Furniture* 10 (Feb. 1918): 111–12.

"Batik Applied to Modern Dress and Interior Decoration." *American Cloak and Suit Review* 18 (September 1919): 133.

Barlow, Susan. "The Cheney Silk Mills." Manchester Historical Society. http://www.manchesterhistory.org/reprints/MHS3_CheneySilkMills.html. Accessed 5 June 2013.

Barmash, Isadore. "Company News; Australians Buy Bonwit Teller." *New York Times*, 1 May 1987.

———. "The Decline of Bonwit Teller: Did Time Pass Retailer By?" *New York Times*, 14 Apr. 1990.

Batchelder, Ernest A. *Design in Theory and Practice*. New York: MacMillan, 1914.

———. *The Principles of Design*. Chicago, IL: Inland Printer Co., 1904.

Bennett, Tony. *The Birth of the Museum*. London and New York: Routledge, 1995.

Benton, Suzanne. "The Silk Industry at War." Master's thesis, Fashion Institute of Technology, 1994.

Bergen, Jane M. Von. "Wanamakers Will Become Hecht's." *Philadelphia Inquirer,* 9 Aug. 1995.

Blaszczyk, Regina Lee. "The Colors of Modernism." In *Seeing High and Low*. Edited by Patricia Johnson. Berkeley: University of California Press, 2006. 228–46.

———. *Producing Fashion: Commerce, Culture, and Consumers*. Philadelphia: University of Pennsylvania Press, 2008.

Blausen, Whitney. "In Search of a National Style." In *Disentangling Textiles*. Edited by Mary Schoeser. London: Middlesex University Press, 2002. 145–52.

———. "Textiles by Ruth Reeves." Master's thesis, Fashion Institute of Technology, 1992.

———, and Mary Schoeser. "Wellpaying Self Support: Women Textile Designers." In *Women Designers in the U.S.A., 1900–2000*. Edited by Pat Kirkham. Exh. cat. New Haven and London: Yale University Press with Bard Graduate Center, 2000. 145–65.

Boardman, Michelle. *All That Jazz: Printed Fashion Silks of the '20s and '30s*. Exh. cat. Allentown, PA: Allentown Art Museum, 1998.

Boas, Franz. *Primitive Art*. 1927. New York: Dover Publications, 1955.

Boyo, Gene. "Wanamaker to Close Main Store after 58 Years on Broadway." *New York Times*, 26 Oct. 1954.

Brody, David. *Visualizing American Empire*. Chicago: University of Chicago Press, 2010.

Bronner, Simon J. *Consuming Visions: Accumulation and Display of Goods in America 1880–1920*. New York: W. W. Norton, 1989.

Bullitt-Lowry, Helen. "High Art Home-Made, or Paris Robbed of Her Prey." *New York Times*, 19 Nov. 1919.

Cahill, Holger. *American Sources of Modern Art*. Exh. cat. New York: Museum of Modern Art, 1933.

Caldwell, John. "Martha Ryther Retrospective to Provide Aid to Fund." *New York Times*, 22 Nov. 1981.

Callahan, Ashley Brown. *Enchanting Modern: Ilonka Karasz (1896–1981)*. Exh. cat. Athens: Georgia Museum of Art, 2003.

———. "Ilonka Karasz: Making Modern." Paper presented at the Sixth Biennial Symposium of the Textile Society of America, Inc., held at The Fashion Institute of Technology, New York, 23–26 Sept. 1998. As reproduced in *Creating Textiles: Makers, Methods and Markets*. The Textile Society of America, 1998.

———. *Modern Threads: Fashion and Art by Mariska Karasz.* Exh. cat. Athens: Georgia Museum of Art, 2007.

Cheney, Sheldon. "News of Theatre Art and Artists." *Theatre Arts* 1 (1917): 143.

Clark, Mary. *Dyeing for a Living: A History of the American Association of Textile Chemists and Colorists: 1921–1996.* Research Triangle Park, NC: American Association for Textile Chemists and Colorists, 2001.

Clifford, James. *The Predicament of Culture*. Cambridge and London: Harvard University Press, 1988.

Coleman, Elizabeth Ann. "Jesse Franklin Turner: A Flight Path for Early Modern American Fashion." *Dress* 25 (1998): 58–64.

Collins, Harry. *The ABC of Dress*. New York: Modern Modes Corporation, 1923.

Conn, Steven. *Museums and American Intellectual Life, 1876–1926.* Chicago: University of Chicago Press, 1998.

Coster, Esther A. "Decorative Value of American Indian Art." *American Museum Journal* 16, no. 5 (May 1916): 301–7.

"Costume Designing from Museum Material." *American Review of Reviews* 58 (Sept. 1918): 319–20.

Crawford, M. D. C. "Cheney Designer Being Sent to Egypt, Won Many Women's Wear Design Award." *Women's Wear*, 15 Feb. 1923. Unpaginated clipping from Culin Archival Collection, General Correspondence [1.4.045], 2/1923, Brooklyn Museum Archives.

———. "Creative Textile Art and the American Museum." *American Museum Journal* 17, no. 3 (March 1917): 253–59.

———. "Design and Color in Ancient Fabrics." *American Museum Journal* 16, no. 7 (Nov. 1916): 417–32.

———. "Design Department." *Women's Wear*, 12 Nov. 1919.

———. "Design Department." *Women's Wear*, 14 Nov. 1919.

———. "Design Department." *Women's Wear*, 18 Nov. 1919.

———. "The Designer and the Textile Industry." *House Beautiful* (Jan. 1919): 15–17, 42.

———. "Evolution of American Textile Design." *New York Evening Globe*, 27 March 1917.

———. *The Heritage of Cotton*. New York: Fairchild Publishing, 1948.

———. "Industrial Art Exhibition Portrays Progress of Costume and Fabric Designing." *Women's Wear*, 7 Nov. 1919. Unpaginated clipping from the Culin Archival Collection. General Correspondence [1.4.005], 11/1919, Brooklyn Museum Archives.

———. "Industrial Art Exhibition to Feature Important Displays." *Women's Wear*, 8 Oct. 1919.

———. "The Loom in the New World." *American Museum Journal* 16, no. 10 (Oct. 1916): 381–88.

———. "Museum Documents and Modern Costume." *American Museum Journal* 18, no. 4 (April 1918): 286–97.

———. "The Museum's Place in Art Industry." *House Beautiful* (Dec. 1918): 368–70.

———. "A New Source of Costume Inspiration: Designers Adapt to the Beauties of Primitive Arts to the Actualities of Modern Life." *Vogue* 50, no. 11 (1 Dec. 1917): 88, 168, 170, 172.

———. "Peruvian Textiles." *Anthropology Papers of the American Museum of Natural History* 12 (1915): 52–104.

———. "Producing the Goods in Original American Design." *Women's Wear*, 27 Sept. 1916.

———. "Professor Dow Offers to Aid Design School." *Women's Wear*, 22 Jan. 1917.

———. "Proposal that Museums Aid Industrial Art of Special Significance to Costume Industries." *Women's Wear*, 17 May 1921.

———. "A School of American Design." *American Silk Journal* 35, no. 12 (Dec. 1916): 60–61.

———. "Taste—The Thing Most Lacking in American Art." *Women's Wear*, 3 Jan. 1919. Unpaginated clipping from the Stewart Culin Archival Collection, General Correspondence [1.4.001], 11/1918–2/1919.

———. "Technical Hints May Be Help in Design Contest." *Women's Wear*, 9 Nov. 1916.

———. "True Democracy Means Good Art for All." *Women's Wear*, 26 Nov. 1919. Unpaginated clipping from the Stewart Culin Archival Collection, General Correspondence [1.4.005], 11/1919.

———. *The Ways of Fashion*. New York: G. P. Putnam, 1941.

Cromley, Elizabeth. "Masculine/Indian." *Winterthur Portfolio* 31, no. 4 (Winter 1996): 265–80.

Darnell, Regna. *And Along Came Boas: Continuity and Revolution in Americanist Anthropology*. Amsterdam Studies in the Theory and History of Linguistic Science, vol. 86. Edited by E. F. Konrad Koerner. Amsterdam and Philadelphia: John Benjamins, 1998.

Davies, Karen. *At Home in Manhattan*. Exh. cat. New Haven, CT: The Yale University Art Gallery, 1983.

"Decorating: The Historic in Stenciling." *Vogue* 38, no. 12 (15 Dec. 1911): 90, 92.

Deloria, Philip J. *Playing Indian*. New Haven and London: Yale University Press, 1998.

Department of Anthropology, American Museum of Natural History. *The Annual Report of the American Museum of Natural History*. New York: American Museum of Natural History, 1916.

"Designers Borrow Patterns From Ancient America." *Science News Letter*, 6 Apr. 1935.

Dilworth, Leah. *Imagining Indians in the Southwest: Persistent Visions of a Primitive Past*. Washington, DC: Smithsonian Institute Press, 1996.

Donahue, Mary. "Design and Industrial Arts in America 1894-1940: An Inquiry into Fashion Design and Art Industry." PhD diss., City University of New York, 2001.

——. "Modern American Fashion Design American Indian Style." In *Part 9: American Identities*. http://web.gc.cuny.edu/ArtHistory/part/part9/identities/articles/donah.html 2003. Accessed 1 Dec. 2010.

Dow, Arthur Wesley. *Composition*. 1899. Berkeley and Los Angeles: University of California Press, 1997.

——. "Designs from Primitive American Motifs." *Columbia Teachers College Record* 16, no. 2 (March 1915): 29-34.

"Dressing on a Limited Income." *Vogue* 54, no. 9 (1 Nov. 1919): 90, 91, and 156.

Edson, Mira Burr. "The Keramic Society of Greater New York." *International Studio* 61, no. 244 (June 1917): CXXVII-CXXIX.

Emil Her Many Horses. "Portraits of Native Women and Their Dresses." In *Identity by Design: Tradition, Change, and Celebration in Native Women's Dresses*. Exh. cat. New York and Washington, DC: HarperCollins in association with the Smithsonian National Museum of the American Indian, 2007.

Falk, Peter H., Audrey M. Lewis, Georgia Kuchen, Veronika Roessler. "Hazel Burnham Slaughter." *Who Was Who in American Art 1564-1975: 400 Years of Artists in America*. Madison, CT: Sound View Press, 1999. 3059.

Fane, Diana, Ira Jacknis, and Lise M. Breen. *Objects of Myth and Memory: American Indian Art at the Brooklyn Museum*. Exh. cat. Brooklyn: Brooklyn Museum in association with the University of Washington Press, 1991.

Field, Jacqueline. "Dyes, Chemistry and Clothing." *Dress* 28 (2001): 77-91.

Finamore, Michelle Tolini. *Hollywood Before Glamour: Fashion in American Silent Film*. New York and Basingstoke, Hampshire, UK: Palgrave Macmillan, 2013.

Fitzhugh, William W., and Aron Crowell. *Crossroads of Continents: Cultures of Siberia and Alaska*. Washington, DC and London: Smithsonian Institution Press, 1988.

Fitzsimons, Theodore Lynch. "The Revival of Batik." *International Studio* 61 (June 1917): CX-CXII.

Freed, Stanley A. *Anthropology Unmasked: Museums, Science, and Politics in New York City*. Wilmington, OH: Orange Frazer Press, 2012. 2 vols.

——, and Ruth S. Freed. "Clark Wissler and the Development of Anthropology in the United States." *American Anthropologist* 85, no. 4 (Dec. 1983): 800-825.

Gibson, Katherine. "Textile Designs by Leon Bakst." *Design-Keramic* 31, no. 6 (Nov. 1929): 108-13.

Goldstein, Gabriel, and Elizabeth Greenberg, eds. *A Perfect Fit: The Garment Industry and American Jewry, 1860-1960*. New York: Yeshiva University Press, 2005.

Green, Martin Burgess. *New York 1913: The Armory Show and the Paterson Strike Pageant*. New York: Collier Books, 1989.

Green, Nancy E. and Jessie J. Poesch. *Arthur Wesley Dow and the American Arts and Crafts*. New York: American Federation of Arts in association with Harry N. Abrams, 1999.

Griffiths, Alison. *Wondrous Difference*. New York: Columbia University Press, 2002.

Harris, Neil. *Cultural Excursions: Marketing Appetites and Cultural Tastes in Modern America*. Chicago: University of Chicago Press, 1990.

Harris, William Laurel. "Industrial Art & American Nationalism." *Good Furniture* 6 (Feb. 1916): 67-74.

——. "Mobilization in the World of Art and Industry." *Good Furniture* 8 (May 1917): 249-58.

——. "The Varied Industries—What Germany Teaches Us." *Good Furniture* 4 (Nov. 1914): 77-84.

Hinsley, Jr., Curtis M. *Savages and Scientists: The Smithsonian Institution and the Development of American Anthropology, 1846-1910*. Washington, DC: Smithsonian Institution Press, 1981.

Hoganson, Kristin L. *The Global Production of American Domesticity, 1865-1920*. Chapel Hill: University of North Carolina Press, 2007.

Hurd, Charles W. "Mallinson Campaign to Popularize American-made Styles." *Printers' Ink* 92, no. 10 (2 Sept. 1915): 3-8, 74-78, 81-82.

Hutchinson, Elizabeth. *The Indian Craze: Primitivism, Modernism, and Transculturation in American Art, 1890-1915*. Durham, NC: Duke University Press, 2009.

"Indian Designs and Colors for Silks." *American Silk Journal* 44, no. 5 (May 1925): 23-24.

"Industrial Notes." *Trenton Evening Times*, 7 Oct. 1898.

"Influence of American Designs to Dominate World's Fashions." *American Silk Journal* 33, no. 3 (March 1914): 29.

Internet Broadway Database. "Harry Collins," ibdb.com/person.php?id=414360. Accessed 31 May 2013.

Jacknis, Ira. "Franz Boas and Exhibits." In *Objects and Others*. Edited by George W. Stocking, Jr. Madison: University of Wisconsin Press, 1985. 75–111.

Jewell, Edward Alden. "Exhibition Opened by Women Artists." *New York Times*, 12 Jan. 1937.

———. "Exhibition Opened by Women Artists." *New York Times*, 25 Mar. 1941.

Kaplan, Amy. *The Anarchy of Empire in the Making of U.S. Culture*. Cambridge: Harvard University Press, 2002.

———, and Donald E. Pease, eds. *Cultures of United States Imperialism*. Durham, NC, and London: Duke University Press, 1993.

Kaplan, Wendy. "America: The Quest for Democratic Design." In *The Arts and Crafts Movement in Europe & America*. Edited by Wendy Kaplan. Exh. cat. New York and Los Angeles: Thames & Hudson in association with the Los Angeles County Museum of Art, 2004. 246–83.

———. *Designing Modernity: The Arts of Reform and Persuasion, 1885–1945*. Exh. cat. New York: Thames and Hudson; Miami: Wolfsonian Foundation, 1995.

King, Elizabeth Miner. "War, Women, and American Clothes." *Scribner's Magazine* 62, no. 5 (Nov. 1917): 592–99.

Kisluk-Grosheide, Daniëlle. "The Hoentschel Collection Comes to New York." In *Salvaging the Past: Georges Hoentschel and French Decorative Arts from The Metropolitan Museum of Art*. Edited by Daniëlle Kisluk-Grosheide, et al. New York and London: Yale University Press with the Bard Graduate Center, 2013. 1–17.

Kissell, Mary Lois. "Aboriginal American Weaving." Paper presented at The National Association of Cotton Manufacturers, 88th Meeting at the Mechanics Fair Building, Boston, 27 April 1910.

———. "The Textile Museum, Its Value as an Educational Factor." Master's thesis, Teachers College Columbia University, 1913.

Koda, Harold, and Andrew Bolton. *Poiret*. Exh. cat. New York and New Haven: The Metropolitan Museum of Art in association with Yale University Press, 2007.

Kramer, Hilton. "Martha Kantor, 84; Painted on Glass." *New York Times*, 10 Jan. 1981.

Kubler, George. *Esthetic Recognition of Ancient Amerindian Art*. New Haven: Yale University Press, 1991.

Laidlaw, Christine Wallace. "The Metropolitan Museum of Art

and Modern Design: 1917–1929." *Journal of Decorative Arts and Propaganda Arts* 8 (Spring 1988): 88–103.

"Launches a Style." *Merchants Record and Show Window* 40, no. 3 (March 1917): 11–13.

Lawrence, Deidre E. "Fashion World and How It Has Been Influenced by Ethnographic Collections in Museums." *Documentation of Nordic Art* (Paris: K. G. Saur, 1993): 140–53.

Leach, William. *Land of Desire: Merchants, Power, and the Rise of a New American Culture*. New York: Pantheon, 1994.

Lears, T. J. Jackson. *No Place of Grace: Antimodernism and the Transformation of American Culture 1880–1920*. Chicago and London: The University of Chicago Press, 1994.

"Lectures on the Textile Collection." *Bulletin of the Metropolitan Museum of Art* 11 (Oct. 1916): 227.

Lovejoy, Arthur O. and George Boas. *Primitivism and Related Ideas in Antiquity*. 1935. Baltimore and London: The Johns Hopkins Press, 1997.

Lucas, Frederic A., et al. *General Guide to the Exhibition Halls of the American Museum of Natural History*. New York: American Museum of Natural History, 1920.

MacCurdy, George Grant. *A Study of Chiriquian Antiquities*. Memoirs of the Connecticut Academy of Arts and Sciences, vol. 3. New Haven: Yale University Press, 1911.

Manchester, H. H. *The Story of Cheney Silk*. New York: Cheney Brothers, 1924.

"Max Meyer Dies; Labor Mediator." Obituary, *New York Times* 1 Feb. 1953.

"Maya Designs the Latest Vogue." *American Silk Journal* 36, no. 3 (March 1917): 39.

"M. C. Migel & Co. Change Name to H. R. Mallinson & Co." *American Silk Journal* 34 (January 1915): 34.

McKnight, Lola S. "The Americana Prints: A Collection of Artist-Designed Textiles." Master's thesis, Fashion Institute of Technology, 1993.

Mead, Charles W. "Ancient Peruvian Cloths." *American Museum Journal* 16, no. 6 (Oct. 1916): 389–94.

———. "The Conventionalized Figures of Ancient Peruvian Art." *Anthropological Papers of the American Museum of Natural History* 7, no. 5 (1915): 195–217.

———. "Peruvian Art: A Help for Students of Design." Guide leaflet, no. 46. New York: American Museum of Natural History, 1917.

———. "Techniques of Some Andean Featherwork." *Anthropological Papers of the American Museum* 1 (1907): 1–17.

Mears, Patricia. "Jessie Franklin Turner: American and 'Exotic' Textile Inspiration." In *Creating Textiles: Makers, Methods and

Markets; Proceedings of the Sixth Biennial Symposium of the Textile Society of America, Inc. Edited by Madelyn Shaw. Earleville, MD: Textile Society of America, 1999. 431–40.

Mechlin, Leila. "Primitive Arts and Crafts Illustrated in the National Museum Collection." In "The Script," *International Studio* 35 (Aug. 1908): LXI–LXVI.

The Metropolitan Museum of Art. *Exhibitions of Work by Manufacturers and Designers: 1917–1923*, Continued as *American Industrial Art: Annual Exhibitions, 1924–26*. New York: The Metropolitan Museum of Art, 1917–26.

Milbank, Caroline Rennolds. *New York Fashion: The Evolution of American Style*. 1989. New York: Harry N. Abrams, 1996.

Miller, Ethelwyn. "Americanism the Spirit of Costume Design." *Journal of Home Economics* 10, no. 5 (May 1918): 207–11.

Mirzoeff, Nicholas. "Photography at the Heart of Darkness: Herbert Lang's Congo Photographs (1909–15)." In *Colonialism and the Object: Empire, Material Culture and the Museum*. Edited by Tim Barringer and Tom Flynn. London and New York: Routledge, 1998. 167–87.

Mitchener, Kris James and Marc Weidenmier. "Empire, Public Goods, and the Roosevelt Corollary." *Journal of Economic History* 65, no. 3 (Sept. 2005): 658–92.

Murdock, George Peter. "Clark Wissler, 1870–1947." *American Anthropologist* 50, no. 2 (April–June, 1948): 219–304.

Museum of Modern Art. Press Release 41130-7, 1 Feb. 1941, online press release archive, www.moma.org. Accessed 6 June 2013.

"Museum Notes." *American Museum Journal* 15, no. 1 (Jan. 1915): 32.

——. *American Museum Journal* 16, no. 10 (Oct. 1916): 411.

——. *American Museum Journal* 17, no. 2 (Feb. 1917): 151.

——. *American Museum Journal* 17, no. 4 (April 1917): 279.

——. *American Museum Journal* 17, no. 5 (May 1917): 360.

——. *American Museum Journal* 17, no. 12 (Dec. 1917): 580.

——. *American Museum Journal* 18, no. 1 (Jan. 1918): 71.

——. *American Museum Journal* 18, no. 7 (Nov. 1918): 622.

N. N. "Art: A Right Way to Use Museums." *The Nation*, 20 Dec. 1919.

"New All-American Silks Shown in the National Museum." *American Silk Journal* 33, no. 3 (March 1914): 63.

New York Times. "4 Big Ribbon Makers in $5,000,000 Combine." 12 July 1922.

——. "American Art and American Fashions." 30 Nov. 1919.

——. "Art at Home and Abroad." 27 Jan. 1918.

——. "Art Notes." 27 Oct. 1917.

——. "Art Notes: News of Activities Here and There." 3 Jan. 1937.

——. "Business Notes." 24 April 1915.

——. "Charles W. Mead, Archaeologist, Dies." 4 Feb. 1928.

——. "Costume Exhibit Closes." 7 June 1938.

——. "Costume Exhibition Opens." 13 Nov. 1919.

——. "David Aaron Dies in Vienna: Retired Manufacturer of Embroidery Victim of Heart Disease." 24 June 1930.

——. "Devise Intercode Plan." 27 Jan. 1935.

——. "Edward L. Mayer." Obituary, 14 May 1953.

——. "Girl Designer Here Wins Scholarship to Study Fashions from the Tomb of Tut-ankh-Amen." 13 Feb. 1923.

——. "Master Craftsmen at Art Alliance." 25 Nov. 1917.

——. "Modern 'Primitive' Designs at the Museum of Natural History." 5 Dec. 1917.

——. "Morris Crawford, Fabrics Authority." Obituary, 25 June 1949.

——. "Museum Acquisitions." 22 July 1928.

——. "News of Art." 25 Oct. 1948.

——. "New Silk Showroom for Cheney Brothers." 15 Oct. 1925.

——. "Notes on Current Art." 28 Sept. 1919.

——. "Silk Now Less a Luxury than Wool." 6 Jan. 1918.

——. "Women Artists." 13 March 1927.

——. "Women Radicals Open Art Exhibit." 3 Feb. 1935.

Osborn, Henry Fairfield. "The Coming Fifty Years: Report of the President." *The Annual Report of the American Museum of Natural History*. New York: American Museum of Natural History, 1920.

"Panama Designs for Handkerchief and Tie Silks." *American Silk Journal* 34, no. 5 (May 1915): 33.

Powell, William S. "Tannahill, Mary Harvey." *The Dictionary of North Carolina Biography*. Chapel Hill: University of North Carolina Press, 1996.

Rainey, Ada. "An Inspiring Exhibition of American Textiles." *Art and Archaeology* 6 (Nov. 1917): 247–52.

Rawson, Marion Nicholl. "American Textile Designs." *American Review of Reviews* 58 (Aug. 1918): 188–90.

Reeves, Ruth. *Guatemalan Exhibition of Textiles and Costumes*. Exh. cat. New York: The National Alliance of Art and Industry, 1935.

Ricard, Serge. "The Roosevelt Corollary." *Presidential Studies Quarterly* 36, no. 1, Presidential Doctrines (March 2006): 17–26.

Richards, Charles R. *Art in Industry: Being the Report of an Industrial Art Survey Conducted under the Auspices of the National Society for Vocational Education and the Department of Education of the State of New York*. New York: MacMillan, 1922.

Rittenhouse, Anne. "Couturiers Under Arms." *Vogue* 44, no. 8 (15 Oct. 1914): 44, 45, and 118.

——. "Fashion under Fire." *Vogue* 44, no. 7 (1 Oct. 1914): 40, 41, and 110.

"The Ritz-Carlton Fashion Fête: Harry Collins Models for Two Lenten Matinees." *American Cloak and Suit Review* 21 (March 1921): 138–39.

Rosaldo, Renato. "Imperialist Nostalgia." *Representations* 26 (Spring 1989): 107–22.

Rosoff, Nancy B. "As Revealed by Art: Herbert Spinden and the Brooklyn Museum." *Museum Anthropology* 28, no. 1 (March 2005): 44–56.

Rubin, William. *Primitivism in 20th Century Art: Affinity of the Tribal and the Modern*. Exh. cat. New York: Museum of Modern Art, 1984.

Rushing, W. Jackson. *Native American Art and the New York Avant-Garde*. Austin: University of Texas Press, 1995.

Rydell, Robert W. *All the World's a Fair*. Chicago: The University of Chicago Press, 1984.

Samuels, Charlotte. *Art Deco Textiles*. London: V&A Publications, 2003.

Saville, Deborah. "Dress and Culture in Greenwich Village." In *Twentieth-Century American Fashion*. Edited by Patricia A. Cunningham and Linda Welter. Oxford and New York: Berg, 2005. 33–56.

——. "Freud, Flappers and Bohemians." *Dress* 30 (2003): 63–79.

Scherer, Johanna C. "The Photographic Document: Photographs as Primary Data in Anthropological Inquiry." In *Anthropology & Photography: 1860–1920*. Edited by Elizabeth Edwards. New Haven: Yale University Press, 1994. 32–41.

Schweitzer, Marlis. "American Fashions for American Women: The Rise and Fall of Fashion Nationalism." In *Producing Fashion: Commerce, Culture, and Consumers*. Edited by Regina Lee Blaszczyk. Philadelphia: University of Pennsylvania Press, 2008. 130–49.

"Seen In New York." *Good Furniture* 8 (June 1917): 313–22.

Shales, Ezra. "John Cotton Dana and the Business of Enlightening Newark: Applied Art at the Newark Public Library and Museum, 1902–29." PhD diss., Bard Graduate Center, 2006.

——. *Made in Newark: Cultivating Industrial Arts and Civic Identity in the Progressive Era*. New Brunswick, NJ, and London: Rivergate Books, 2010.

Shaw, Madelyn. "American Silk from a Marketing Magician: H. R. Mallinson & Co." In *Silk Roads, Other Roads: Proceedings of the 8th Biennial Symposium of the Textile Society of America, Inc*. Northampton, MA, 2002.

——, Jacqueline Field, and Marjorie Senechal. *American Silk, 1830–1930: Entrepreneurs and Artifacts*. Costume Society of America Series. Lubbock: Texas Tech University Press, 2007.

Sherwood, George Herbert. "Free Education by the American Museum of Natural History in Public Schools and Colleges: History and Status of Museum Instruction and its Extension to the Schools of Greater New York and Vicinity." *Miscellaneous Publications of the American Museum of Natural History* 13. New York: American Museum of Natural History, 1920.

Shirley, Lois. "Your Clothes Come from Hollywood." *Photoplay* 35, no. 3 (Feb. 1929): 70–71, 130–32.

"Small Paintings on View." *New York Times*, 5 May 1932.

Spencer, Frank. "Some Notes on the Attempt to Apply Photography to Anthropometry during the Second Half of the Nineteenth Century." In *Anthropology & Photography: 1860–1920*. Edited by Elizabeth Edwards. New Haven: Yale University Press, 1994. 99–107.

Spinden, Herbert J. "Creating a National Art." *Natural History: Journal of The American Museum of Natural History* 19, no. 6 (Dec. 1919): 622–30.

——. *Exhibition of Industrial Art in Textiles and Costumes*. Exh. cat. New York: American Museum of Natural History, 1919.

——. "Series of Photographs from the First Exhibition of American Textiles, Costumes, and Mechanical Processes." *Natural History: Journal of The American Museum of Natural History* 19, no. 6 (Dec. 1919): 631–54.

——. "The Teaching of Industrial Art." *Harvard Alumni Bulletin* 22 (23 Oct. 1919): 103–4.

Stansell, Christine. *American Moderns: Bohemian New York and the Creation of a New Century*. New York: Metropolitan Books, 2000.

Stocking, George W., Jr., ed. *Objects and Others: Essays on Museums and Material Culture*. Madison: University of Wisconsin Press, 1985.

Tarbell, Ida M. "An Appeal to American Women." *Silk* 7, no. 12 (Dec. 1914): 59.

Tarbell, Roberta K. *Hugo Robus (1885–1964)*. Exh. cat. Washington, DC: Smithsonian Press for the National Collection of Fine Arts, 1980.

Tartsinis, Ann Marguerite. "Intimately and Unquestionably Our Own": The American Museum of Natural History and

Its Influence on American Textile and Fashion Industries, 1915–1927." Master's thesis, Bard Graduate Center, 2011.

Thompson, J. Eric S. Introduction to *A Study of Maya Art, Its Subject Matter and Historical Development*, by Herbert J. Spinden. New York: Dover, 1975. v–x.

Thurman, Christa C. Mayer. "Textiles: As Documented by the Craftsman." In *The Ideal Home: The History of Twentieth-Century American Craft, 1900–1920*. Edited by Janet Kardon. Exh. cat. New York: Harry N. Abrams, 1993. 100–110.

Torgovnick, Marianna. *Gone Primitive: Savage Intellects, Modern Lives*. Chicago and London: University of Chicago Press, 1990.

Trask, Jeffrey. "American Things: The Cultural Value of Decorative Arts in the Modern Museum, 1905–1931." PhD diss., Columbia University, 2006.

———. *Things American: Art Museums and Civic Culture in the Progressive Era*. Philadelphia: University of Pennsylvania Press, 2012.

Troy, Nancy J. *Couture Culture: A Study in Modern Art and Fashion*. Cambridge: MIT Press, 2003.

Troy, Virginia Gardner. *Anni Albers and Ancient American Textiles: From Bauhaus to Black Mountain*. Burlington, VT: Ashgate, 2002.

———. *The Modernist Textile*. Hampshire, UK: Lund Humphries, 2006.

Tuttle, Virginia Clayton, Elizabeth Stillinger, and Erika Doss. *Drawing on America's Past: Folk Art, Modernism, and the Index of American Design*. Chapel Hill: University of North Carolina Press, 2002.

"The Unseen Label: The Contribution of the American Wholesale Designers." *Vogue* 76, no. 9 (27 Oct. 1930): 66, http://search.proquest.com/docview/879185127. Accessed 31 May 2013.

Valliant, George C. *Indian Arts in North America*. New York: Cooper Square Publishers, 1973.

Van Liew, H. A. "Mexican Designs and Colorings for Fall Silks." *American Silk Journal* 33, no. 3 (March 1914): 57.

Van Saun, Freya. "The Road to Beauty: Stewart Culin and the American Clothing and Textile Industries." Master's thesis, Bard Graduate Center, 1999.

Voso Lab, Susan. "'War' Drobe and World War I." In *Dress in American Culture*. Edited by Patricia A. Cunninham and Susan Voso Lab. Bowling Green, OH: Bowling Green State University Popular Press, 1993. 200–19.

Whitley, Lauren D. "Morris De Camp Crawford and American Textile Design, 1916–1921." Master's thesis, Fashion Institute of Technology, 1994.

———. "Morris De Camp Crawford and the 'Designed in America' Campaign, 1916–1922" (1998). Textile Society of America Symposium Proceedings. Paper 215. http://digitalcommons.unl.edu/tsaconf/215.

Williams, Beryl. *Fashion is Our Business*. Philadelphia and New York: J. B. Lippincott Company, 1945.

Wilson, Kristina. *The Modern Eye: Stieglitz, MoMA, and the Art of the Exhibition, 1925–1934*. New Haven and London: Yale University Press, 2009.

Wissler, Clark. "Costumes of the Plains Indians." *Anthropological Papers of the American Museum of Natural History* 17, no. 2 (1915): 39–91.

———. "Indian Beadwork: A Help for Students of Design." Guide leaflet, no. 50. New York: American Museum of Natural History, 1919.

———. "Moccasin Exhibit in the American Museum." *American Museum Journal* 16, no. 5 (May 1916): 308–14.

———. Review of "Yarn and Cloth Making: An Economic Study by Mary Lois Kissell." *American Anthropologist* 21, no. 1 (Jan.–March 1919): 92.

———. "Riding Gear of the North American Indians." *Anthropological Papers of the American Museum of Natural History* 17, no. 1 (1915): 1–38.

———. "Structural Basis to the Decorations to the Costumes Among the Plains Indians." *Anthropological Papers of the American Museum of Natural History* 17, no. 3 (1916): 93–114.

———. "A Suggested Study of Costumes." *American Museum Journal* 16, no. 7 (1916): 465–67.

"Women Radicals." *New York Times*, 3 Feb. 1935.

Women's Wear. "Exhibition of Models by Members of the Designer's Association." 28 July 1915.

———. "Indian Bead Motifs are Woven into Modern Designs." 8 Nov. 1919.

———. "Making Designers." 19 July 1915.

———. "Making Designers." 22 June 1915.

———. "A Modern Maya Maid." 31 Jan. 1917.

Zimmer, William. "Female Artists Depict Shifting View of Women." *New York Times*, 23 Sept. 1984.

Index

Photographic Credits